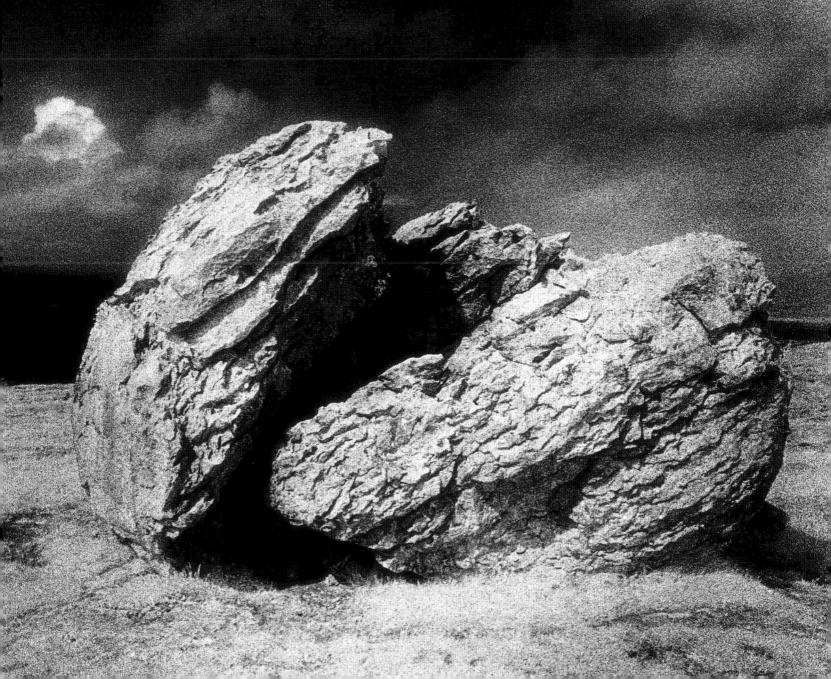

THE TWILIGHT HOUR

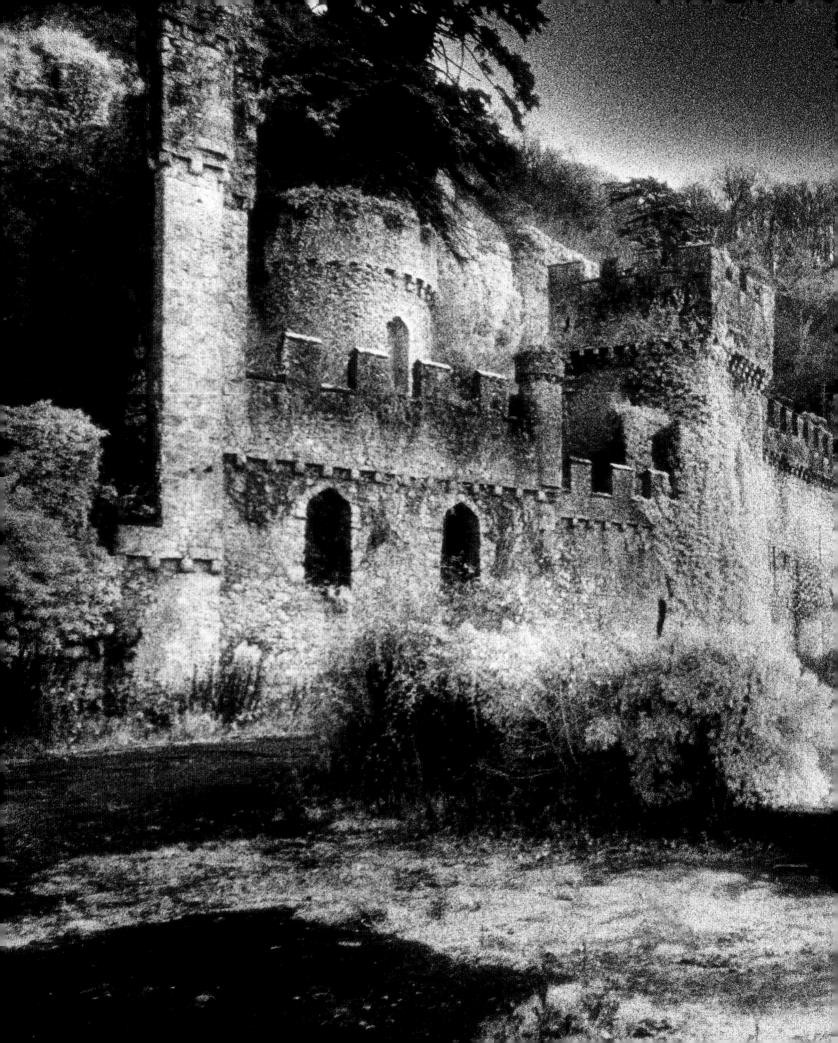

Simon Marsden

The Twilight Hour

Celtic Visions from the Past

Little, Brown

For Jason and Ann,
fellow travellers in *The Haunted Realm*

A *Little, Brown* Book

First published in Great Britain in 2003 by Little, Brown

Copyright photographs © Simon Marsden 2003
Copyright text on pages 8-13, 19-20, 27, 33-4, 40, 44-6, 53, 58, 66,
76–9, 84, 95–6, 100, 110–15, 122–6 © Simon Marsden 2003

The moral right of the author has been asserted.

For permission to quote from their work the author gratefully
acknowledges: *The Matrix* by Jonathan Aycliffe, used by permission
of HarperCollins Publishers; 'The Haunted House' by Robert Graves,
used by permission of Carcanet Press; *The White People*,
The Novel of the Black Seal, *The Great God Pan* by Arthur Machen, used by
permission of A. M. Heath; *The Golden Age*, 'The Magi' by W. B. Yeats,
used by permission of A. P. Watt.

Every attempt has been made to trace and contact copyright holders,
but in some instances this has not been possible. Please notify the
publisher of any inadvertent omissions of acknowledgements or
permissions and these will be rectified in future editions.

Privacy notice: as several of the houses included in this book are
private properties and therefore not open to the public,
the author asks that the reader respects their privacy.

Photograph on page 1: Rocks, The Burren, County Clare, Ireland;
on pages 2–3: Gwrych Castle, Abergele, North Wales

Design by Andrew Barron @ thextention

A CIP catalogue record for this book is available from the British Library.

ISBN 0 316 64537 0

Printed and bound in Italy

Little, Brown
An imprint of Time Warner Books UK
Brettenham House, Lancaster Place, London WC2E 7EN

www.TimeWarnerBooks.co.uk
www.simonmarsden.co.uk

Between two worlds life hovers like a star,
'Twixt night and morn, upon the horizon's verge.
How little do we know that which we are!
How less what we may be! The eternal surge
Of time and tide rolls on, and bears afar
Our bubbles; as the old burst, new emerge,
Lash'd from the foam of ages; while the graves
Of empires heave but like some passing waves.

From *Don Juan* by
George Gordon, Lord Byron, 1819–24

CONTENTS

INTRODUCTION 8

'The Great God Pan' by Arthur Machen 14

'The Haunted House' by Robert Graves 16

GLAMIS CASTLE 18

Dracula by Bram Stoker 22

Ancient Legends, Mystic Charms & Superstitions of Ireland by Lady Wilde 24

DUNTULM CASTLE 26

The Matrix by Jonathan Aycliffe 28

PLAS TEG 32

'A Spirit Passed Before Me' by Lord Byron 36

The Magi' by W. B. Yeats 37

Carmilla by Joseph Sheridan Le Fanu 38

THIRLWALL CASTLE 40

Wuthering Heights by Emily Brontë 42

CHARLEVILLE CASTLE 44

'The White People' by Arthur Machen 48

KITTY'S STEPS 52

The Fall of the House of Usher by Edgar Allan Poe 54

The Hound of the Baskervilles by Arthur Conan Doyle 56

OLD CASTLE HACKETT 58

The Strange Case of Dr Jekyll and Mr Hyde by Robert Louis Stevenson 60

The Dream by Lord Byron 64

SLIEVE NA CALLIAGH 66

Dracula by Bram Stoker 68

Melmoth the Wanderer by Charles Maturin 72

'The Marriage of Heaven and Hell' by William Blake 74

RATHKILL HOUSE 76

The Oval Portrait by Edgar Allan Poe 80

The Matrix by Jonathan Aycliffe 82

MELROSE ABBEY 84

The Wondersmith by Fitz-James O'Brien 88

Wuthering Heights by Emily Brontë 92

CASTLE LESLIE 94

The Familiar by Joseph Sheridan Le Fanu 98

RANNOCH MOOR 100

Dracula by Bram Stoker 102

The Golden Age by W. B. Yeats 104

What Was It? by Fitz-James O'Brien 106

LEAP CASTLE 110

The Novel of the Black Seal by Arthur Machen 116

'Alone' by Edgar Allan Poe 118

The Photographs 120

Biographies 122

Bibliography 127

Acknowledgements 128

INTRODUCTION

'REAL VISION IS THE ABILITY TO SEE THE INVISIBLE'

Jonathan Swift, author of *Gulliver's Travels*

The ancient Celts, one of the oldest peoples in Europe, embraced the awesome power of nature and the suspension of reality. They made poets their kings and recognised that this world was not the only level of existence: another unseen realm of the ever-living, of spirits, demons and ghosts, was always close to the surface of their reality and was therefore very visible to them. They regarded the many ancient earthworks and standing stones of their precursors to be the dwelling places of beings from this 'otherworld', beings whom the Irish called the Sidhe. Their name embodies the halfway state between one world and the next, a vital theme of Celtic art and myth, and they were said to be of two kinds: 'tall and shining', or 'opalescent' – lit from within. Noble in appearance, these ghost warriors inhabited a timeless land, a magical realm that cut across spatial boundaries and embraced both good and evil; a kingdom where everything was possible, where poets and wanderers were at peace.

To the Celts, man was not separate from nature, but a part of it. Every river, lake and well, every plain, hill and mountain had its own name. It was as if the ground had some sacred power and this harmony with nature brought with it a powerful supernatural knowledge. They could tell the future by observing the flight of birds and the behaviour of animals, the patterns of clouds and the flow of rivers. The

Roman writer Virgil tells how the woods 'were the first seat of sylvan powers, of nymphs and fauns, and savage men who took their birth from trunks of trees and stubborn oaks'. Today in our cathedrals and churches we still find the beautiful but sinister carvings of the 'green man', who epitomises the darkness and terror of these primeval forests.

Supernatural agencies pervaded every aspect of the Celts' lives and surroundings. It was their holy men and soothsayers, the Druids, who gained access to this ancestral spirit world through a process of initiation into its primordial secrets, re-awakening latent powers, which they then channelled for their own ends. They were known to have practised both animal and human sacrifices at ritual gatherings on hilltops and in oak forests. The human head was considered by the Celts to be the supreme source of spiritual power and was conspicuous in their rituals. After battle they would hang the severed heads of their enemies from their horses' necks, later nailing them to the entrance of their homes.

As a race they knew that death was not the end, merely the soul's transmigration into a new body – whether it be animate or inanimate, an animal or a tree – and that this was only a temporary state until it was re-awakened by some psychic power.

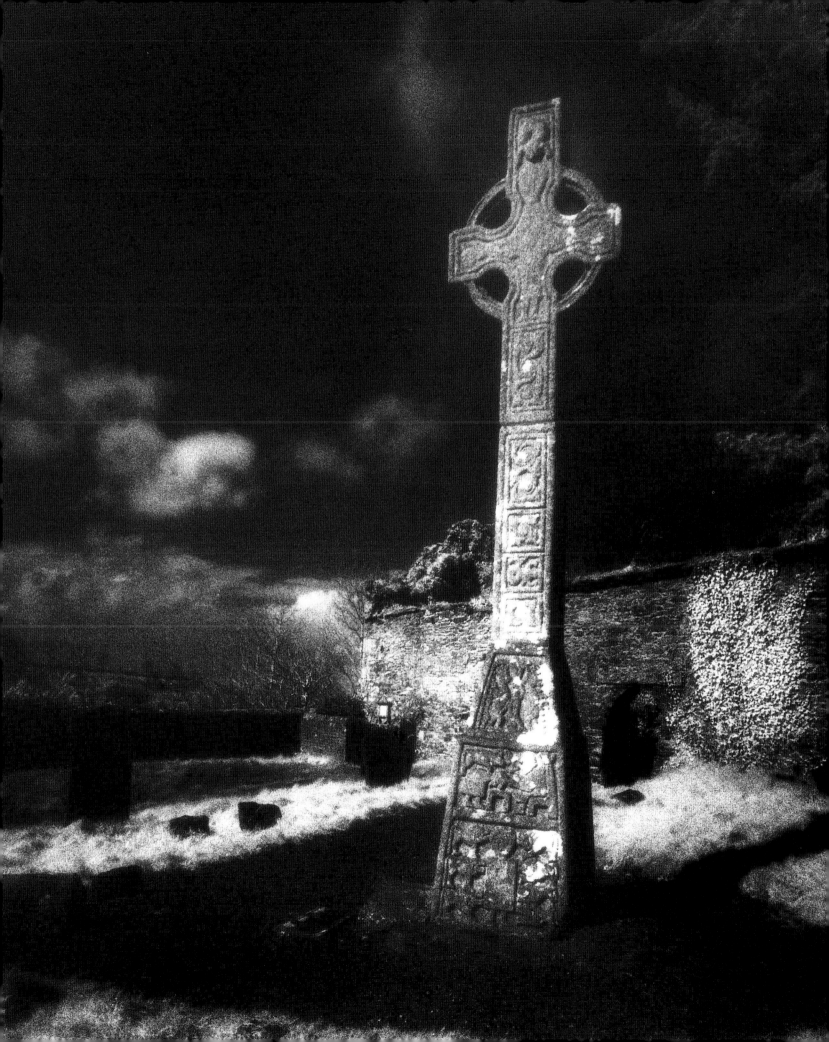

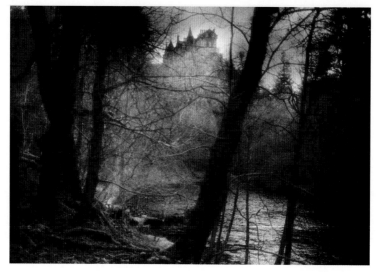

'I feel that there is much to be said of the Celtic belief that the souls of those whom we have lost are held captive in some inferior being, in an animal, in a plant, in some inanimate object, and effectively lost to us until the day (which to many never comes) when we happen to pass by a tree, or to obtain possession of the object, which forms their prison. Then they start and tremble, they call us by name, and as soon as we have recognised their voice the spell is broken. We have delivered them: they have overcome death and return to share our life.'
Marcel Proust, *A La Recherche du Temps Perdu*, 'Swann's Way', I

These Celtic mysteries were defined in the flux of in-between states, where everything is an integrated, inseparable part of the whole: the dew is neither rain nor sea-water; the sacred mistletoe is neither a plant nor a tree; and the Sidhe is neither dead nor alive, but inhabits the otherworld in an embodiment of the ancient dream state. The entrances to this visionary kingdom were believed to be at ancient sites known as 'edges', and the twilight hour, the period between day and night, was considered a dangerous time when one's earthly spirit or soul might cross over into this other supernatural world that so fired the imaginations of this proud and mysterious race.

In this book I have selected the creations of poetic visionaries: extracts and poems from the acknowledged literary geniuses in the genre of supernatural and fantasy literature, all of whom have strong Celtic ancestry and have been driven by the collective unconscious of their mysterious past. Seeking out this otherworld, most felt themselves to be outsiders standing on the edge, searching for a truth in a world through which the mass simply drift with no perspective on their past. Some, like Emily Brontë and Joseph Sheridan Le Fanu, led a reclusive, melancholic lifestyle; others, like Charles Maturin and Fitz-James O'Brien, were unashamedly eccentric; while Arthur Machen, William Butler Yeats and Sir Arthur Conan Doyle embraced spiritualism and the occult. For the master of the macabre, Edgar Allan Poe, the only escape was through drink and drugs.

'Deep into the darkness peering, long I stood there, wondering, fearing, doubting, dreaming dreams no mortals ever dared to dream before.'
Edgar Allan Poe, 'The Raven'

Because of their Celtic ancestry, their view of our world was continually challenged by a greater reality; a genetic memory of a higher existence; an intrinsic truth whose eternal light shines in the unbroken rhythms of the past. I have illustrated

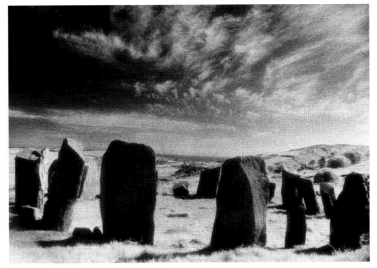

their fictional texts with my own photographs of the kind of landscapes and architecture that would have inspired these writers.

I have also retold some real ghost stories from these Celtic realms. I believe that timeless spirits and primordial powers still haunt many ancient buildings and monuments. One such is Glamis Castle in Scotland – the childhood home of the late Queen Mother – amongst whose many phantoms is the chilling legend of the monster of Glamis. This fortress was built on a site that was believed by the Celts to have been the sacred abode of ancient spirits of the earth and air. Another location is the most haunted house in Ireland – Leap Castle – sited on a vast, ancient rock where several ley lines cross. Our distant ancestors believed that these timeworn tracks of primal energy were paths of psychic activity that could be used for either good or evil. The castle was once the seat of the violent O'Carroll clan and is haunted by a foul smelling elemental, said to be the embodiment of all the evil acts that have been committed there over the centuries.

Our world today is driven by the relentless and all-consuming marriage of science and commerce. We appear to be dismissing or forgetting much that our distant ancestors knew: our links with nature and the ancient magic from man's farthest and darkest past, things that are rooted indelibly within the mind of man. Science can explain anything away if one allows it to, just as all one's original thoughts and beliefs as a child can be eroded by the cynicism of one's elders.

'It was, perhaps, on these mornings, as he rode to his mechanical work, that vague and floating fancies that must have long haunted his brain began to shape themselves, and to put on the form of definite conclusions, from which he could no longer escape, even if he had wished it. Darnell had received what is called a sound commercial education, and would therefore have found great difficulty in putting into articulate speech any thought that was worth thinking; but he grew certain on these mornings that the common sense which he had always heard exalted as man's supremest faculty was, in all probability, the smallest and least considered item in the equipment of an ant of average intelligence. And with this, as an almost necessary corollary, came a firm belief that the whole fabric of life in which he moved was sunken, past all thinking in the grosser absurdity; that he and all his friends and acquaintances and fellow workers were interested in matters in which men were never meant to be interested, were pursuing aims which they were never meant to pursue, were, indeed much like fair stones of an altar serving as a pigsty wall.'

Arthur Machen, *A Fragment of Life*

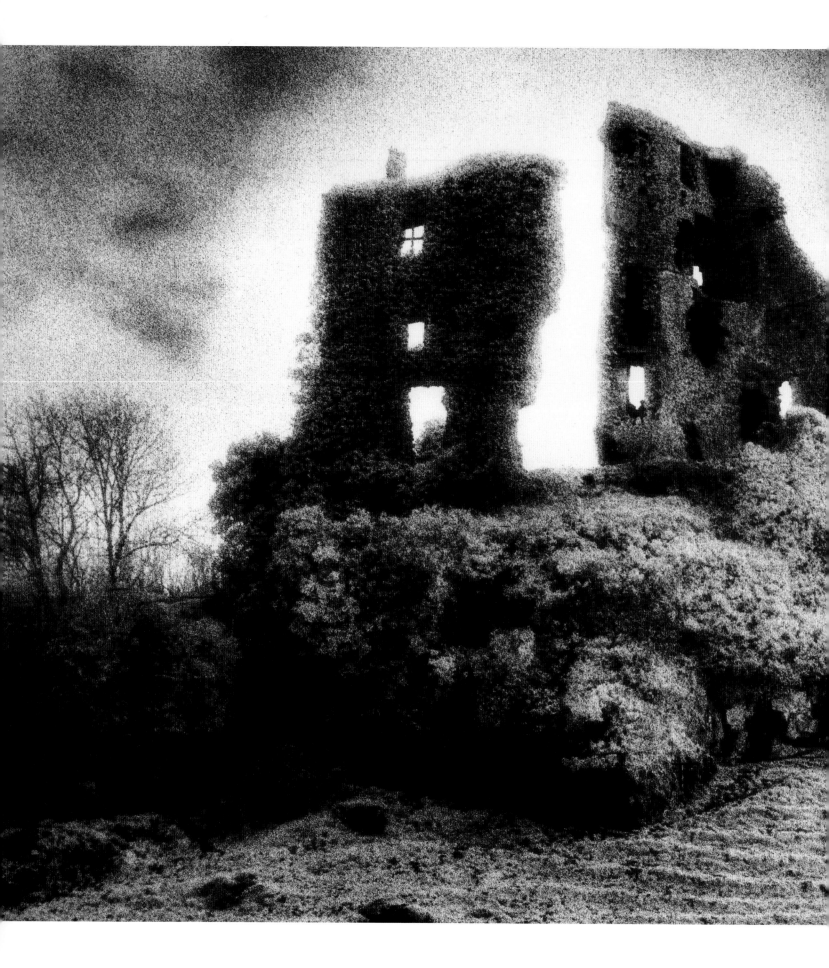

I, too, believe that another dimension – a spirit world – runs parallel to our own so-called 'real' world, and that sometimes, when the conditions are right, we can see into and become part of this supernatural domain. It is known that we have two sensory systems – one conscious and the other unconscious – and that the unconscious processes information faster and more accurately. This system is known as our sixth sense and is tuned into the spiritual world. We have quite deliberately suppressed these powers, as they are of little use to us in our highly mechanised modern-day world, but we all possess remnants of this inherent intellect and can reactivate it if we desire. For me it is a question of how receptive we are willing to be, how far we are prepared to open our minds to this intermingling of physical and supernatural worlds.

With their tales of a magical dimension, the Celtic storytellers – in Gaelic, the *seanchui* – perfected the near impossible art of rationalising this otherworld. Simply by convincingly actualising the impossible, they made our physical world seem mundane, less real. These ancient beliefs still live on in the subconscious minds of Celts, a forgotten wisdom that is more real to them than our materialistic existence, a knowledge that outlasts time.

Simon Marsden
JUNE 2003

THE GREAT GOD PAN

'LOOK ABOUT YOU, CLARKE. YOU SEE THE MOUNTAIN, AND HILL FOLLOWING AFTER HILL, AS WAVE ON WAVE, YOU SEE THE WOODS AND ORCHARDS, THE FIELDS OF RIPE CORN, AND THE MEADOWS REACHING TO THE REED BEDS BY THE RIVER. YOU SEE ME STANDING HERE BESIDE YOU, AND HEAR MY VOICE; BUT I TELL YOU THAT ALL THESE THINGS — YES, FROM THAT STAR THAT HAS JUST SHONE

out in the sky to the solid ground beneath our feet – I say that all these are but dreams and shadows: the shadows that hide the real world from our eyes. There is a real world, but it is beyond this glamour and this vision, beyond these "chases in Arras, dreams in a career", beyond them all as beyond a veil. I do not know whether any human being has ever lifted that veil; but I do know, Clarke, that you and I shall see it lifted this very night from before another's eyes. You may think all this is strange nonsense; it may be strange, but it is true, and the ancients knew what lifting the veil means. They called it seeing the God Pan.'…

Clarke heard the words quite distinctly, and knew that

Raymond was speaking to him, but for the life of him he could not rouse himself from his lethargy. He could only think of the lonely walk he had taken fifteen years ago; it was his last look at the fields and woods he had known since he was a child, and now it all stood out in brilliant light, as a picture, before him. Above all there came to his nostrils the scent of summer, the smell of flowers mingled, and the odour of the woods, of cool shaded places, deep in the green depths, drawn forth by the sun's heat; and the scent of the good earth, lying as it were with arms stretched forth, and smiling lips, overpowered all. His fancies made him wander, as he had wandered long ago, from the fields into the wood,

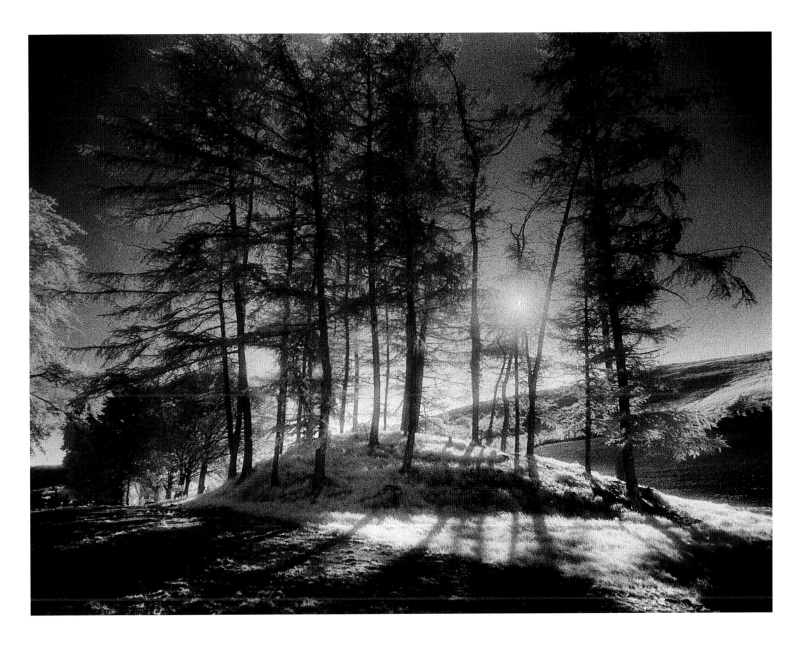

tracking a little path between the shining undergrowth of beech trees; and the trickle of water dropping from the limestone rock sounded as a clear melody in the dream. Thoughts began to go astray and to mingle with other recollections; the beech alley was transformed to a path beneath ilex trees, and here and there a vine climbed from bough to bough, and sent up waving tendrils and drooped with purple grapes, and the sparse grey-green leaves of a wild olive tree stood out against the dark shadows of the ilex. Clarke, in the deep folds of dream, was conscious that the path from his father's house had led him into an undiscovered country, and he was wondering at the strangeness of it

all, when suddenly, in place of the hum and murmur of the summer, an infinite silence seemed to fall on all things, and the wood was hushed, and for a moment of time he stood face to face there with a presence, that was neither man nor beast, neither the living nor the dead, but all things mingled, the form of all things but devoid of all form. And in that moment, the sacrament of body and soul was dissolved and a voice seemed to cry 'Let us go hence,' and then the darkness of darkness beyond the stars, the darkness of everlasting.

From *The Great God Pan* by Arthur Machen, 1894

THE HAUNTED HOUSE

'Come, surly fellow, come: a song!'
What, fools? Sing to you?
Choose from the clouded tales of wrong
And terror I bring to you:

Of a night so torn with cries,
Honest men sleeping
Start awake with rabid eyes,
Bone-chilled, flesh creeping,

Of spirits in the web-hung room
Up above the stable,
Groans, knocking in the gloom,
The dancing table,

Of demons in the dry well
That cheep and mutter,
Clanging of an unseen bell,
Blood choking the gutter,

Of lust frightful, past belief,
Lurking unforgotten,
Unrestrainable endless grief
In breasts long rotten.

A song? What laughter or what song
Can this house remember?
Do flowers and butterflies belong
To a blind December?

Robert Graves, 1918

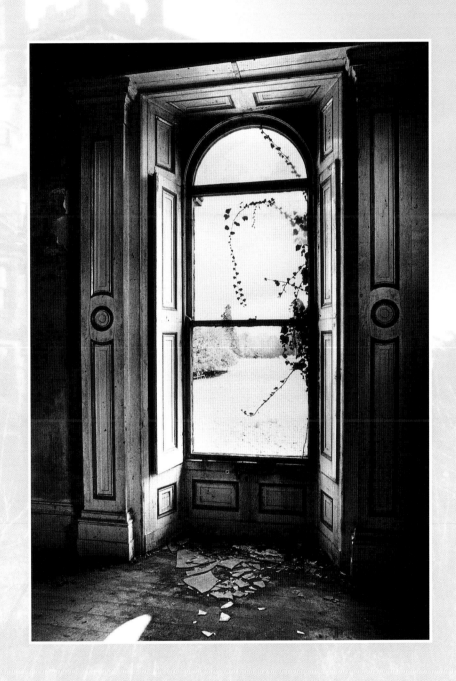

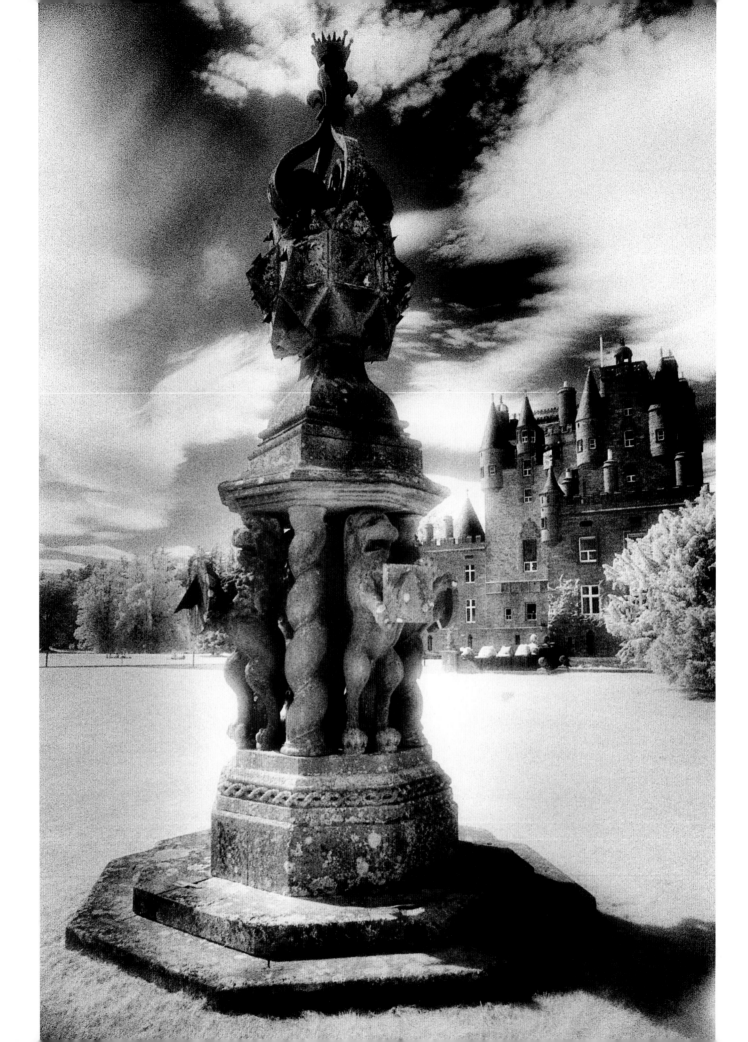

GLAMIS CASTLE

THIS GRIM AND MENACING FAIRYTALE CASTLE WAS BUILT ON A SITE THAT WAS BELIEVED SINCE EARLY CELTIC TIMES TO BE THE SACRED ABODE OF ANCIENT SPIRITS OF THE EARTH AND AIR. THE FORTRESS IS STEEPED IN HISTORY AND IS SAID TO BE PEOPLED BY A LEGION OF GHOSTS. AS I ENTERED THE SPECTACULAR DEMESNE THROUGH THE AWESOME DEVIL GATES AND CONTINUED

down the long avenue towards the castle, with its many baronial towers commanding the skyline, the words of the romantic Scottish poet and novelist, Sir Walter Scott, who stayed the night here in 1793, came back to haunt me. 'I must own,' he wrote, 'that when I heard door after door shut, after my conductor had retired, I began to consider myself as too far from the living, and somewhat too near the dead.'

Thought to be the oldest inhabited castle in Scotland, since 1372 it has been the seat of the Bowes-Lyon family, and later of the Earls of Strathmore and Kinghorne, and is the childhood home of the late Queen Mother. There are over ninety rooms in the castle, many left empty, but it is the legend of the Secret Room and the Monster of Glamis that has given the castle its widespread notoriety over the years. It is said that at some time towards the beginning of the nineteenth century, a monster was born to be the heir of Glamis. This poor, misshapen creature, more like a toad than a man, was said to be immensely strong and was imprisoned in a secret chamber somewhere within the fifteen-foot walls of the castle, unseen by anyone other than a trusty keeper, who fed him through an iron grille. Only three people – the then Earl, his next eldest son on his coming of age and the factor of the estate – could know the

awful secret of his whereabouts and his exact identity. The mystery of his existence remains to this day. Rumours circulated that the monster, having achieved a great age, died in 1921, but there seems to be no record of his death. Lord Halifax in his famous *Ghost Book* of 1936 tells of large stones with rings in them in several bedroom cupboards, which were later made into coal stores to deter inquisitive guests, and of a workman who unsuspectingly uncovered a hidden passage near the chapel and who, after lengthy interrogation by his superiors, was induced to emigrate with his family. An area on the roof of the castle is still known as the Mad Earl's Walk, but whether this was for exercising the monster at night, or referred to another member of the family, it is not known.

Another version of the story claims that because of an ancient family curse, a hideous vampire is born into every generation of this haunted family, which must be imprisoned to curtail its unquenchable thirst for human blood. Whatever the truth of the legend it is hard to ignore the reputed words of the fifteenth Earl: 'If you could only guess the nature of the secret, you would go down on your knees and thank God that it was not yours.'

Lady Glamis, the beautiful widow of the sixth Lord

Glamis, was controversially burnt alive as a witch on Castle Hill in Edinburgh in 1537, and her ghost, surrounded by a reddish glow, has been seen hovering above the Clock Tower. It is said that after her death many supernatural phenomena began to plague the castle. In the oldest part of the building is Duncan's Hall, traditionally the scene of the murder of King Duncan by Macbeth, Thane of Glamis, in Shakespeare's tragedy. Lady Elphinstone, the Queen Mother's sister, is said to have been frightened by the sinister atmosphere of this room as a child. Another apparition is the pale face of a terrified young girl, seen staring from a barred window of the castle. She is said to have had her tongue cut out and her hands amputated at the wrist because of some secret she discovered. There is also the spectre of a small mischievous boy, a negro servant, who frequently appears to visitors in the Queen Mother's sitting room.

Another gruesome tale concerns the Haunted Chamber within the ghostly crypt. Long ago members of the Ogilvy clan sought shelter at the castle during a feud with their enemies, the Lindsays, and were permitted to hide in this remote dungeon. The then Lord Glamis had the vault bricked up and the unfortunate men starved to death. When the chamber was opened a century later their skeletons were found strewn across the floor, some in such a position as to suggest that they died literally gnawing the flesh from their arms. Terrifying poltergeist activity has been experienced in this part of the castle.

The many impressive family portraits throughout the castle – especially that of the third Earl of Strathmore by the Dutch artist Jacob de Wet, and the bizarre dress of this flamboyant nobleman – fascinated me. Nothing appears quite as it seems and the overall sense of power throughout the rambling pile, the size and number of the vast rooms and dark stone passageways, is without doubt intimidating. I came away from the castle as if in a dream, transfixed by fleeting shadows and unsolved mysteries.

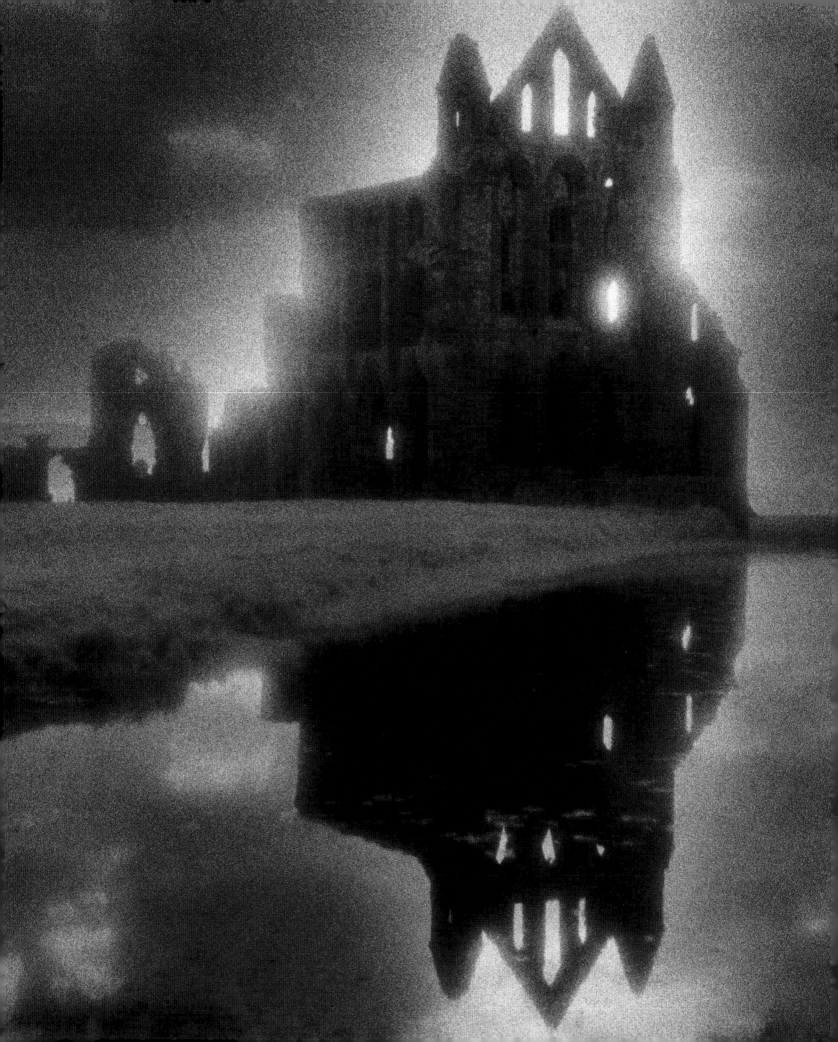

NINA MURRAY'S JOURNAL

At the edge of the West Cliff above the pier I looked across the harbour to the East Cliff, in the hope or fear – I don't know which – of seeing Lucy in our favourite seat. There was a bright full moon, with heavy black, driving clouds, which threw the whole scene into a fleeting diorama of light and shade as they sailed across.

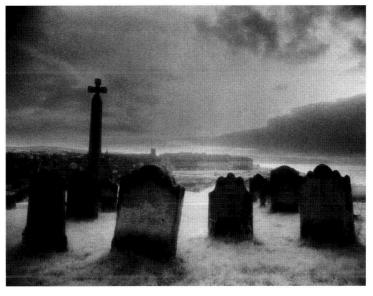

For a moment or two I could see nothing, as the shadow of a cloud obscured St Mary's Church and all around it. Then as the cloud passed I could see the ruins of the Abbey coming into view; and as the edge of a narrow band of light as sharp as a sword-cut moved along, the church and the churchyard became gradually visible. Whatever my expectation was, it was not disappointed, for there, on our favourite seat, the silver light of the moon struck a half-reclining figure, snowy white. The coming of the cloud was too quick for me to see much, for shadow shut down on light almost immediately; but it seemed to me as though something dark stood behind the seat where the white figure shone, and bent over it. What it was, whether man or beast, I could not tell; I did not wait to catch another glance, but flew down the steep steps to the pier and along by the fish-market to the bridge, which was the only way to reach the East Cliff. The town seemed as dead, for not a soul did I see; I rejoiced that it was so, for I wanted no witness of poor Lucy's condition. The time and distance seemed endless; and my knees trembled and my breath came laboured as I toiled up the endless steps to the Abbey. I must have gone fast, and yet it seemed to me as if my feet were weighted with lead, and as though every joint in my body were rusty. When I got almost to the top I could see the seat and the white figure, for I was now close enough to distinguish it even through the spells of shadow. There was undoubtedly something, long and black, bending over the half-reclining white figure. I called in fright, 'Lucy! Lucy!' and something raised a head, and from where I was I could see a white face and red, gleaming eyes. Lucy did not answer, and I ran on to the entrance of the churchyard. As I entered, the church was between me and the seat, and for a minute or so I lost sight of her. When I came in view again the cloud had passed, and the moonlight struck so brilliantly that I could see Lucy half reclining with her head lying over the back of the seat. She was quite alone, and there was not a sign of any living thing about.

From 'Nina Murray's Journal', *Dracula* by Bram Stoker, 1897

THE BANSHEE

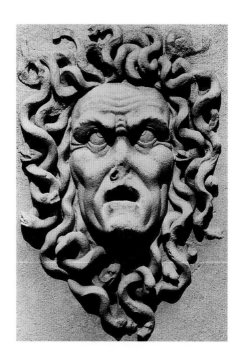

THE BANSHEE MEANS, ESPECIALLY, THE WOMAN OF THE FAIRY RACE, FROM VAN, 'THE
WOMAN — THE BEAUTIFUL'; THE SAME WORD FROM WHICH COMES *VENUS*. SHILOH-VAN WAS
ONE OF THE NAMES OF BUDDHA — 'THE SON OF THE WOMAN'; AND SOME WRITERS AVER THAT
IN THE IRISH *SULLIVAN* (SULLI-VAN) MAY BE FOUND THIS ANCIENT NAME OF BUDDHA.

As the Leanan-Sidhe was the acknowledged *spirit of life*, giving inspiration to the poet and the musician, so the Ban-Sidhe was the *spirit of death*, the most weird and awful of all the fairy powers.

But only certain families of historic lineage, or persons gifted with music and song, are attended by this spirit; for music and poetry are fairy gifts, and the possessors of them show kinship to the spirit race – therefore they are watched over by the spirit of life, which is prophecy and inspiration; and by the spirit of doom, which is the revealer of the secrets of death.

Sometimes the Banshee assumes the form of some sweet singing virgin of the family who died young, and has been given the mission by the invisible powers to become the harbinger of coming doom to her mortal kindred. Or she may be seen at night as a shrouded woman, crouched beneath the trees, lamenting with veiled face; or flying past in the moonlight, crying bitterly: and the cry of this spirit is mournful beyond all other sounds on earth, and betokens certain death to some member of the family whenever it is heard in the silence of the night.

From *Ancient Legends, Mystic Charms & Superstitions of Ireland*, by Lady Jane Francesca Wilde, 1887

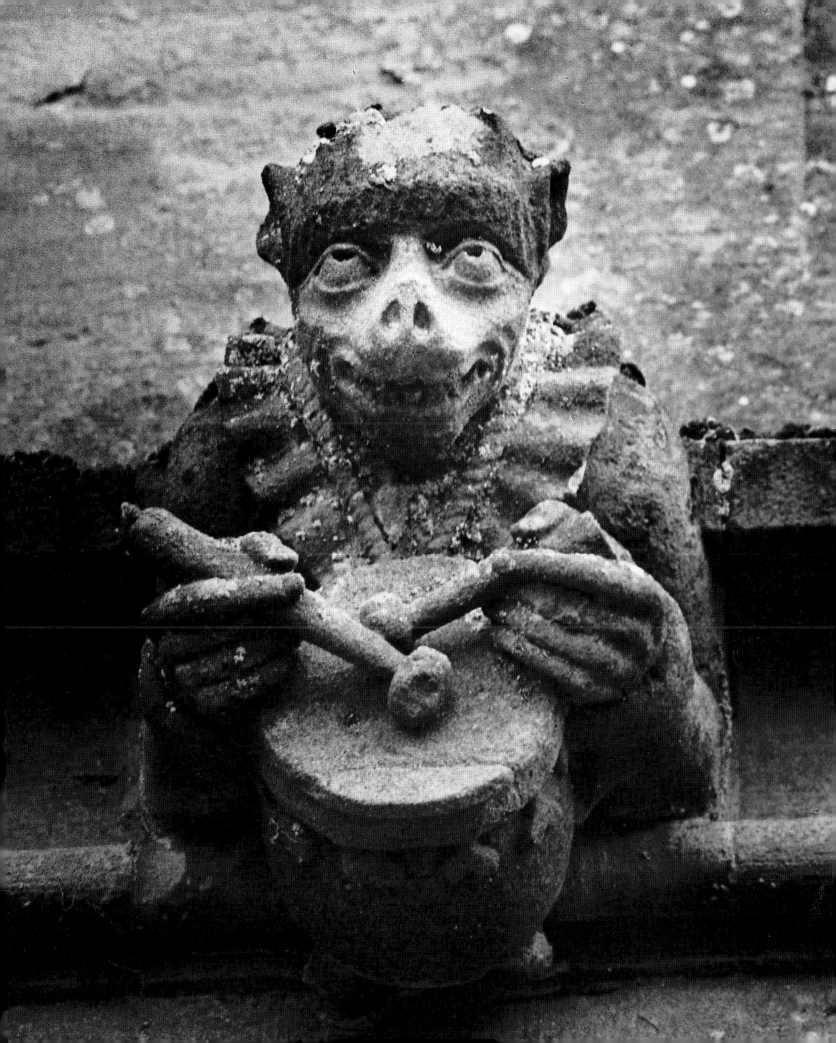

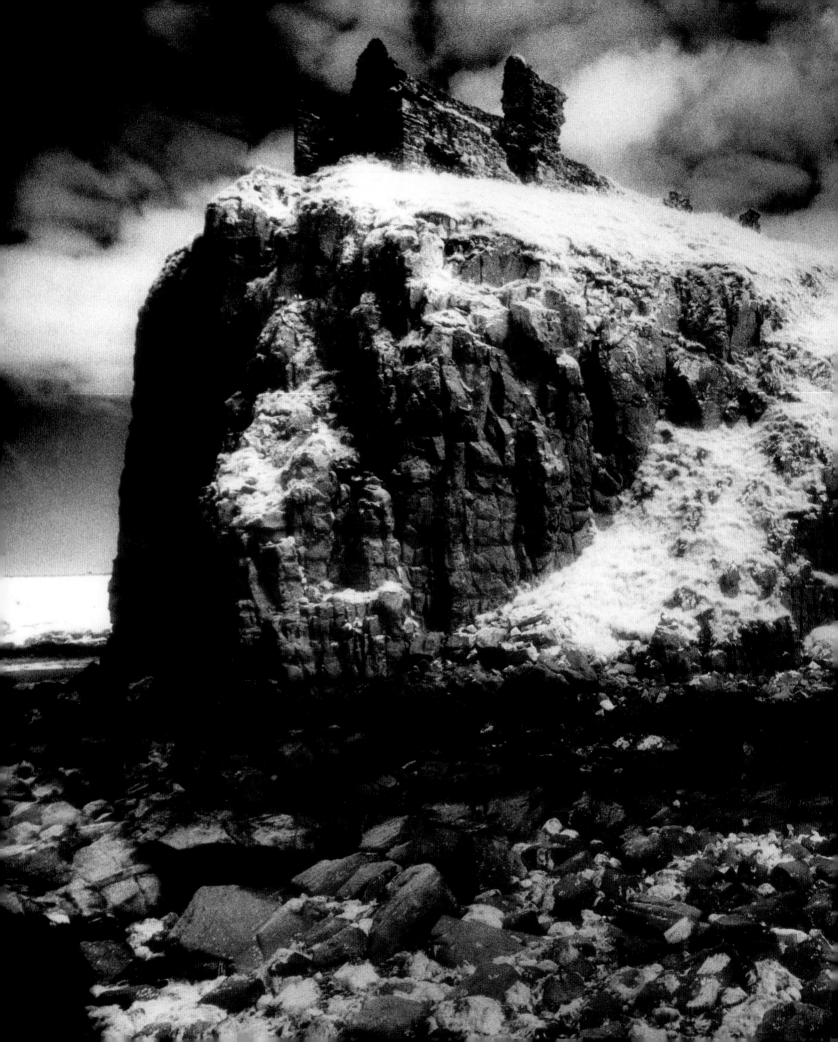

DUNTULM CASTLE

THE SPECTRAL RUINS OF DUNTULM CASTLE ARE PERCHED HIGH UP ON A PROMINENT ROCK FACE IN THE FAR NORTH-WEST CORNER OF THE LEGENDARY AND MAGICAL ISLE OF SKYE, A TREASURY OF CELTIC FOLKLORE. A PRINCIPAL SEAT OF THE MACDONALDS, LORDS OF THE ISLES, THE CASTLE HAD A PARTICULARLY VIOLENT HISTORY UNTIL THE CLAN WAS

forced to abandon it around 1730 because, as legend says, they could no longer live with the tragic and horrific ghosts that endlessly roamed its once great halls.

The most awesome phantom is that of Donald Gorm Môr, the ruthless MacDonald chieftain who bled to death in the castle, mortally wounded by an arrow. One of his sons, an infant of only eighteen months, is said to have accidentally fallen from the arms of his nurse standing on the castle walls and was dashed to death on the cruel rocks below. The old woman, despite her desperate cries of remorse, was hurled down after him and her pathetic apparition is still seen by the edge of the cliff.

But by far the most terrible legend tells of the imprisonment and death of a cousin of Donald Gorm, Uisdean Môr. They were rivals for not only the leadership of the clan, but also for the love of the same woman. Eventually the cunning of Donald Gorm triumphed, when he captured his cousin by trickery and imprisoned him in the deepest and darkest dungeon in the castle, leaving him with only a piece of salt beef, a loaf of bread and a jug of water. When the young man could control his hunger no longer he devoured the salt beef and the bread. Overtaken by an uncontrollable thirst he then raised the jug to his lips, but to his horror it was empty – his cousin's last perverted, evil act. He died insane, his agonised screams piercing the thick walls of the castle, as they still do today.

The dark dungeon vaults have long since been filled in with stones, but one can still see the hollows hewn into the rock face below the fortress where the MacDonalds secured their majestic galleys, and as the icy cold winds shriek and howl through the remaining stones of the castle walls, these eerie hauntings seem all too real.

THE MATRIX

Tired from my hours of note-taking, my mind turned readily enough to the relatively undemanding task of poring over a book not directly connected with my paper. I read on, lulled by the lateness of the hour, the silence, the dim lighting, and my own fatigue, entranced by the weird lilting verses and their haunting tone. I understood very little.

As I turned a page towards the end, I saw, not a pentagram or a talisman as I had expected, but a wood-cut illustration. It took me about half a minute to disentangle the subject and composition of the drawing, but to this day I wish I had never done so. Printed on my mind's eye were shapes and figures of unspeakable horror. It had been no more than a glimpse, but in that moment of recognition I had seen forms that I will never forget as long as I live.

The woodcut depicted not an Eastern scene as might have been expected, but one set in Europe, the interior of a large church, huge and vaulted, with shadows on both sides of a wide nave. Thick carved pillars divided the nave from the side aisles, and a heavy curtain hung in front of the chancel, blocking all the eastern end of the church from view.

Along one side were ranged several stone tombs, topped with monuments. One near the chancel end had been opened, a great iron door swung back. On the ground lay what I took to be corpses, as though they had been dragged from their resting places and scattered in the aisle. That was sufficiently revolting in itself to make me shudder, but it was not the real horror of the drawing.

Just visible in the opening of the tomb were several indistinct figures, stooped over the remains of the dead. They had short, stumpy bodies, naked bodies the colour of parchment, white meat, bloodless, eternally pale. They were bent over the corpses, sucking and nibbling. And one ... Dear God, I cannot forget this – one was turning its head to look directly at the viewer. It did not have a face exactly, and it was shrouded in a piece of rotting cloth, but I could tell that it had no eyes. It had no eyes, but I knew that it could see.

I slammed the book shut and sat back, stupefied by the

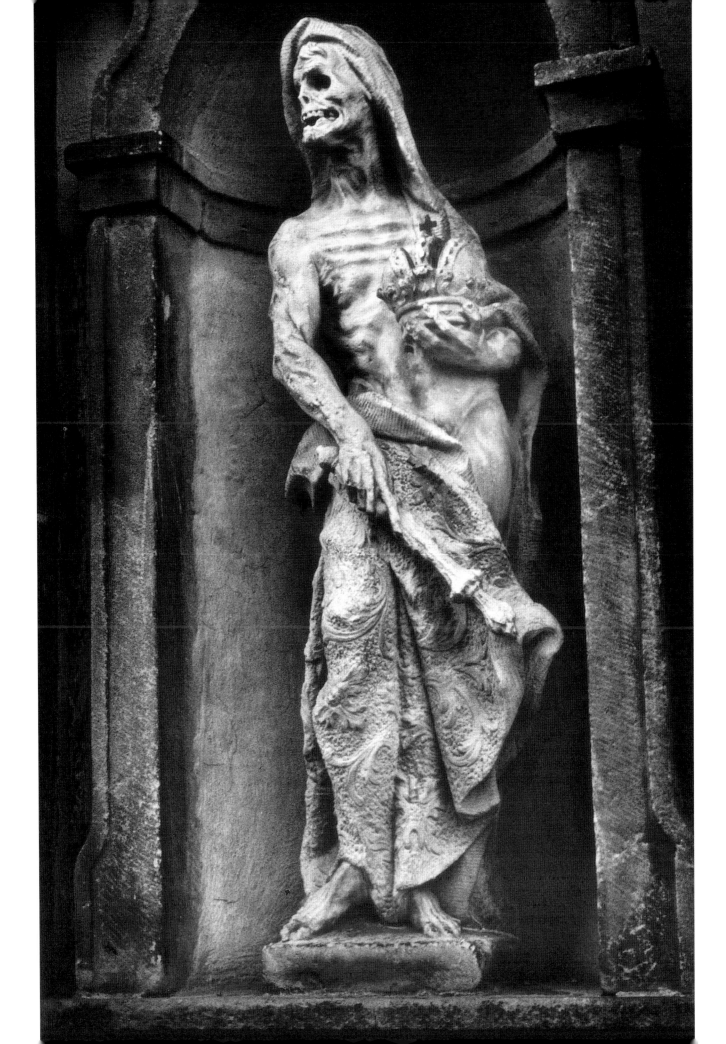

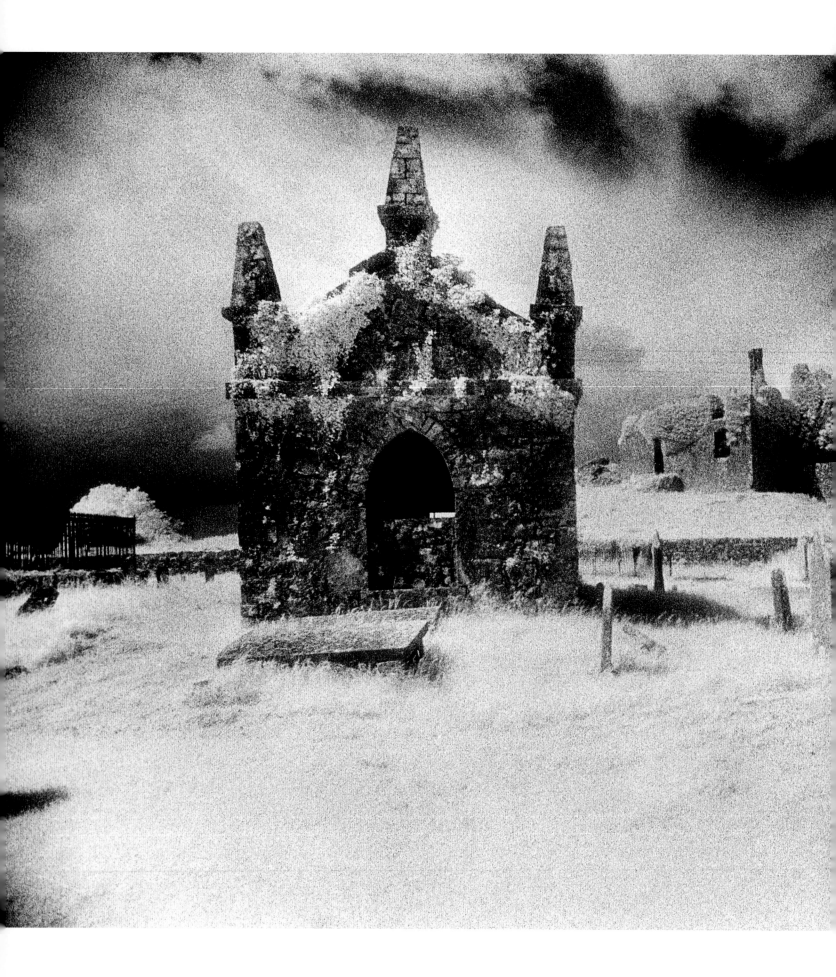

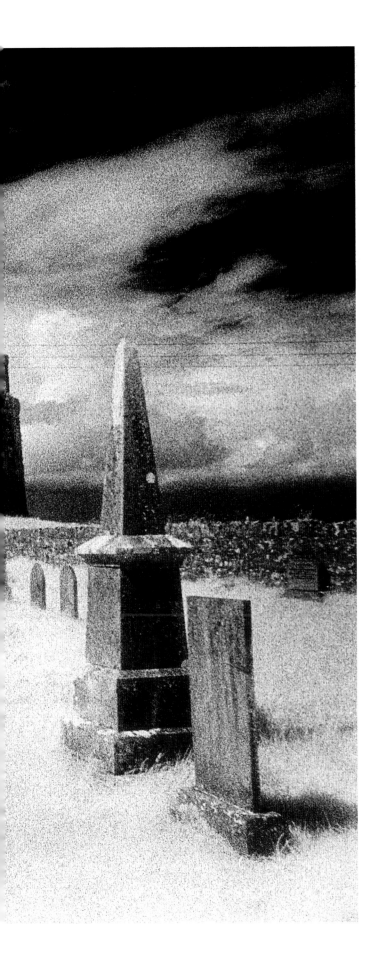

obscenity of the woodcut I had happened on. One thing I knew with absolute certainty, and I know it now without any hint of doubt – whoever the artist was who had penned that loathsome scene had not imagined it, but drawn it from life.

As I sat there, glancing nervously about me, I became aware for the first time that there were noises in the room above me. Something told me that they had been there for some time, but, engrossed as I had been in my reading, I had failed to notice them. I strove to make out what they could be. A sort of flapping and scraping that moved slowly across the floor above my head. At first I thought it must be a member of the Fraternity come to investigate the lights, or that, perhaps, the apartment upstairs had been rented without my knowledge.

But even as I listened, something in the quality of the sounds told me that, whatever was making them, it was not human. My heart seemed to freeze as the noises moved across the room in the direction of the door that led to the second floor landing. I heard the door opening, and the sound moving across a wooden floor. Terrified, I went to the door of the library. Somewhere above me, I could hear it, very soft, like seaweed on damp rocks, flapping and wriggling across the landing.

As I stood listening, it reached the first step and started down the stairs.

From *The Matrix* by Jonathan Aycliffe, 1994

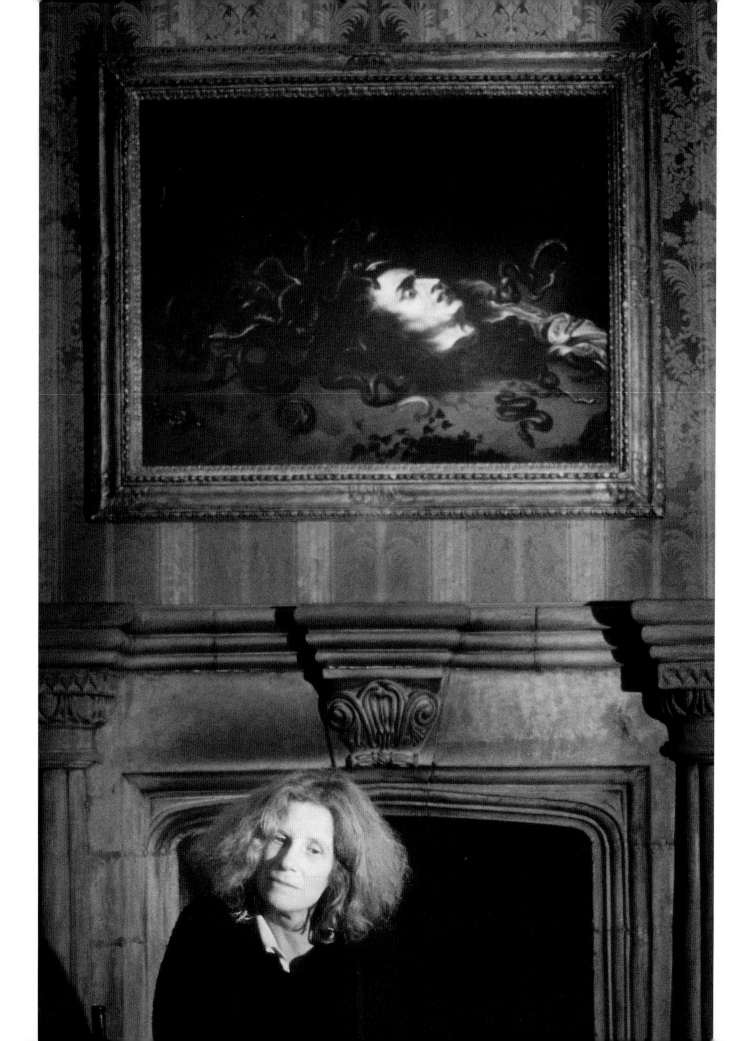

PLAS TEG

SOMBRE AND GAUNT, THIS EERIE JACOBEAN MANSION LIES IN AN AREA OF WALES RICH IN PRE-HISTORIC SITES AND LEGENDS OF WITCHCRAFT. THE FORBIDDING BUILDING UNCANNILY RESEMBLES A VAST, DARK MAUSOLEUM AND FOR MANY YEARS LAY DERELICT, INHABITED ONLY BY GHOSTS. IT WAS BUILT IN 1610 BY SIR JOHN TREVOR, WHO HELD THE LUCRATIVE POSITION OF SURVEYOR

to the Queen's Navy. Many of the huge beams that support the house's high ceilings were taken from the great wooden ships that were the pride of Britain's naval power at the time.

There have been an unusual number of suicides in the house and grounds over the years and it is another John Trevor, the last of the male line, who haunts the Regency Bedroom. Here, he slowly died in agony from the awful injuries he received after deliberately crashing his horse and carriage, following the tragic and mysterious death of his young wife in 1743. Because of its ghostly reputation the house was shunned by local people when it was left empty.

Another grieving phantom is a beautiful daughter of the Trevors who lived about two hundred years ago, and whose lover was killed in a duel by a rival. To avoid the advances of the jealous victor she threw herself and her jewels into a deep well in the garden. Her pathetic ghost roams through the house and grounds and American servicemen who were billeted at Plas Teg during World War II frequently saw her

there. It is said that in Victorian times a gardener was sitting on the edge of the well when suddenly he felt sharp, bony fingers clutch his shoulder, trying to pull him backwards. Terrified, he jumped up and peered into the murky waters below, but could see nothing. In the nineteenth century there used to be a white stone lodge gate in front of the house where the gatekeeper hanged himself after seeing 'something'. This building was never occupied again and was eventually demolished. Late at night motorists have reported seeing ghostly horsemen riding through the trees near the mansion.

The house was saved and spectacularly renovated in the 1980s by the remarkable Cornelia Bayley, who filled the vast, cold rooms with beautiful and unusual furniture, wall hangings and mysterious paintings, creating a fantasy world that is hard to describe in words. One room, known as the Indian Bedroom because of its Eastern furnishings, was once used as a local magistrate's court. Felons were sentenced and hanged here, disappearing on the end of a

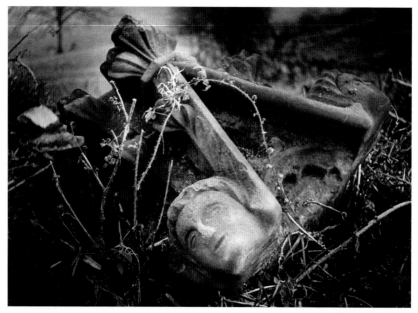

rope through a trap door in the floor.

Outside, the garden remains an overgrown wilderness full of architectural curiosities. I was particularly intrigued by part of a broken frieze of carved heads, which resembled a decadent symbolist masterpiece. I was attempting to find the haunted well when a car suddenly drove up and out stepped the fragile figure of Cornelia Bayley, her hair covered in paint from renovating another of her beloved ruins nearby. Over dinner she told me how at first the house had seemed to bring her nothing but bad luck. One of her favourite dogs had inexplicably viciously attacked another for no reason, and she would often hear mysterious footsteps and banging noises coming from the Regency Bedroom. The door of her own bedroom would sometimes shake in the middle of the night as if it were alive. She finally had the house exorcised and since then the disturbances have not been so bad. She now believes that the spirit of the mansion has become her lover and she wants to decorate the walls of the Great Hall with paint that has been mixed with the blood of all her friends, as an offering to the house.

Cornelia went on to tell me how she felt possessed by the building and knew she could never leave. 'I will be a ghost here,' she said, 'I have no choice.' Later I took some portraits of her in a room known as the Great Chamber, which is dominated by a chilling painting of Medusa. Cornelia appears to have risen to a higher plane of consciousness than her fellow mortals, existing on a level that is in harmony with the supernatural.

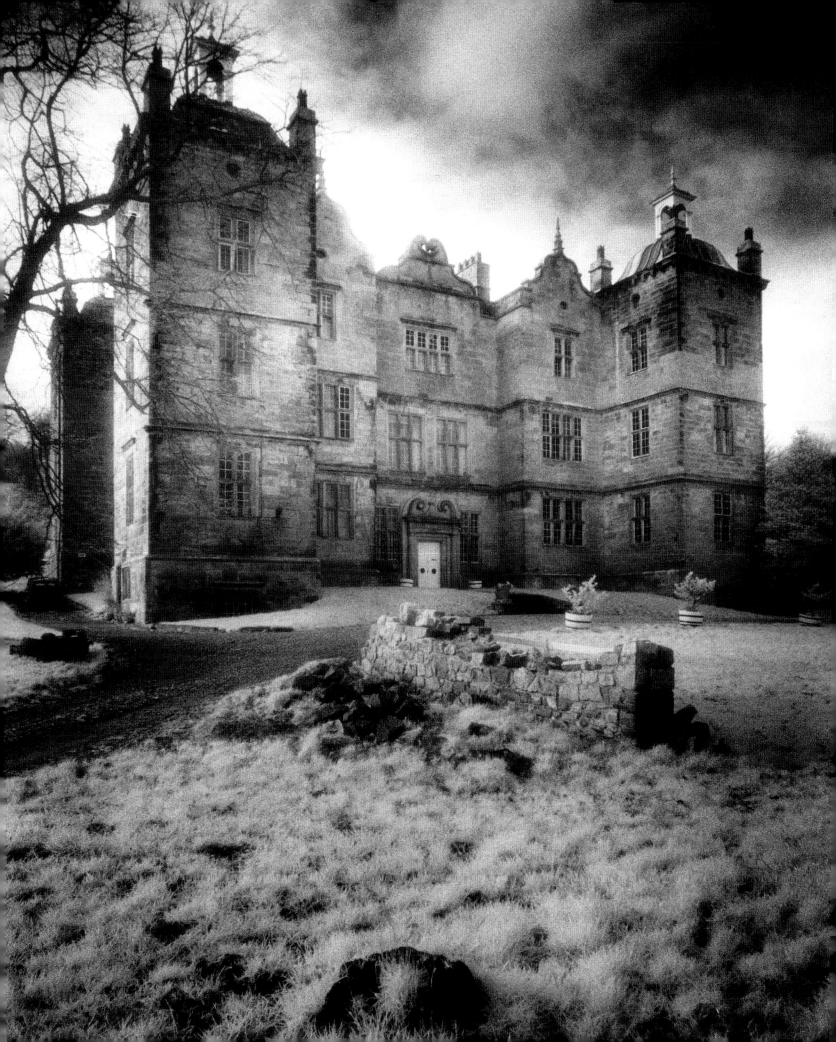

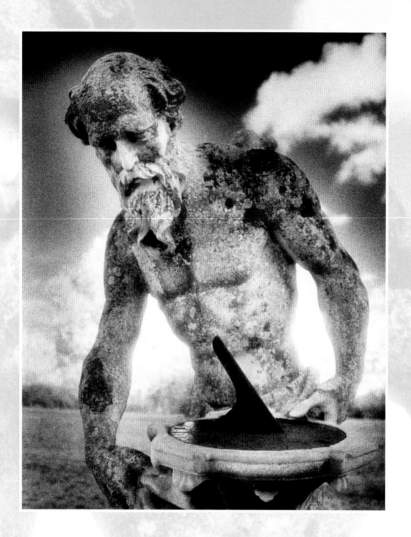

A spirit passed before me: I beheld
The face of immortality unveiled –
Deep sleep came down on every eye save mine –
And there it stood, – all formless – but divine:
Along my bones the creeping flesh did quake;
And as my damp hair stiffened, thus it spake:

'Is man more just than God? Is man more pure
Than He who deems even Seraphs insecure?
Creatures of clay – vain dwellers in the dust!
The moth survives you, and are ye more just?
Things of a day! You wither ere the night,
Heedless and blind to Wisdom's wasted light!'

'A Spirit Passed Before Me' from *Job*
by George Gordon, Lord Byron, 1814

THE MAGI

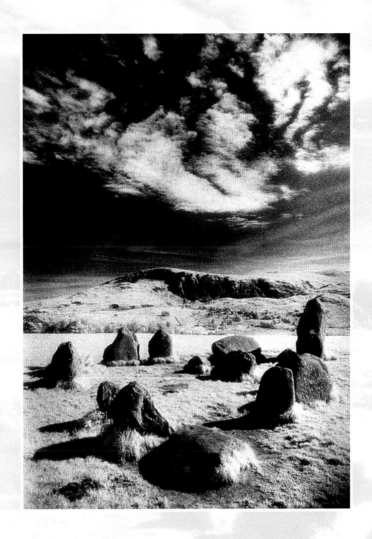

Now as at all times I can see in the mind's eye,

In their stiff, painted clothes, the pale unsatisfied ones

Appear and disappear in the blue depth of the sky

With all their ancient faces like rain-beaten stones,

And all their helms of silver hovering side by side,

And all their eyes still fixed, hoping to find once more,

Being by Calvary's turbulence unsatisfied,

The uncontrollable mystery on the bestial floor.

From *The Magi* by W. B. Yeats, 1916

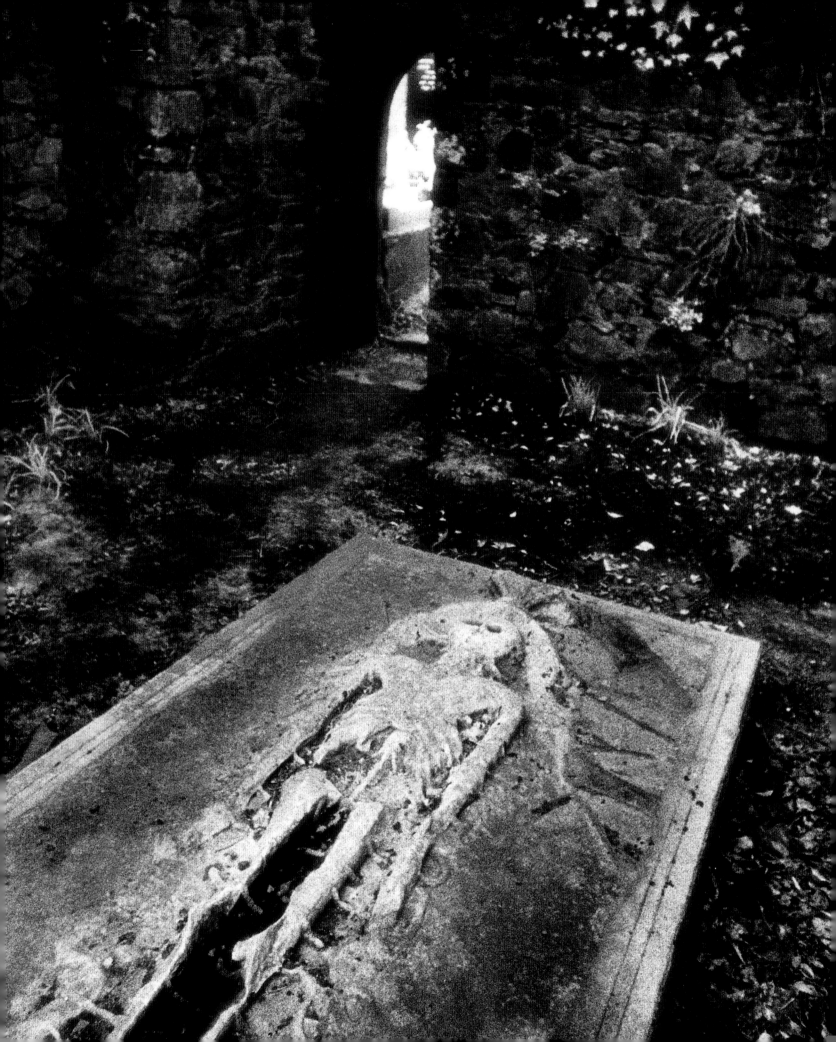

CARMILLA

THE NEXT DAY THE FORMAL PROCEEDINGS TOOK PLACE IN THE CHAPEL OF KARNSTEIN. THE GRAVE OF THE COUNTESS MIRCALLA WAS OPENED; AND THE GENERAL AND MY FATHER RECOGNISED EACH HIS PERFIDIOUS AND BEAUTIFUL GUEST, IN THE FACE NOW DISCLOSED TO VIEW. THE FEATURES, THOUGH A HUNDRED AND FIFTY YEARS HAD PASSED SINCE HER FUNERAL, WERE TINTED WITH

the warmth of life. Her eyes were open; no cadaverous smell exhaled from the coffin. The two medical men ... attested the marvellous fact, that there was a faint but appreciable respiration, and a corresponding action of the heart. The limbs were perfectly flexible, the flesh elastic; and the leaden coffin floated with blood, in which to a depth of seven inches, the body lay immersed. Here then, were all the admitted signs and proofs of vampirism. The body, therefore, in accordance with the ancient practice, was raised, and

a sharp stake driven through the heart of the vampire, who uttered a piercing shriek at the moment, in all respects such as might escape from a living person in the last agony. Then the head was struck off, and a torrent of blood flowed from the severed neck. The body and head were next placed on a pile of wood, and reduced to ashes, which were thrown upon the river and borne away.

From *Carmilla* by Joseph Sheridan Le Fanu, 1872

THIRWALL CASTLE

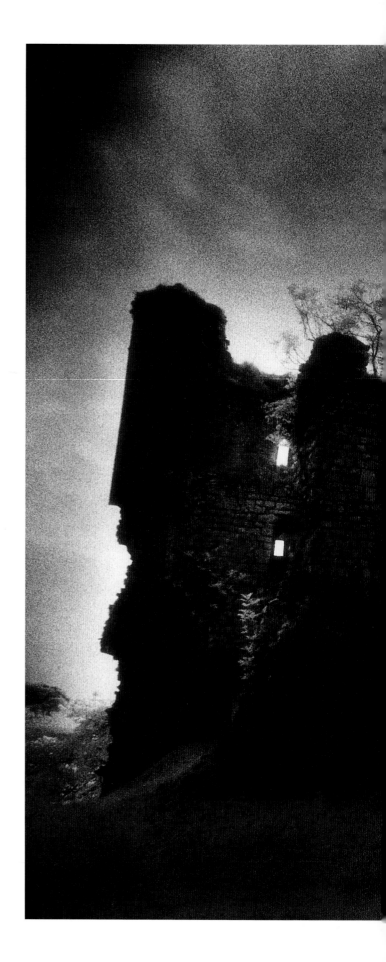

TO THE CELTS WATER HELD SUPERNATURAL POWERS AND SIGNIFIED A LINK WITH THE UNDER-WORLD, ESPECIALLY SPRINGS AND WELLS, WHICH WERE SEEN TO SPONTANEOUSLY EMANATE FROM

deep within the earth. According to legend, somewhere within the dark, eerie ruins of Thirlwall Castle, lying close to the Scottish Borders, is an overgrown well containing a fabulous hoard of treasure, guarded by a hideous, deformed dwarf.

In the thirteenth century Baron John de Thirlwall returned to the Northumbrian castle in triumph after a successful campaign in some bloody foreign war, and with him he brought a baggage train of booty that he had pillaged from his unfortunate victims. The pride of these spoils was a solid gold table and he appointed one of his retainers, a misshapen and horrifying dwarf with supernat-ural powers, to guard it. Rumours of these riches became rife in the borderlands, until the Scots finally stormed the castle one night, taking the defenders by surprise and butchering every last man of them.

When the attackers reached the chamber where they knew the treasure was hidden, the table was gone. One of their number looked out of a window and saw the repulsive dwarf struggling to throw the table down a deep well in the courtyard. The attackers rushed to him, their swords drawn, but they were too late, as first the table and then the dwarf disappeared from view. The dwarf's distorted features were made more terrifying by his evil sneer as he cast a spell to seal the mouth of the well. A spell that can only be broken by 'the coming of one who is the only son of a widow'.

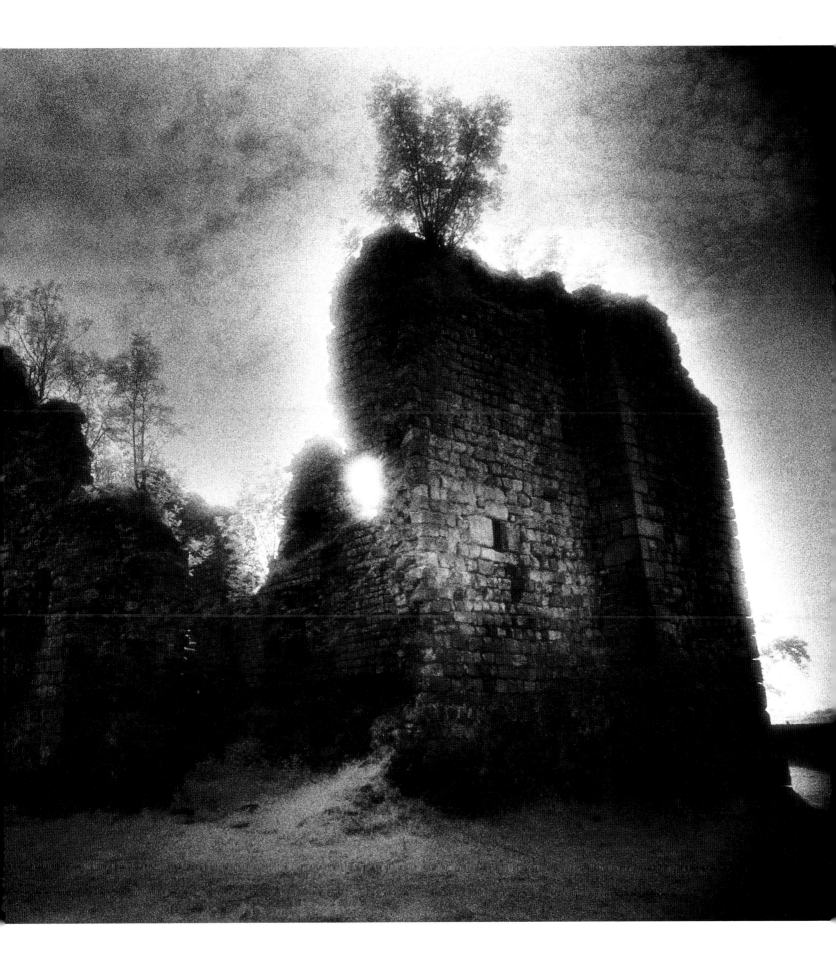

WUTHERING HEIGHTS

THIS TIME, I REMEMBERED I WAS LYING IN THE OAK CLOSET, AND I HEARD DISTINCTLY THE GUSTY WIND, AND THE DRIVING OF THE SNOW; I HEARD, ALSO, THE FIR-BOUGH REPEAT ITS TEASING SOUND, AND ASCRIBED IT TO THE RIGHT CAUSE: BUT, IT ANNOYED ME SO MUCH, THAT I RESOLVED TO SILENCE IT, IF POSSIBLE; AND, I THOUGHT, I ROSE AND ENDEAVOURED TO UNHASP THE CASE-

ment. The hook was soldered into the staple, a circumstance observed by me, when awake, but forgotten.

'I must stop it, nevertheless!' I muttered, knocking my knuckles through the glass, and stretching an arm out to seize the importunate branch: instead of which, my fingers closed on the fingers of a little, ice-cold hand!

The intense horror of nightmare came over me; I tried to draw back my arm, but, the hand clung to it, and a most melancholy voice sobbed,

'Let me in – let me in!'

'Who are you?' I asked, struggling, meanwhile, to disengage myself.

'Catherine Linton,' it replied, shiveringly (why did I think Linton? I had read Earnshaw twenty times for Linton). 'I'm come home, I'd lost my way on the moor!'

As it spoke, I discerned, obscurely, a child's face looking through the window – terror made me cruel; and, finding it useless to attempt shaking the creature off, I pulled its wrist on to the broken pane, and rubbed it to and fro till the blood ran down and soaked the bed-clothes: still it wailed, 'Let me

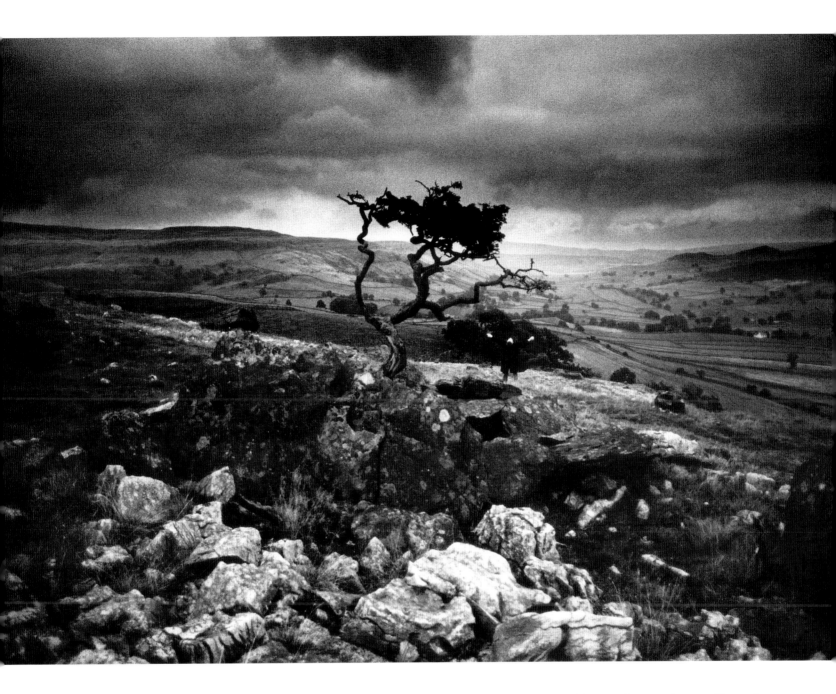

in!' and maintained its tenacious gripe, almost maddening me with fear.

'How can I?' I said at length. 'Let me go, if you want me to let you in!'

The fingers relaxed, I snatched mine through the hole, hurriedly piled the books up in a pyramid against it, and stopped my ears to exclude the lamentable prayer.

I seemed to keep them closed above a quarter of an hour; yet, the instant I listened again, there was the doleful cry moaning on!

'Begone!' I shouted, 'I'll never let you in, not if you beg for twenty years!'

'It's twenty years,' mourned the voice, 'twenty years, I've been a waif for twenty years!'

Thereat began a feeble scratching outside, and the pile of books moved as if thrust forward.

I tried to jump up; but, could not stir a limb; and so yelled aloud, in a frenzy of fright.

From *Wuthering Heights* by Emily Brontë, 1847

43

CHARLEVILLE FOREST

THIS MAGNIFICENT GOTHIC EXTRAVAGANZA, HIDDEN DEEP WITHIN AN ANCIENT OAK FOREST, WAS DESIGNED BY FRANCIS JOHNSTON IN THE EIGHTEENTH CENTURY FOR THE FABULOUSLY WEALTHY DILETTANTE RICHARD CHARLES BURY, LATER VISCOUNT CHARLEVILLE, AND TOOK FOURTEEN YEARS TO COMPLETE. BOTH MEN SHARED AN INTEREST IN MYSTICAL THEORIES AND GEOMETRY, SITING THE

castle where several ley lines, paths which connect prehistoric sites, crossed. These timeworn tracks were believed by our distant ancestors to have been conductors of a primal energy or earth force, and at the points where they cross unusual levels of paranormal activity have always been reported.

In one of the towers there is a bedroom where the vaulted ceiling meets in an eight-pointed star, a geometric device which concentrates energy. I was told that this room had been the subject of violent poltergeist activity over the years.

Amongst the many apparitions that have been seen in the dark corridors and eerie cellars of the castle is the ghost of a little girl who died while sliding down the banister of the Great Staircase. The present owner's children, aged four and six, have played with her and say that she told them her name is Harriet and that she lived at the castle long ago. The children's mother told me she was recently woken in the middle of the night by the sound of a child singing, followed by a piercing scream and then silence.

Another explanation for the existence of supernatural

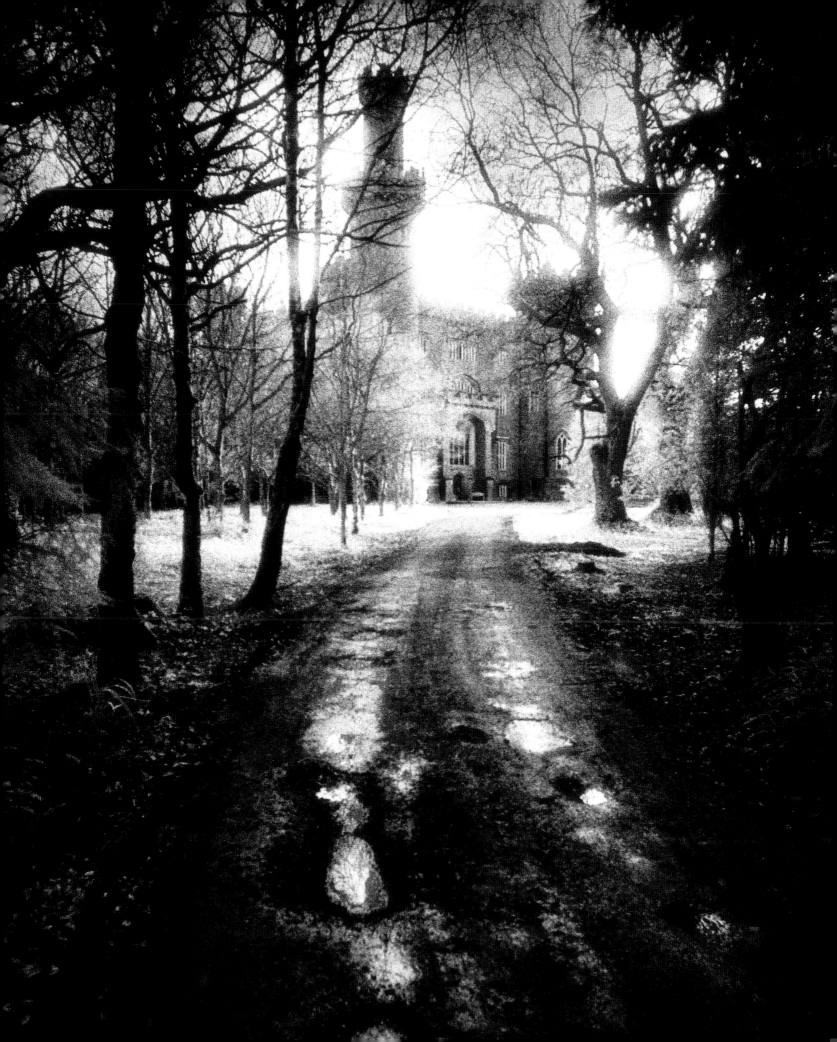

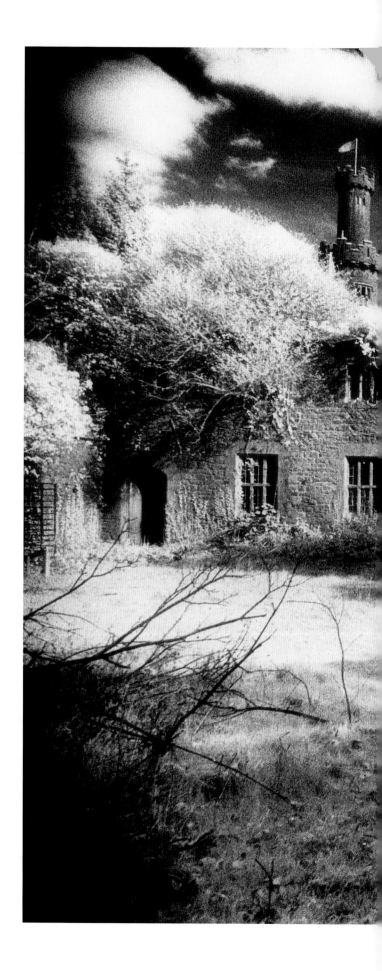

phenomena is what has become known as the 'tape-recording' theory. This concept proposes that certain inanimate objects such as stone and wood, because of their chemical make-up and the magnetic energy fields that surround them, are capable of storing extreme emotions, much the same as the materials involved in modern recording techniques capture sound. Then, when the conditions are right – particularly when the surroundings are damp, as in old buildings like this – and in the presence of a psychic or sensitive person, they can be replayed or re-activated.

What is it about buildings such as this, and gothic architecture in particular, which inspires such dark visions? For me they are symbols of a vast stillness, a silence more powerful than man. But are they also perhaps part of a universal subconscious, a mystical and spiritual solitude – their ivy-clad windows, soaring towers and crumbling walls creating a timeless melancholy of death, enveloped by the chill of the supernatural.

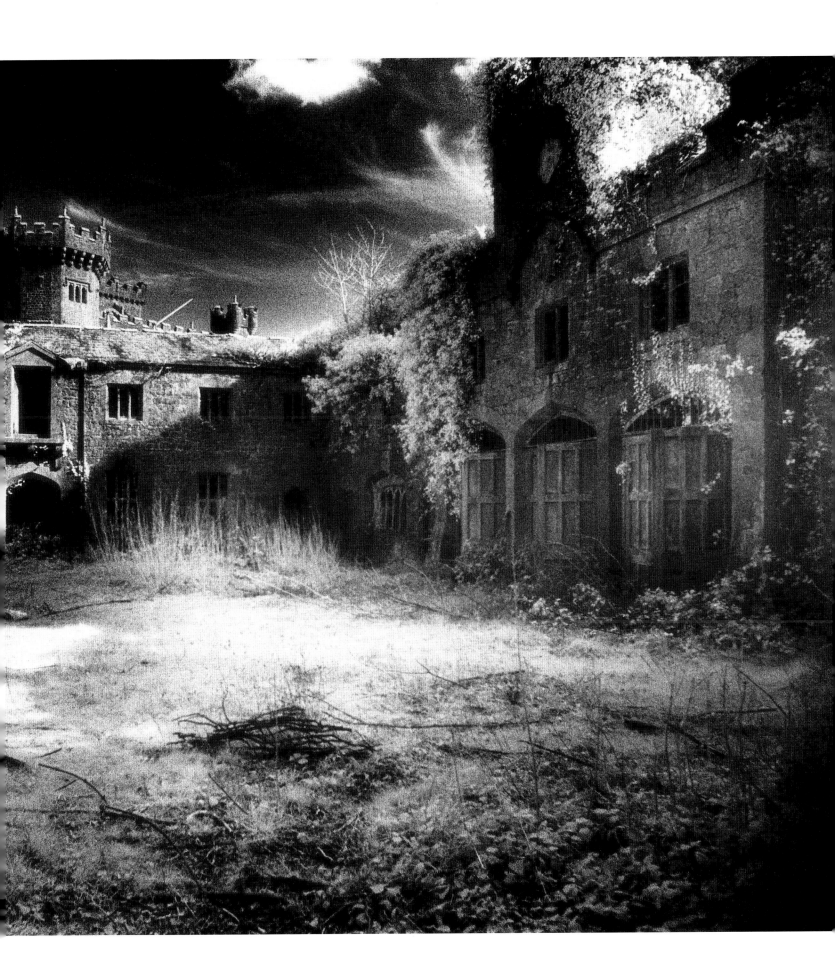

THE WHITE PEOPLE

AND SOMETIMES NURSE TOLD ME TALES THAT SHE HAD HEARD FROM HER GREAT-GRANDMOTHER, WHO WAS VERY OLD, AND LIVED IN A COTTAGE ON THE MOUNTAIN ALL ALONE. SHE TOLD ME ONE VERY STRANGE STORY ABOUT THE HILL, AND I TREMBLED WHEN I REMEMBERED IT. SHE SAID THAT PEOPLE ALWAYS WENT THERE IN SUMMER, WHEN IT WAS VERY HOT, AND THEY HAD TO DANCE A GOOD DEAL.

It would be all dark at first, and there were trees there, which made it much darker, and people would come, one by one, from all directions, by a secret path which nobody else knew, and two persons would keep the gate, and every one as they came up had to give a very curious sign, which nurse showed me as well as she could, but she said she couldn't show me properly. And all kinds of people would come: there would be gentle folks and village folks, and some old people and boys and girls, and quite small children, who sat and watched. And it would all be dark as they came in, except in one corner where someone was burning something that smelt strong and sweet, and made them laugh, and there one would see a glaring of coals, and the smoke mounting up red. So they would all come in, and when the last had come there was no door any more, so that no one else could get in, even if they knew there was anything beyond. And once a gentleman who was a stranger and had ridden a long way, lost his path at night, and his horse took him into the very middle of the wild country, where everything was upside down, and there were dreadful marshes and great stones everywhere, and holes underfoot, and the trees looked like gibbet-posts, because they had great black arms that stretched out across the way. And this strange gentleman was very frightened, and his horse began to shiver all over, and at last it stopped and wouldn't go any farther, and the gentleman got down and tried to lead the horse, but it wouldn't move, and it was all covered with a sweat, like death. So the gentleman went on all alone, going farther and farther into the wild country, till at last he came to a dark place, where he heard shouting and singing and crying, like nothing he had ever heard before. It all sounded quite close to him, but he couldn't get in, and so he began to call, and while he was calling, something came behind him, and in a minute his mouth and arms and legs were all bound up, and he fell into a swoon. And when he came to himself, he was lying by the roadside, just where he had first lost his way, under a blasted oak with a black trunk, and his horse was tied beside him. So he rode on to the town and told the people there what had happened, and some of them were amazed, but others knew. So when once every-

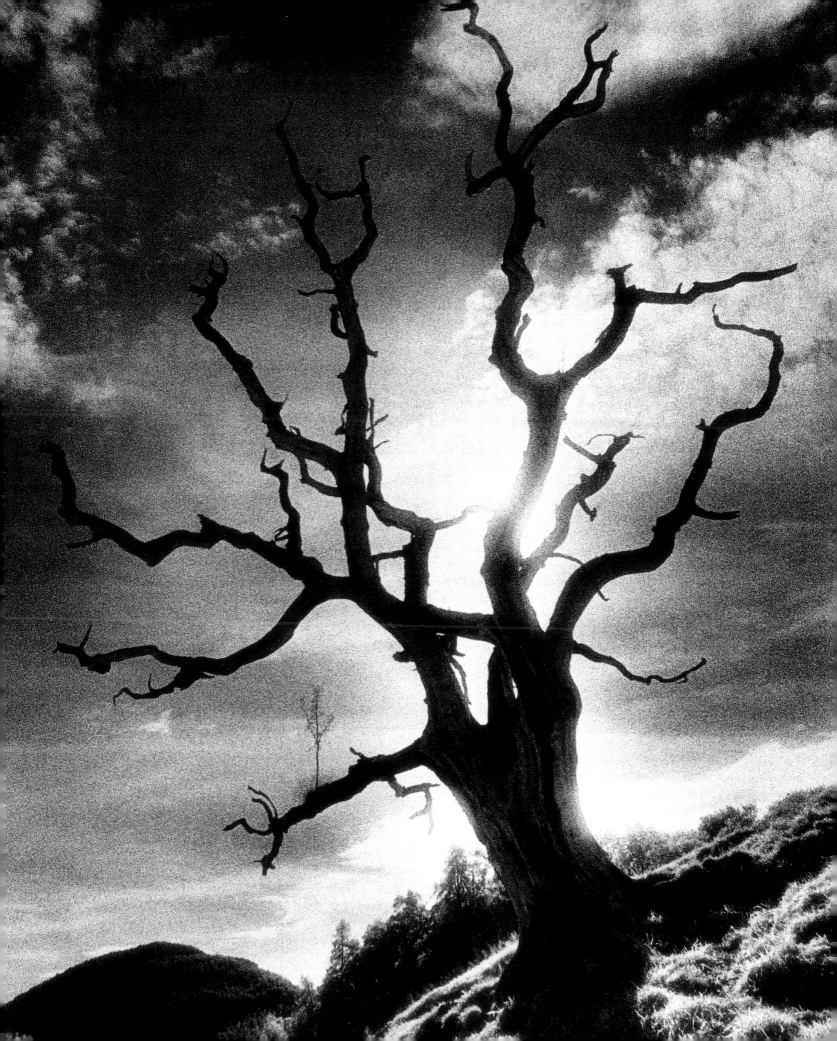

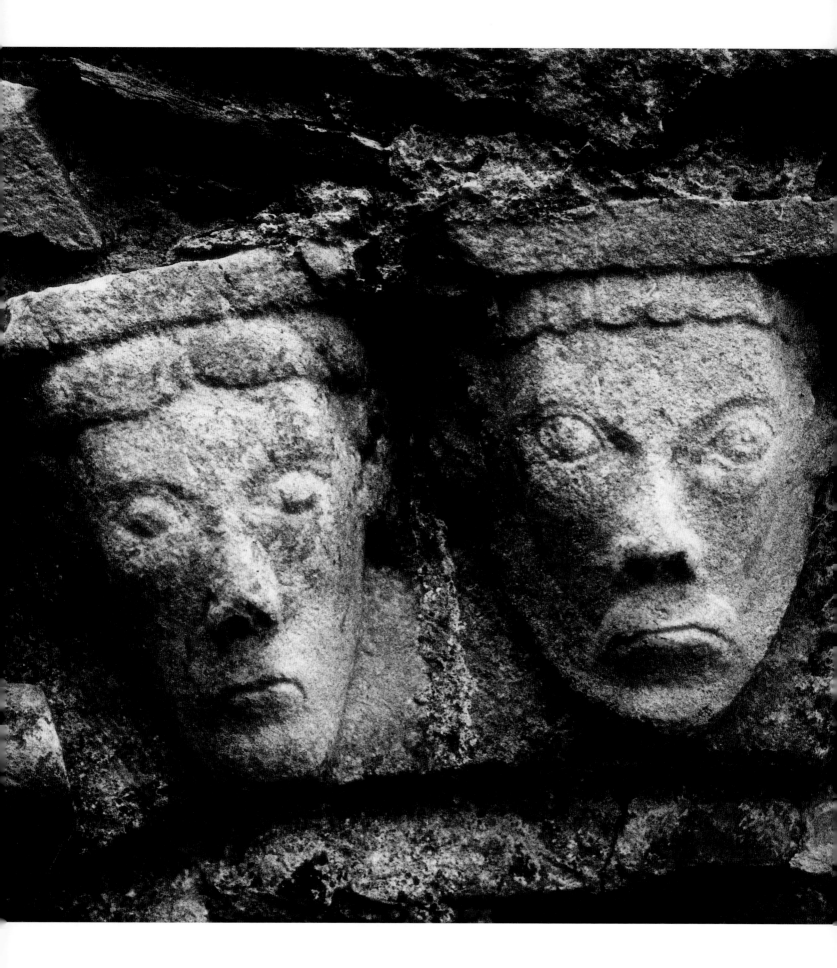

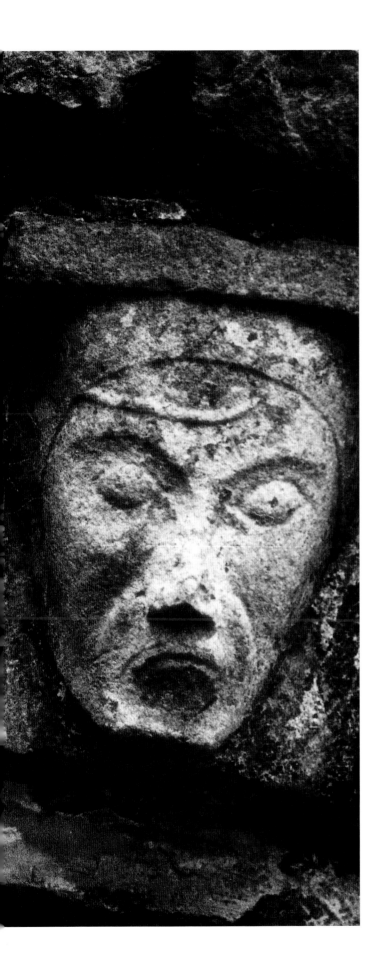

body had come, there was no door at all for anybody else to pass in by. And when they were all inside, round in a ring, touching each other, someone began to sing in the darkness, and someone else would make a noise like thunder with a thing they had on purpose, and on still nights people would hear the thundering noise far, far away beyond the wild land, and some of them, who thought they knew what it was, used to make a sign on their breasts when they woke up in their beds at dead of night and heard that terrible deep noise, like thunder on the mountains. And the noise and the singing would go on and on for a long time, and the people who were in a ring swayed a little to and fro; and the song was in an old, old language that nobody knows now, and the tune was queer. Nurse said her great-grandmother had known someone who remembered a little of it, when she was quite a little girl, and nurse tried to sing some of it to me, and it was so strange a tune that I turned all cold and my flesh crept as if I had put my hand on something dead.

From *The White People* by Arthur Machen, 1899

KITTY'S STEPS

THE ANCIENT CELTIC SUPERSTITION OF WATER SPRITES OR WHITE LADIES STILL SURVIVES IN MANY LANDS. THESE WRAITHS MATERIALISE FROM SPRINGS AND WATERFALLS TO ENTICE A VICTIM, A HUMAN SACRIFICE, TO JOIN THEM IN THEIR WATERY BOWERS. THEY HAVE THEIR ORIGIN IN THE GREAT WHITE GODDESS, DIANA OF THE MOON, AN ANCIENT RULER OVER NATURE, WHO WOULD APPEAR IN MANY

different forms, 'the queen of air and darkness'. It is not hard to imagine why the tall and slender waterfall in the wild and beautiful Lydford Gorge in Devon is known as the White Lady, but it is from the smaller, more secluded cascade known as Kitty's Steps, and the haunted pool below it, that the following story originates.

Many years ago an old lady, who was simply known as Kitty, was returning home through the gorge one summer evening. She was a creature of habit and would always take a shortcut by passing through the ravine rather than keeping to the recognised path. This route took her past the waterfall, which she knew well, having played there as a child. But she never returned home that night and several days later the red handkerchief that she always wore tied around her head was found near the pool. What exactly happened to her has never been explained. Some say she slipped and fell,

others that she was beckoned by a supernatural force. On the anniversary of her death her ghost is said to appear near the waterfall, her head bowed, staring into the dark waters of the pool.

In 1968 a young soldier in a hurry to return to his camp one night took the same shortcut through the gorge. He was missing for several weeks, despite an extensive search of the area. Some time later his body was found floating on the surface of the mysterious pool below Kitty's Steps. A verdict of accidental death was brought in and the coroner made the following statement: 'He could have been overcome by the atmosphere of the gorge, which I personally think is not a cheerful place, even in daytime. In the gloom and damp he may have been mesmerised by its eeriness and had a certain compulsion to jump in – but there is no evidence of premeditation.'

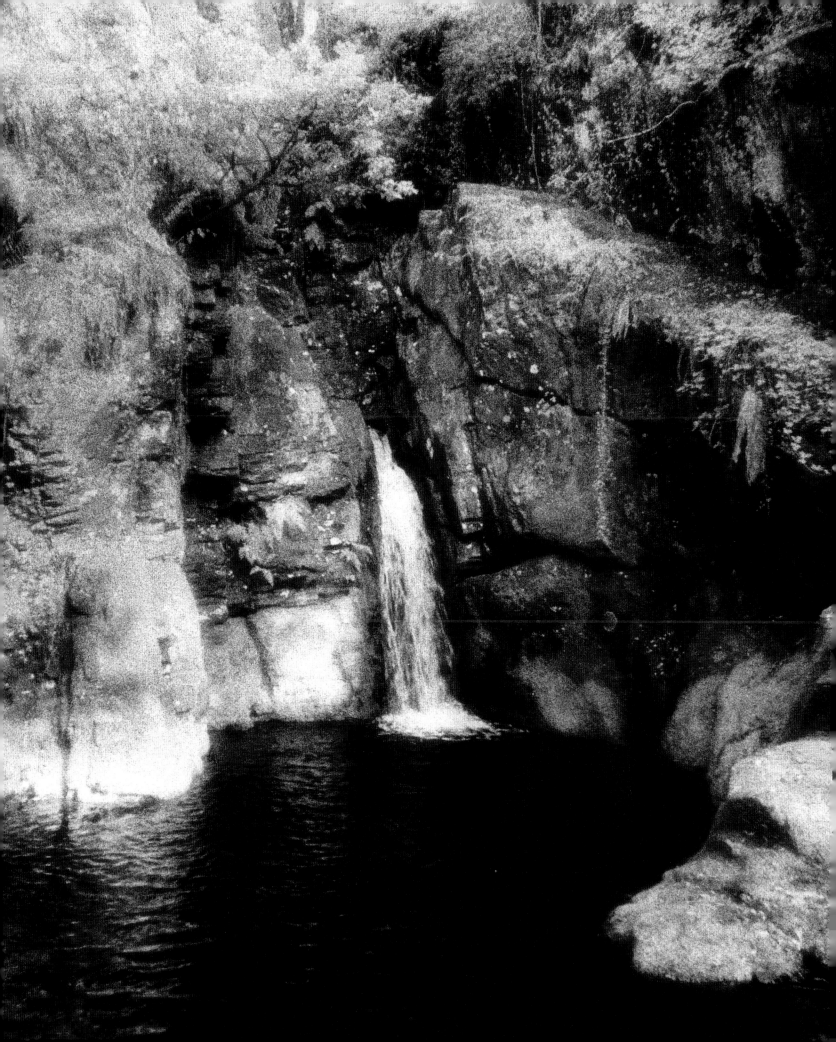

THE FALL OF THE HOUSE OF USHER

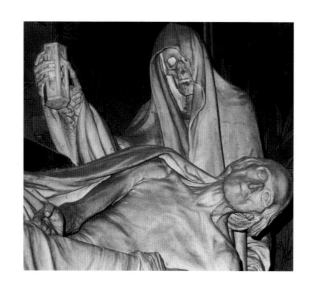

During the whole of a dull, dark, and soundless day in the autumn of the year, when the clouds hung oppressively low in the heavens, I had been passing alone, on horseback, through a singularly dreary tract of country, and at length found myself, as the shades of the evening drew on, within view of the melancholy House of Usher. I know not how it

was – but, with the first glimpse of the building, a sense of insufferable gloom pervaded my spirit. I say insufferable; for the feeling was unrelieved by any of that half-pleasurable, because poetic, sentiment with which the mind usually receives even the sternest natural images of the desolate or terrible. I looked upon the scene before me – upon the mere house, and the simple landscape features of the domain – upon the bleak walls – upon the vacant eye-like windows – upon a few rank sedges – and upon a few white trunks of decayed trees – with an utter depression of soul which I can compare to no earthly sensation more properly than to the after-dream of the reveller upon opium – the bitter lapse into every-day life – the hideous dropping off of the veil. There was an iciness, a sinking, a sickening of the heart – an unredeemed dreariness of thought which no goading of the imagination could torture into aught of the sublime. What was it – I paused to think – what was it that so unnerved me in the contemplation of the House of Usher? It was a mys-

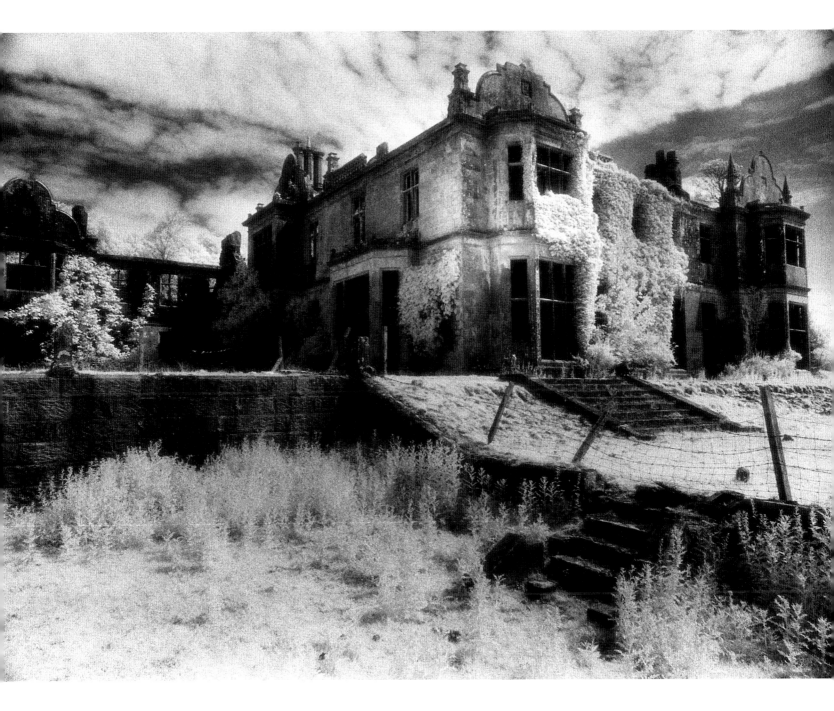

tery all insoluble; nor could I grapple with the shadowy fancies that crowded upon me as I pondered. I was forced to fall back upon the unsatisfactory conclusion, that while, beyond doubt, there are combinations of very simple natural objects which have the power of thus affecting us, still the analysis of this power lies among considerations beyond our depth. It was possible, I reflected, that a mere different arrangement of the particulars of the scene, of the details of the picture, would be sufficient to modify, or perhaps to annihilate its capacity for sorrowful impression; and, acting upon this idea, I reined my horse to the precipitous brink of a black and lurid tarn that lay in unruffled lustre by the dwelling, and gazed down – but with a shudder even more thrilling than before – upon the remodelled and inverted images of the grey sedge, and the ghastly tree-stems, and the vacant and eye-like windows.

From *The Fall of the House of Usher* by Edgar Allan Poe, 1839

THE CURSE OF THE BASKERVILLES

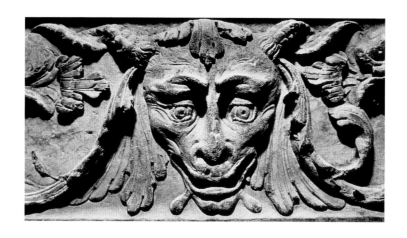

THEY HAD GONE A MILE OR TWO WHEN THEY PASSED ONE OF THE NIGHT SHEPHERDS UPON THE MOOR-LANDS, AND THEY CRIED TO HIM TO KNOW IF HE HAD SEEN THE HUNT. AND THE MAN, AS THE STORY GOES, WAS SO CRAZED WITH FEAR THAT HE COULD SCARCE SPEAK, BUT AT LAST HE SAID THAT HE HAD INDEED SEEN THE UNHAPPY MAIDEN, WITH THE HOUNDS UPON HER TRACK. 'BUT I HAVE SEEN MORE

than that,' said he, 'for Hugo Baskerville passed me upon his black mare, and there ran mute behind him such a hound of hell as God forbid should ever be at my heels.'

So the drunken squires cursed the shepherd and rode onwards. But soon their skins turned cold, for there came a sound of galloping across the moor, and the black mare, dabbled with white froth, went past with trailing bridle and empty saddle. Then the revellers rode close together, for a great fear was on them, but they still followed over the moor, though each, had he been alone, would have been right glad

to have turned his horse's head. Riding slowly in this fashion, they came at last upon the hounds. These, though known for their valour and their breed, were whimpering in a cluster at the head of a deep dip or goyal, as we call it, upon the moor, some slinking away and some, with starting hackles and staring eyes, gazing down the narrow valley before them.

The company had come to a halt, more sober men, as you may guess, than when they started. The most of them would by no means advance, but three of them, the boldest,

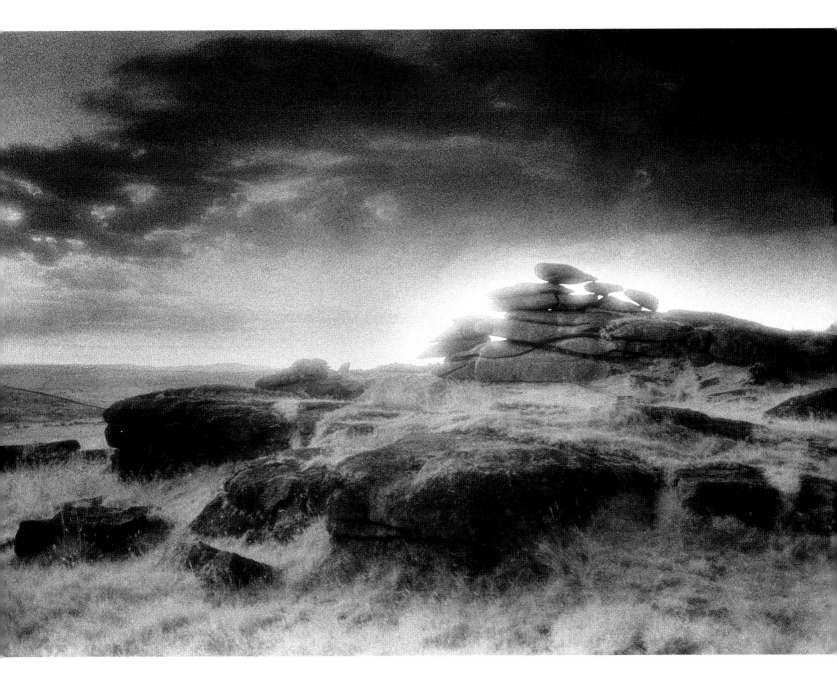

or, it may be, the most drunken, rode forward down the goyal. Now it opened into a broad space in which stood two of those great stones, still to be seen there, which were set by certain forgotten peoples in days of old. The moon was shining bright upon the clearing, and there in the centre lay the unhappy maid where she had fallen, dead of fear and of fatigue. But it was not the sight of her body, nor yet was it that of the body of Hugo Baskerville lying near her, which raised the hair upon the heads of these three dare-devil roysterers, but it was that, standing over Hugo, and plucking at his throat, there stood a foul thing, a great black beast, shaped like a hound, yet larger than any hound that ever mortal eye has rested upon. And even as they looked the thing tore the throat out of Hugo Baskerville, on which, as it turned its blazing eyes and dripping jaws upon them, the three shrieked with fear and rode for dear life, still screaming, across the moor.

From 'The Curse of the Baskervilles', *The Hound of the Baskervilles* by Arthur Conan Doyle, 1902

'OLD' CASTLE HACKETT

THIS ANCIENT THIRTEENTH-CENTURY CASTLE OF
THE KIRWANS LIES BENEATH KNOCKMAA HILL
IN COUNTY GALWAY, WHICH WAS BELIEVED TO
BE THE LEGENDARY OTHERWORLD SEAT OF
FINVARRA, RULER OF THE FAIRIES OF CONNAUGHT.

'Finvarra, the king of the fairies of the West, keeps up
friendly relations with most of the best families of Galway,
especially the Kirwans of Castle Hackett, for Finvarra is a
gentleman, every inch of him, and the Kirwans always leave
out kegs of the best Spanish wine for him each night. In
return, it is said, the wine vaults of Castle Hackett are never
empty, though the wine flows freely for all comers.' (Adapted
from *Ancient Legends, Mystic Charms & Superstitions of Ireland*
by Lady Jane Francesca Wilde, 1887)

Early in the eighteenth century the Kirwans built a new
mansion a short distance from the old castle, where their
ancestors still reside today. In 1956 General Sir Denis
Kirwan Bernard left instructions in his will that he should be
buried upright in the Celtic fashion, together with his
favourite horse, on the summit of Knockmaa Hill, facing the
Galway Plain and the mountains beyond – the land that he
loved.

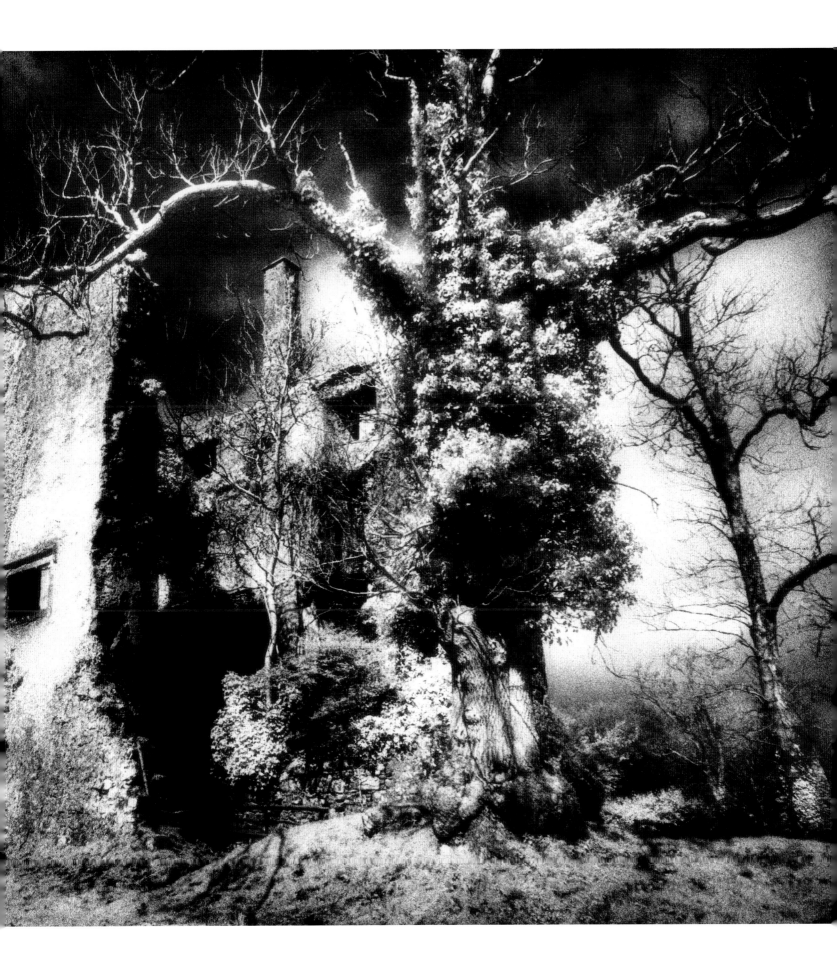

HENRY JEKYLL'S FULL STATEMENT OF THE CASE

I HAD LONG SINCE PREPARED MY TINCTURE; I PURCHASED AT ONCE, FROM A FIRM OF WHOLESALE CHEMISTS, A LARGE QUANTITY OF A PARTICULAR SALT WHICH I KNEW, FROM MY EXPERIMENTS, TO BE THE LAST INGREDIENT REQUIRED; AND LATE ONE ACCURSED NIGHT, I COMPOUNDED THE ELEMENTS, WATCHED THEM BOIL AND SMOKE TOGETHER IN THE GLASS, AND WHEN THE EBULLITION HAD SUBSIDED,

with a strong glow of courage, drank off the potion.

The most racking pangs succeeded: a grinding in the bones, deadly nausea, and a horror of the spirit that cannot be exceeded at the hour of birth or death. Then these agonies began swiftly to subside, and I came to myself as if out of a great sickness. There was something strange in my sensations, something indescribably new and, from its very novelty, incredibly sweet. I felt younger, lighter, happier in body; within I was conscious of a heady recklessness, a current of disordered sensual images running like a mill race in my fancy, a solution of the bonds of obligation, an unknown but not an innocent freedom of the soul. I knew myself, at the first breath of this new life, to be more wicked, tenfold more wicked, sold a slave to my original evil; and the thought, in that moment, braced and delighted me like wine. I stretched out my hands, exulting in the freshness of these sensations; and in the act, I was suddenly aware that I had lost in stature.

There was no mirror, at that date, in my room; that which stands beside me as I write, was brought there later on and for the very purpose of these transformations. The night, however, was far gone into the morning – the morning, black as it was, was nearly ripe for the conception of the day – the inmates of my house were locked in the most

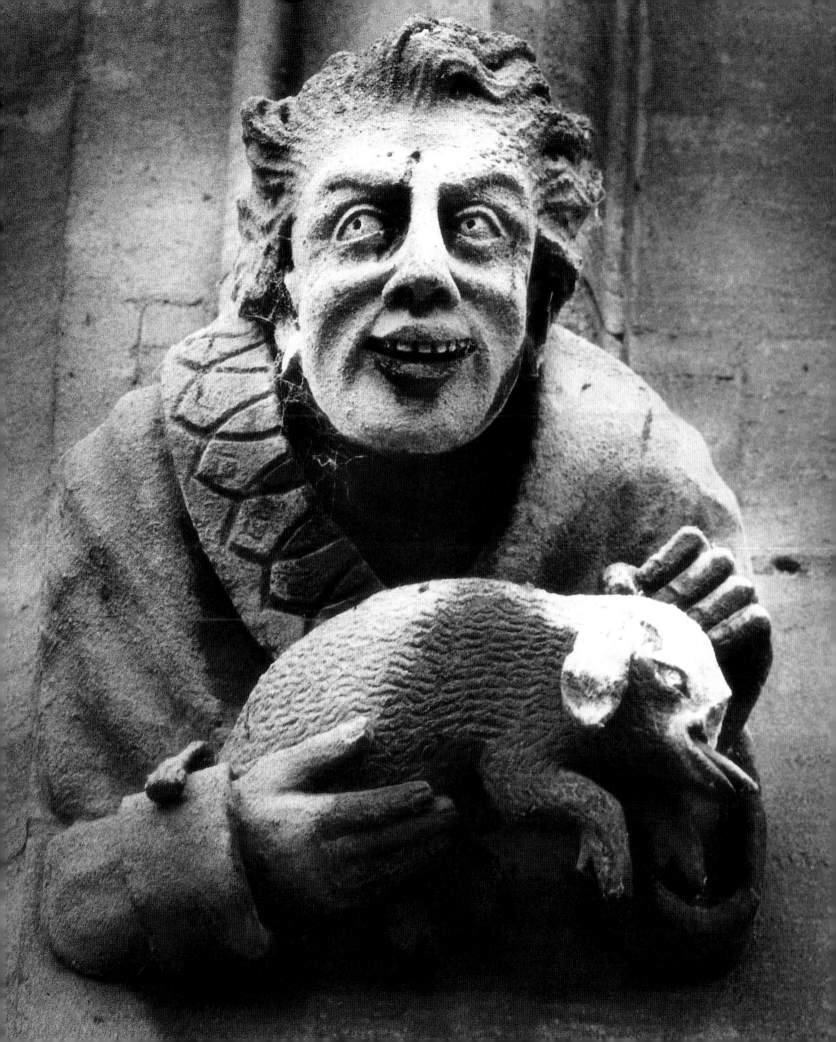

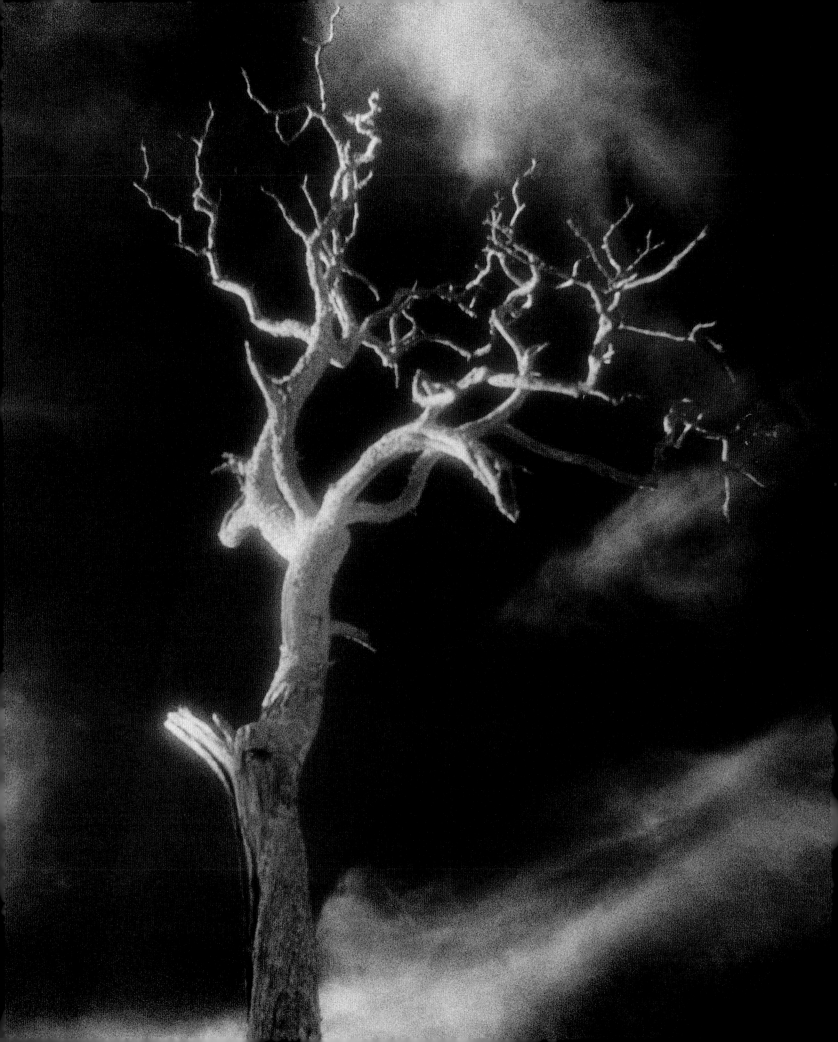

rigorous hours of slumber; and I determined, flushed as I was with hope and triumph, to venture in my new shape as far as to my bedroom. I crossed the yard, wherein the constellations looked down upon me, I could have thought, with wonder, the first creature of that sort that their unsleeping vigilance had yet disclosed to them; I stole through the corridors, a stranger in my own house; and coming to my room, I saw for the first time the appearance of Edward Hyde.

I must here speak by theory alone, saying not that which I know, but that which I suppose to be most probable. The evil side of my nature, to which I had now transferred the stamping efficacy, was less robust and less developed than the good which I had just deposed. Again, in the course of my life, which had been, after all, nine tenths a life of effort, virtue and control, it had been much less exercised and much less exhausted. And hence, as I think, it came about that Edward Hyde was so much smaller, slighter and younger than Henry Jekyll. Even as good shone upon the countenance of the one, evil was written broadly and plainly on the face of the other. Evil besides (which I must still believe to be the lethal side of man) had left on that body an imprint of deformity and decay. And yet when I looked upon that ugly idol in the glass, I was conscious of no repugnance, rather of a leap of welcome. This, too, was myself. It seemed natural and human. In my eyes it bore a livelier image of the spirit, it seemed more express and single, than the imperfect and divided countenance, I had been hitherto accustomed to call mine. And in so far I was doubtless right. I have observed that when I wore the semblance of Edward Hyde, none could come near to me at first without a visible misgiving of the flesh. This, as I take it, was because all human beings, as we meet them, are commingled out of good and evil: and Edward Hyde, alone in the ranks of mankind, was pure evil.

'Henry Jekyll's Full Statement of the Case',
from *The Strange Case of Dr Jekyll and Mr Hyde*
by Robert Louis Stevenson, 1886

THE DREAM

A change came o'er the spirit of my dream

The Wanderer was alone as heretofore,

The beings which surrounded him were gone,

Or were at war with him; he was a mark

For blight and desolation, compass'd round

With Hatred and Contention; Pain was mix'd

In all which was served up to him, until,

Like to the Pontic monarch of old days,

He fed on poisons, and they had no power,

But were a kind of nutriment; he lived

Through that which had been death to many men,

And made him friends of mountains; with the stars

And the quick Spirits of the Universe

He held his dialogues: and they did teach

To him the magic of their mysteries;

To him the book of Night was open'd wide,

And voices from the deep abyss reveal'd

A marvel and a secret. – Be it so.

From *The Dream*
by George Gordon, Lord Byron, 1816

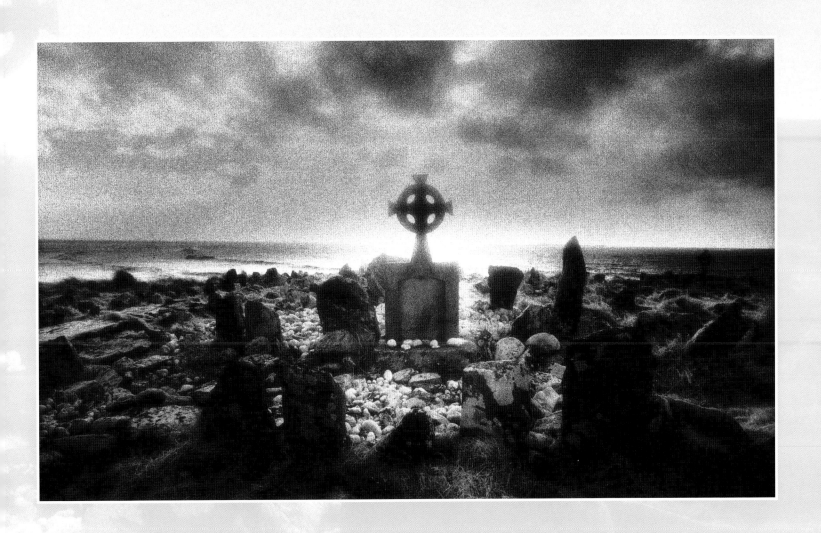

SLIEVE NA CALLIAGH

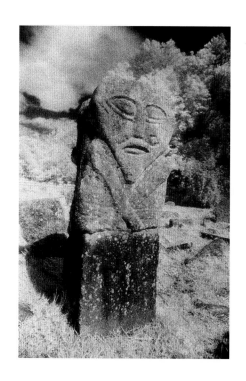

THE CELTS WERE IN AWE OF THE MANY EARTHWORKS AND STANDING STONES OF THE ANCIENT BRITONS, BELIEVING THEM TO BE THE DWELLING PLACES OF BEINGS FROM THE OTHERWORLD. IT IS SAID THAT THEIR HOLY MEN, THE DRUIDS, WENT THROUGH A PROCESS OF INITIATION INSIDE THESE DARK INTERIORS TO GAIN ACCESS TO THEIR ANCESTRAL SPIRIT WORLD.

One such site is a series of hilltop passage graves known as Slieve Na Calliagh, or the Hill of the Witch. On its lonely summit there are thirty tombs in all, some still to be opened. On excavation most were found to contain human bones or cremated ashes, weapons and jewellery from the Bronze Age, and many of the chambers were decorated with strange carvings and ritual signs.

The Druids worshipped both the sun and the moon, conducting their ceremonies according to the position of the planets and stars. They were known to have performed human sacrifices. The long ascent to the cairns must be made on foot, but local people stay away – they say that the ancient graves are haunted by mysterious figures and eerie screams in the dead of night.

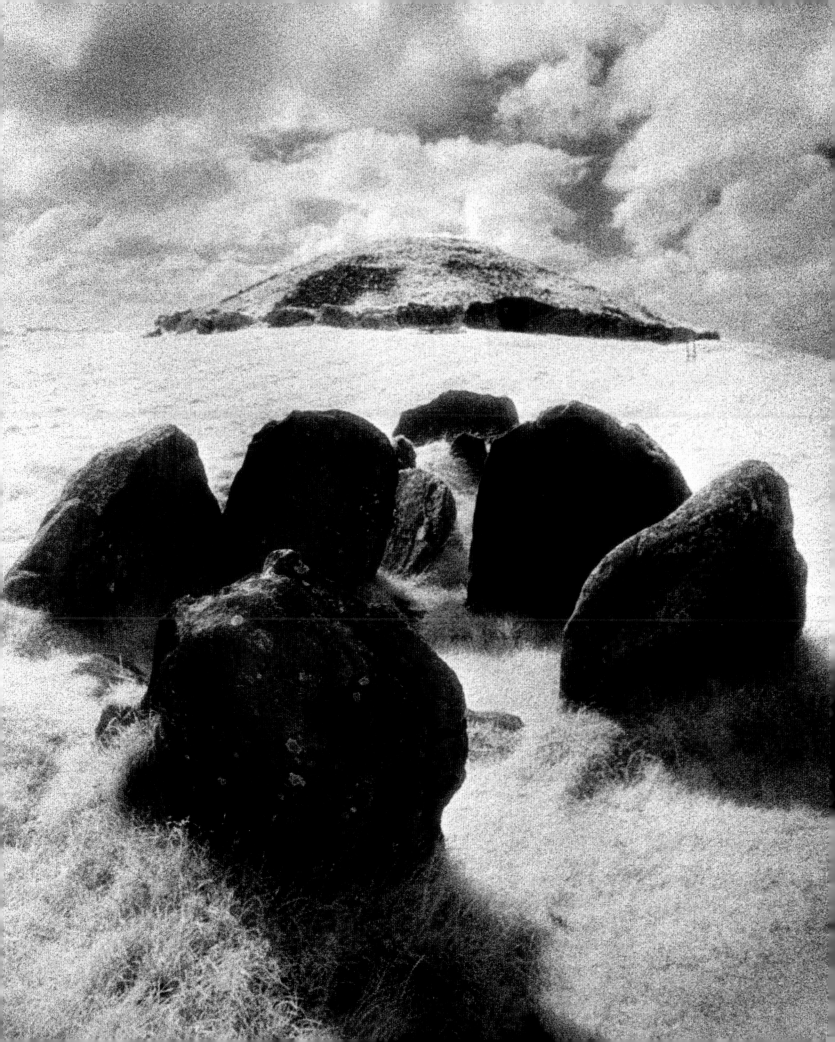

JONATHAN HARKER'S JOURNAL

30 June, morning. — These may be the last words I ever write in this diary. I slept till just before the dawn, and when I woke threw myself on my knees, for I determined that if Death came he should find me ready. At last I felt that subtle change in the air, and I knew that the morning had come. Then came the welcome cock-crow, and I felt that I was safe.

With a glad heart, I opened my door and ran down to the hall. I had seen that the door was unlocked, and now escape was before me. With hands that trembled with eagerness, I unhooked the chains and drew back the massive bolts.

But the door would not move. Despair seized me. I pulled, and pulled, at the door, and shook it till, massive as it was, it rattled in its casement. I could see the bolt shot. It had been locked after I left the Count.

Then a wild desire took me to obtain that key at any risk, and I determined then and there to scale the wall again and gain the Count's room. He might kill me, but death now seemed the happier choice of evils. Without a pause I rushed up to the east window, and scrambled down the wall, as before, into the Count's room. It was empty, but that was as I expected. I could not see a key anywhere, but the heap of gold remained. I went through the door in the cor-ner and down the winding stair and along the dark passage to the old chapel. I knew now well enough where to find the monster I sought.

The great box was in the same place, close against the wall, but the lid was laid on it, not fastened down, but with the nails ready in their places to be hammered home. I knew I must search the body for the key, so I raised the lid, and laid it back against the wall; and then I saw something which filled my very soul with horror. There lay the Count, but looking as if his youth had been half renewed, for the white hair and moustache were changed to dark iron-grey; the cheeks were fuller, and the white skin seemed ruby-red underneath; the mouth was redder than ever, for on the lips were gouts of fresh blood, which trickled from the corners of the mouth and ran over the chin and neck. Even the deep, burning eyes seemed set amongst swollen flesh, for the lids

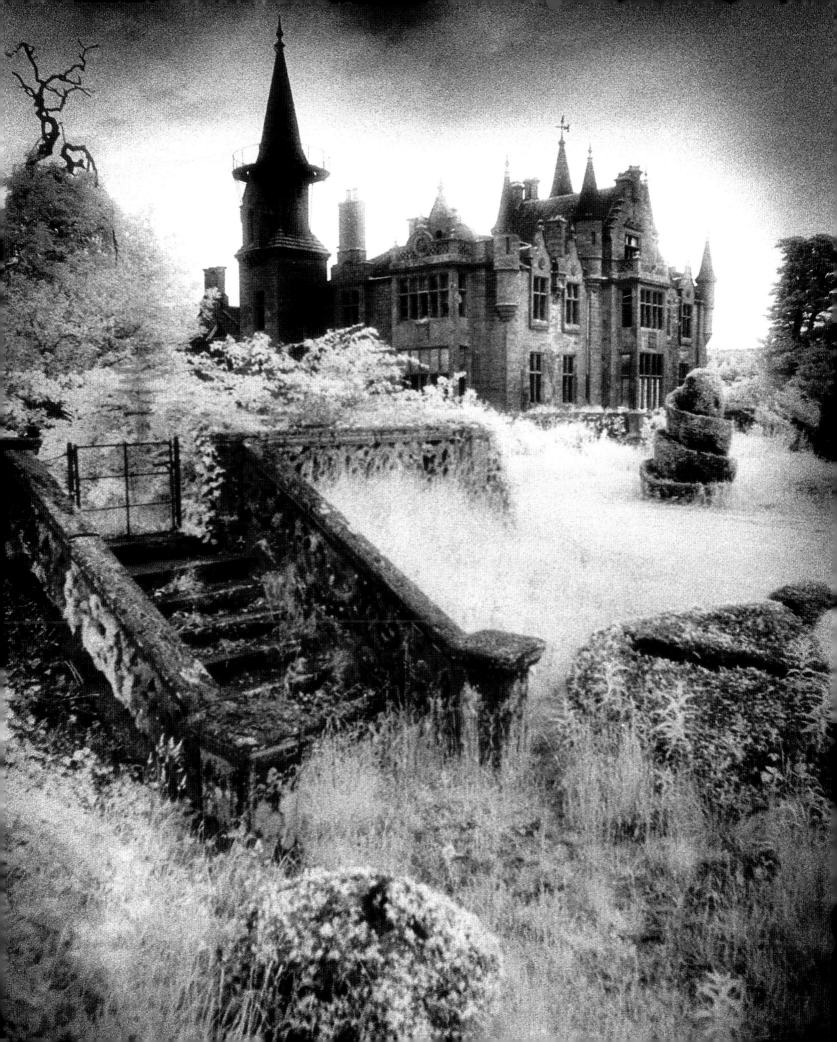

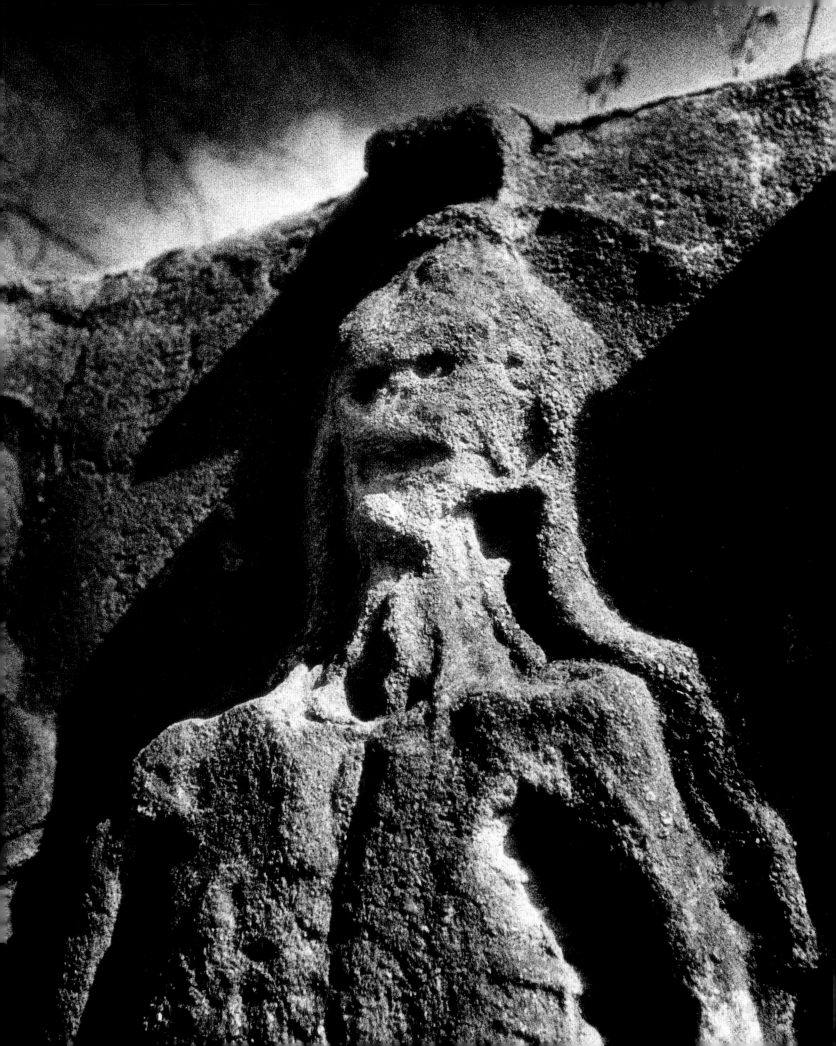

and pouches underneath were bloated. It seemed as if the whole awful creature were simply gorged with blood; he lay like a filthy leech, exhausted with his repletion. I shuddered as I bent over to touch him, and every sense in me revolted at the contact; but I had to search, or I was lost. The coming night might see my own body a banquet in a similar way to those horrid three. I felt all over the body, but no sign could I find of the key. Then I stopped and looked at the Count. There was a mocking smile on the bloated face which seemed to drive me mad. This was the being I was helping to transfer to London, where, perhaps, for centuries to come he might, amongst its teeming millions, satiate his lust for blood, and create a new and ever-widening circle of semi-demons to batten on the helpless. The very thought drove me mad. A terrible desire came upon me to rid the world of such a monster. There was no lethal weapon at hand, but

I seized a shovel which the workmen had been using to fill the cases, and lifting it high struck, with the edge downward, at the hateful face. But as I did so the head turned, and the eyes fell full upon me, with all their blaze of basilisk horror. The sight seemed to paralyse me, and the shovel turned in my hand and glanced from the face, merely making a deep gash above the forehead. The shovel fell from my hand across the box, and as I pulled it away the flange of the blade caught the edge of the lid, which fell over again, and hid the horrid thing from my sight. The last glimpse I had was of the bloated face, bloodstained and fixed with a grin of malice which would have held its own in the nethermost hell.

From 'Jonathan Harker's Journal', *Dracula*
by Bram Stoker, 1897

MELMOTH THE WANDERER

'I HAVE SOUGHT HIM EVERYWHERE. THE DESIRE OF MEETING HIM ONCE MORE IS BECOME AS A BURNING FIRE WITHIN ME … IT IS THE NECESSARY CONDITION OF MY EXISTENCE. I HAVE VAINLY SOUGHT HIM AT LAST IN IRELAND, OF WHICH I FIND HE IS A NATIVE. PERHAPS OUR FINAL MEETING WILL BE IN …' SUCH WAS THE CONCLUSION OF THE MANUSCRIPT WHICH MELMOTH FOUND IN HIS UNCLE'S CLOSET. WHEN HE

had finished it, he sunk down on the table near where he had been reading it, his face hidden in his folded arms, his senses reeling, his mind in a mingled state of stupor and excitement. After a few moments, he raised himself with an involuntary start, and saw the picture gazing at him from its canvas. He was within ten inches of it as he sat, and the proximity appeared increased by the strong light that was accidentally thrown on it, and its being the only representation of a human figure in the room. Melmoth felt for a moment as if he were about to receive an explanation from its lips.

He gazed on it in return … all was silent in the house … they were alone together. The illusion subsided at length: and as the mind rapidly passes to opposite extremes, he

remembered the injunction of his uncle to destroy the portrait. He seized it, his hand shook at first, but the moldering canvas appeared to assist him in the effort. He tore it from the frame with a cry half terrific, half triumphant … It fell at his feet … and he shuddered as it fell. He expected to hear some fearful sounds, some unimaginable breathings of prophetic horror, follow this act of sacrilege, for such he felt it, to tear the portrait of his ancestor from his native walls. He paused and listened: 'There was no voice, nor any that answered;' but as the wrinkled and torn canvas fell to the floor, its undulations gave the portrait the appearance of smiling. Melmoth felt horror indescribable at this transient and imaginary resuscitation of the figure. He caught it up, rushed into the next room, tore, cut, and hacked it in every

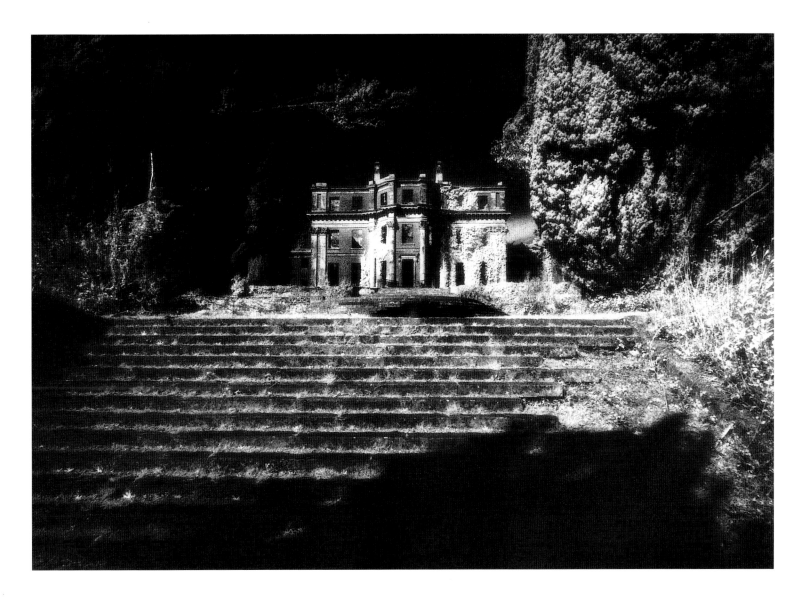

direction, and eagerly watched the fragments that burned like tinder in the turf fire which had been lit in his room. As Melmoth saw the last blaze, he threw himself into bed, in hope of a deep and intense sleep. He had done what was required of him, and felt exhausted both in mind and body; but his slumber was not so sound as he had hoped for. The sullen light of the turf fire, burning but never blazing, disturbed him every moment. He turned and turned, but still there was the same red light glaring on, but not illuminating, the dusky furniture of the apartment. The wind was high that night, and as the creaking door swung on its hinges, every noise seemed like the sound of a hand struggling with the lock, or of a foot pausing on the threshold. But (for Melmoth never could decide) was it in a dream or

not, that he saw the figure of his ancestor appear at the door? … hesitatingly as he saw him at the first on the night of his uncle's death … saw him enter the room, approach his bed, and heard him whisper, 'You have burned me then; but those are flames I can survive … I am alive … I am beside you.' Melmoth started, sprung from his bed, it was broad daylight. He looked round.

There was no human being in the room but himself. He felt a slight pain in the wrist of his right arm. He looked at it; it was black and blue, as from the recent grip of a strong hand.

From *Melmoth the Wanderer*
by Charles Maturin, 1820

THE MARRIAGE OF HEAVEN AND HELL

The ancient tradition that the world will be consumed in fire at the end of six thousand years is true, as I have heard from Hell.

For the cherub with his flaming sword is hereby commanded to leave his guard at the tree of life, and when he does, the whole creation will be consumed and appear infinite and holy whereas it now appears finite and corrupt.

This will come to pass by an improvement of sensual enjoyment.

But first the notion that man has a body distinct from his soul is to be expunged; this I shall do, by printing in the infernal method, by corrosives, which in Hell are salutary and medicinal, melting apparent surfaces away, and displaying the infinite which was hid.

If the doors of perception were cleansed everything would appear to man as it is, infinite.

For man has closed himself up, till he sees all things thro' narrow chinks of his cavern.

From *The Marriage Of Heaven and Hell*
by William Blake, *c.* 1790–3

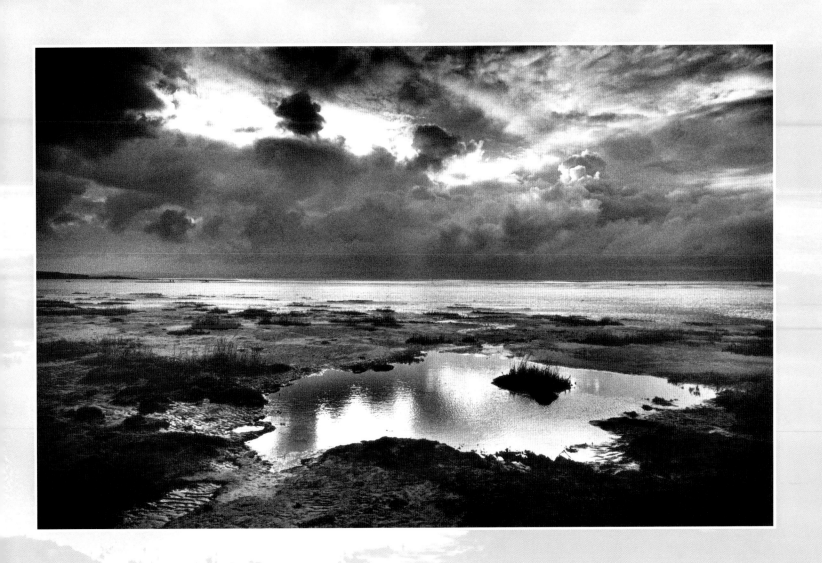

RATHKILL HOUSE

THE LONELY RUIN OF RATHKILL HOUSE LIES ON THE WILD COASTLINE OF THE WEST OF IRELAND. ITS FORMER OWNERS, THE ANGLO-IRISH PERCEVAL FAMILY, HAVE LONG SINCE LEFT THE AREA, BUT THE TERRIFYING HAUNTING THAT LED TO THE DESTRUCTION OF THEIR FAMILY HOME LIVES ON IN THE MEMORY OF THE LOCAL PEOPLE.

In the late nineteenth century Giles Perceval, an eminent archaeologist, travelled extensively in the Far East, bringing back a large collection of treasure, including Syrian swords and daggers, and several mummies which he had plundered from an Egyptian tomb. It would appear that almost as soon as these ancient artifacts were installed in the house, extremely unpleasant and malicious poltergeist activities began. A strange, evil figure would be seen on the stairway at night, and terrible loud crashes were heard throughout the house, with crockery and ornaments found smashed the next morning. On one occasion the whole house shook. Several of the servants left and a gardener was terrified by the apparition of a tall, dark shadow disappearing through the woods into the sea followed by maniacal laughter. The manifestations became so bad that the owners had a party of Jesuit priests exorcise the mansion, but after three weeks they were forced to leave, admitting that they were powerless in the face of such evil. The building was abandoned and now stands as an empty shell.

I found one room in the ruin particularly oppressive —

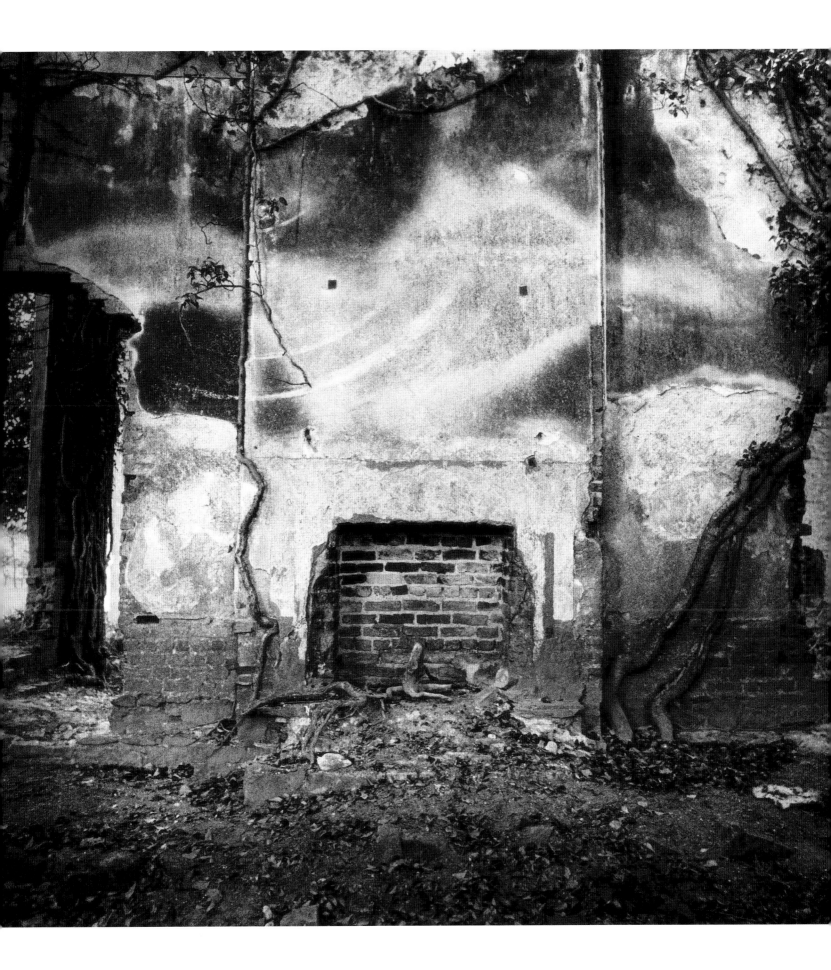

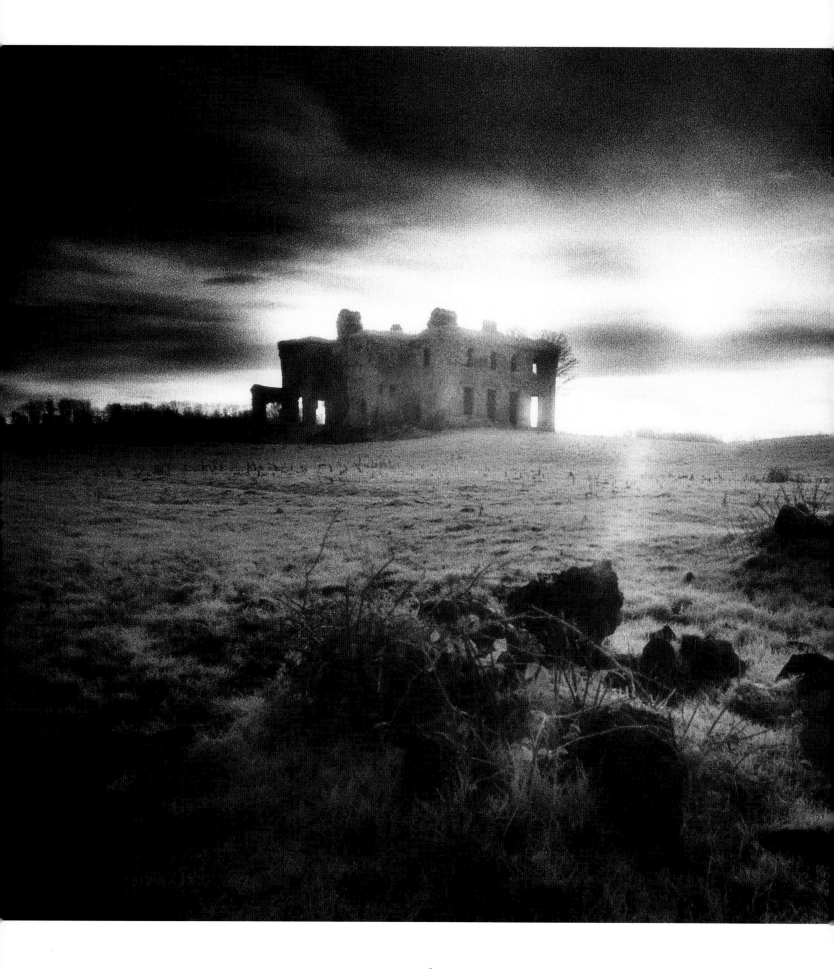

the wall above the fireplace had strange patterns on the plasterwork. It was as if something terrible had once passed through this area.

The ancient Egyptians, like the Celts, attributed supreme powers to their priests and holy men: the mysteries of life and death were laid before them and they could control the secrets of fate and destiny that were hidden from ordinary mortals. Possessing almost boundless powers, they could enable humans to assume diverse forms at will and project their souls into animals and other creatures; even inanimate figures and pictures could become living beings and carry out their commands. Each person, it was believed, had a shadow or double known as a kha, which lived on inside the tomb when their physical body died. Here it was kept alive with fresh offerings of food, drink and incense as well as fantastic treasures, but if these gifts were taken away the spirit would wander abroad to reclaim them and to wreak havoc and death on those who had defiled the tomb.

THE OVAL PORTRAIT

SHE WAS A MAIDEN OF RAREST BEAUTY, AND NOT MORE LOVELY THAN FULL OF GLEE. AND EVIL WAS THE HOUR WHEN SHE SAW, AND LOVED, AND WEDDED THE PAINTER. HE, PASSIONATE, STUDIOUS, AUSTERE, AND HAVING ALREADY A BRIDE IN HIS ART: SHE A MAIDEN OF RAREST BEAUTY, AND NOT MORE LOVELY THAN FULL OF GLEE; ALL LIGHT AND SMILES, AND FROLICSOME AS THE YOUNG FAWN;

loving and cherishing all things; hating only the Art which was her rival; dreading only the pallet and brushes and other untoward instruments which deprived her of the countenance of her lover. It was thus a terrible thing for this lady to hear the painter speak of his desire to portray even his young bride. But she was humble and obedient, and sat meekly for many weeks in the dark high turret-chamber where the light dripped upon the pale canvas only from overhead. But he, the painter, took glory in his work, which went on from hour to hour, and from day to day. And he was a passionate, and wild, and moody man, who became lost in reveries; so that he would not see that the light which fell so ghastly in that lone turret withered the health and the spirits of his bride, who pined visibly to all but him. Yet she smiled on and still on, uncomplainingly, because she saw that the painter (who had high renown) took a fervid and burning pleasure in his task, and wrought day and night to depict her who so loved him, yet who grew daily more dispirited and weak. And in sooth some who beheld the portrait spoke of its resemblance in low words, as of a mighty marvel, and a proof not less of the power of the painter than of his deep love for her whom he depicted so surpassingly well. But at length, as the labour drew nearer to its conclusion, there were admitted none into the turret; for the painter had grown wild with the ardour of his work, and turned his eyes from the canvas rarely, even to regard the countenance of his wife. And he would not see that the tints which he spread upon the canvas were drawn from the cheeks of her who sat beside him. And when many weeks had passed, and but little remained to do, save one brush upon the mouth and one tint upon the eye, the spirit of the lady again flickered up as the flame within the socket of the lamp. And then the brush was given, and then the tint was placed; and, for one moment, the painter stood entranced before the work which he had wrought; but in the next, while he yet gazed, he grew tremulous and very pallid, and aghast, and crying with a loud voice, 'This is indeed Life itself!' turned suddenly to regard his beloved: – She was dead!

From *The Oval Portrait* by Edgar Allan Poe, 1850

THE MATRIX

I BEGAN TO GROW COLD. AS I REACHED UP TO DRAW THE WINDOW DOWN AGAIN, SOMETHING CAUGHT MY EYE. IT MIGHT HAVE BEEN THERE SOME TIME, BUT UNNOTICED ON ACCOUNT OF ITS POSITION A LITTLE BELOW THE LINE OF THE TREES, NEAR WHERE THE MEADOW REACHED THEM. REACHING FOR THE WINDOW, MY EYE HAD BEEN BROUGHT DOWNWARDS, PERMITTING ME TO SEE

that part of the landscape more clearly. I think it was the movement that caught my eye. I held my breath, thinking that I had surprised a fox or a squirrel moving across the snow. But it was larger, big enough to be a wolf, I thought. Except that there are no wild wolves in Scotland now.

As I watched, the creature moved again, crawling in the direction of the house. It had long legs and moved awkwardly, more like a spider or a crab than an animal of the forest accustomed to walking on all fours. As I watched it come towards me, I felt more than simple cold rush through me. There was something unnatural about the thing on the ground, yet it had an almost human quality about it. I could

not tear myself from the window, horrified and frightened though I was. The creature moved slowly, yet with determination, across the still surface of the open field, dragging its limbs through the snow, and leaving in its wake a narrow furrow.

From time to time, it would halt and lift its head, as though sniffing the air. Was it hunting? Was it blind and merely questing? As it reached a point about halfway, I could see it more clearly, though mercifully not in any detail. It stopped again and raised its front quarters, then raised its head, and I was sure that long matted hair, like a woman's, trailed from it, and that it was in some sense human.

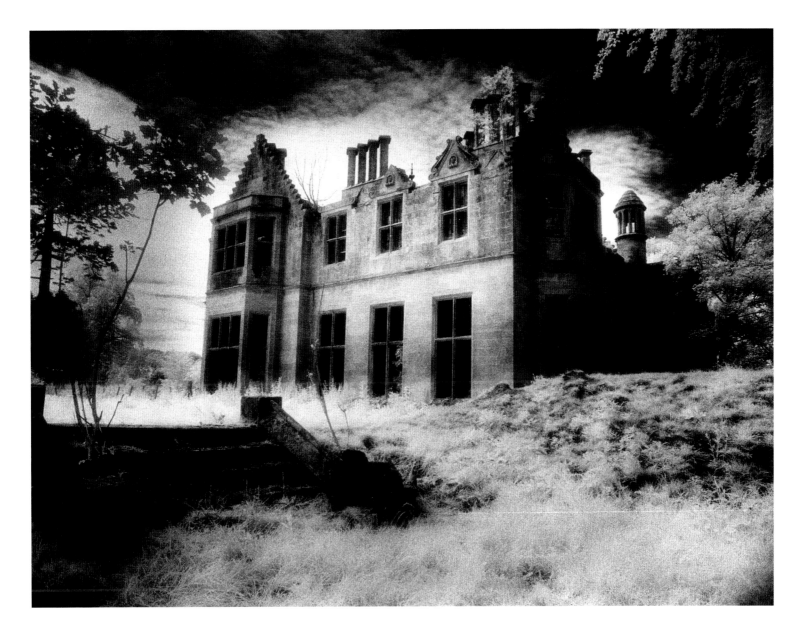

It continued its halting progress towards the house. I had a horror of it now, a mounting loathing that urged me to close the window and huddle beneath my blankets. But it was light outside and dark in my room, and I could not face the darkness. The thing shuffled through the snow, nearer and nearer the house, articulating its long arms and legs like the appendages of a dreadful insect.

Suddenly, another form appeared, this time from the direction of the house. A man wearing a long coat was walking towards the creature, and in moments I recognised him as Duncan. I almost cried out to warn him of the creature's presence, but it was quickly apparent that he was actually heading straight for it. Trudging through the deep snow, he took perhaps half a minute to reach it. When he did so, he bent down and helped it raise itself on its legs. His back concealed it from me at first, then, as he moved to one side in order to assist it, I saw it stand erect. And though it was still too far from me to see more than the outline, I saw that it wore a long dress and that its hair fell almost to the ground.

I pulled the window down and let the curtains fall across it. In the darkness, I could hear my own breath rasping.

From *The Matrix* by Jonathan Aycliffe, 1994

MELROSE ABBEY

IMMORTALISED IN SIR WALTER SCOTT'S EPIC
POEM *THE LAY OF THE LAST MINSTREL*, THE FOR-
BIDDING TWELFTH-CENTURY ABBEY RUINS LIE IN
THE SCOTTISH BORDERS, A FEW MILES FROM THE

romantic novelist's home, Abbotsford House. The eerie
shape of a tall, dark figure haunts the gothic pile and is said
to creep or snake its way along the stone floors and through
the crumbling arches. This strange creature is believed to be
a vampire, either the lost soul of a monk who forsook his
vows to practise the black arts, or the evil spirit of Michael
Scott, the medieval scholar accused of being both a wizard
and a witch. His tomb lies at the entrance to the sanctuary,
an area known for its unusually cold temperature and air of
menace.

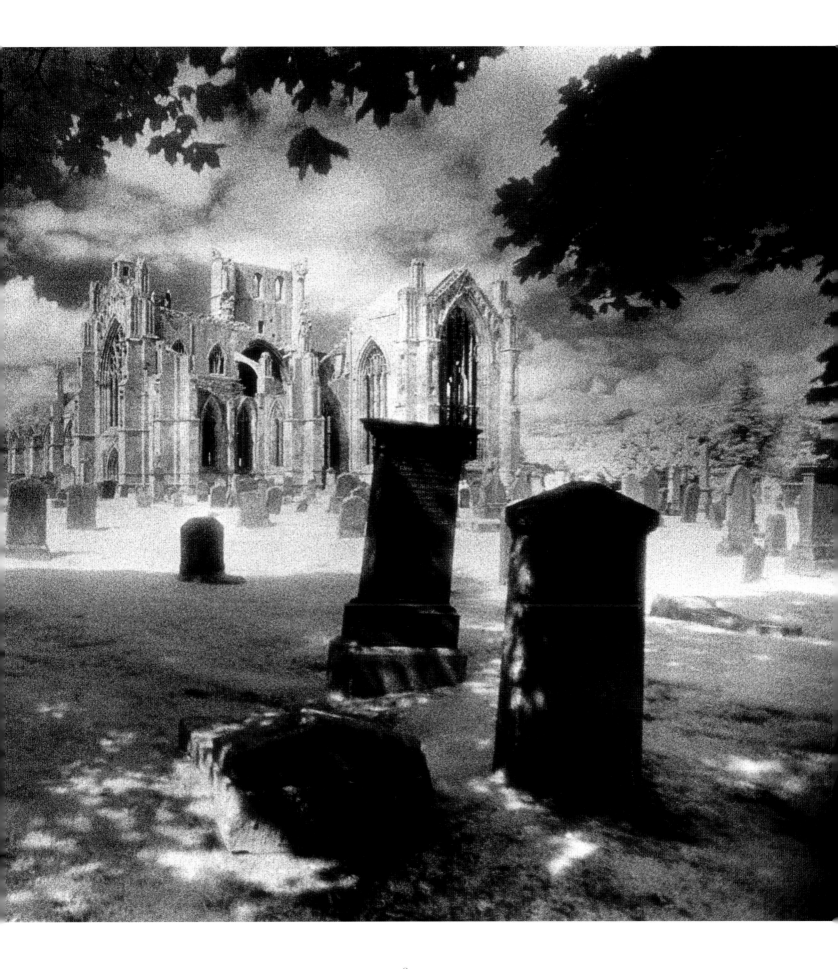

If thou would'st view fair Melrose aright,

Go visit it by pale moonlight;

For the gay beams of lightsome day

Gild, but to flout, the ruins grey.

When the broken arches are black in night,

And each shafted oriel glimmers white;

When the cold light's uncertain shower

Streams on the ruin'd central tower;

When buttress and buttress, alternately,

Seem framed of ebon and ivory;

When silver edges the imagery,

And the scrolls that teach thee to live and die;

When distant Tweed is heard to rave,

And the owlet to hoot o'er the dead man's grave

Then go – but go alone the while –

Then view St David's ruin'd pile;

And, home returning, soothly swear,

Was never scene so sad and fair!

From *The Lay of the Last Minstrel*
by Sir Walter Scott

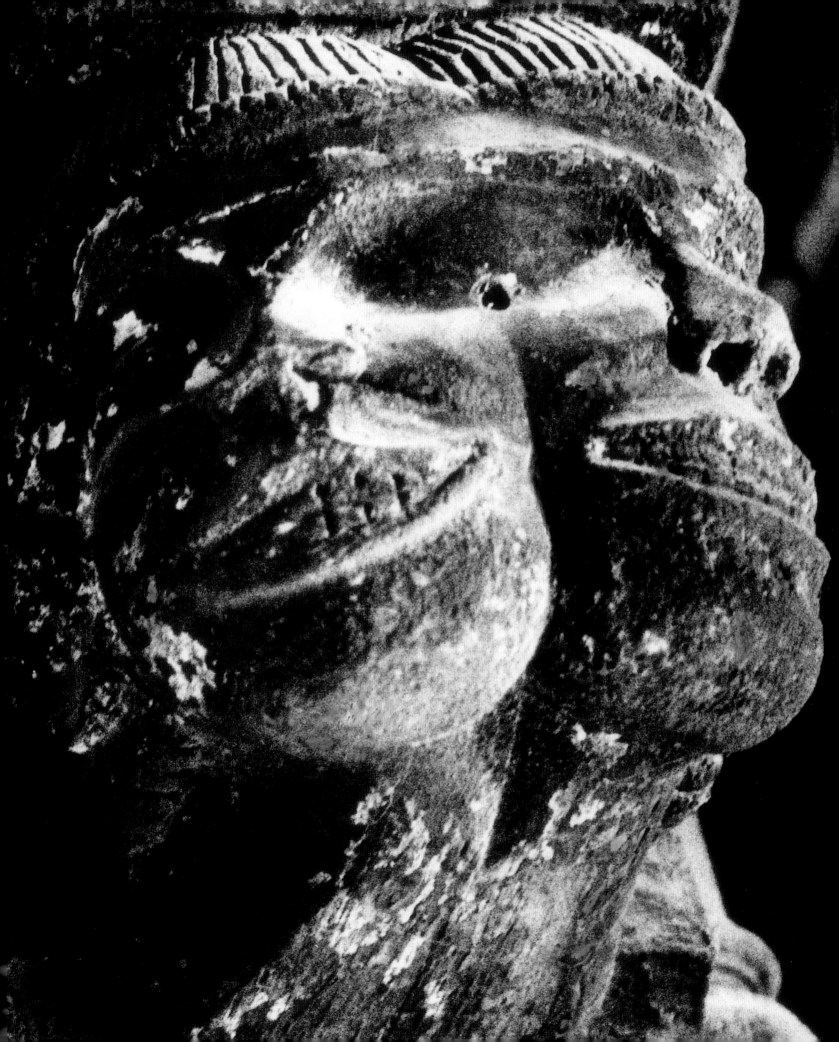

THE WONDERSMITH

Then took place an astonishing spectacle. The myriads of armed dolls, that lay in piles about the room, became suddenly imbued with motion. They stood up straight, their tiny limbs moved, their black eyes flashed with wicked purposes, their thread-like swords gleamed as they waved them to and fro. The villainous souls imprisoned in the bottle began to work within them. Like the Lilliputians, when they found the giant Gulliver asleep, they scaled in swarms the burly sides of the four sleeping gipsies. At every step they took, they drove their thin swords and quivering daggers into the flesh of the drunken authors of their being. To stab and kill was their mission, and they stabbed and killed with incredible fury. They clustered on the Wondersmith's sallow cheeks and sinewy throat, piercing every portion with their diminutive poisoned blades. Filomel's fat carcass was alive with them. They blackened the spare body of Monsier Kerplonne. They covered Oaksmith's huge form like a cluster of insects.

Overcome completely with the fumes of wine, these tiny wounds did not for a few moments awaken the sleeping victims. But the swift and deadly poison Macousha with which the weapons had been so fiendishly anointed, began to work. Herr Hippe, stung into sudden life, leaped to his feet, with a dwarf army clinging to his clothes and his hands – always stabbing, stabbing, stabbing. For an instant, a look of stupid bewilderment clouded his face; then the horrible truth burst upon him. He gave a shriek like that which a horse utters when he finds himself fettered and surrounded by fire – a shriek that curdled the air for miles and miles.

'Oaksmith! Kerplonne! Filomel! Awake! awake! We are lost! The souls have got loose! We are dead! poisoned! O accursed ones! O demons, ye are slaying me! Ah! fiends of hell!'

Aroused by these frightful howls, the three gipsies sprang also to their feet, to find themselves stung to death by the manikins. They raved, they shrieked, they swore. They staggered round the chamber. Blinded in the eyes by the ever-stabbing weapons – with the poison already burning in their veins like red-hot lead – their forms swelling and discoloring visibly every moment – their howls and attitudes and furious gestures made the scene look like a chamber in hell.

Maddened beyond endurance, the Wondersmith, half

blinded and choking with the venom that had congested all
the blood-vessels of his body, seized dozens of the manikins
and dashed them into the fire, trampling them down with
his feet.

'Ye shall die too, if I die,' he cried, with a roar like that of
a tiger. 'Ye shall burn, if I burn. I gave ye life – I give ye
death. Down! – down! – burn! flame! Fiends that ye are, to
slay us! Help me, brothers! Before we die, let us have our
revenge!'

On this, the other gipsies, themselves maddened by
approaching death, began hurling manikins, by handfuls
into the fire. The little creatures, being wooden of body,
quickly caught the flames, and an awful struggle for life took
place in miniature in the grate. Some of them escaped from
between the bars and ran about the room, blazing, writhing
in agony, and igniting the curtains and other draperies that
hung around. Others fought and stabbed one another in the
very core of the fire, like combating salamanders. Meantime,
the motions of the gipsies grew more languid and slow, and
their curses were uttered in choked guttural tones. The faces
of all four were spotted with red and green and violet, like
so many egg-plants. Their bodies were swollen to a frightful
size, and at last they dropped on the floor, like over-ripe
fruit shaken from the boughs by the winds of autumn.

From *The Wondersmith* by Fitz-James O'Brien, 1859

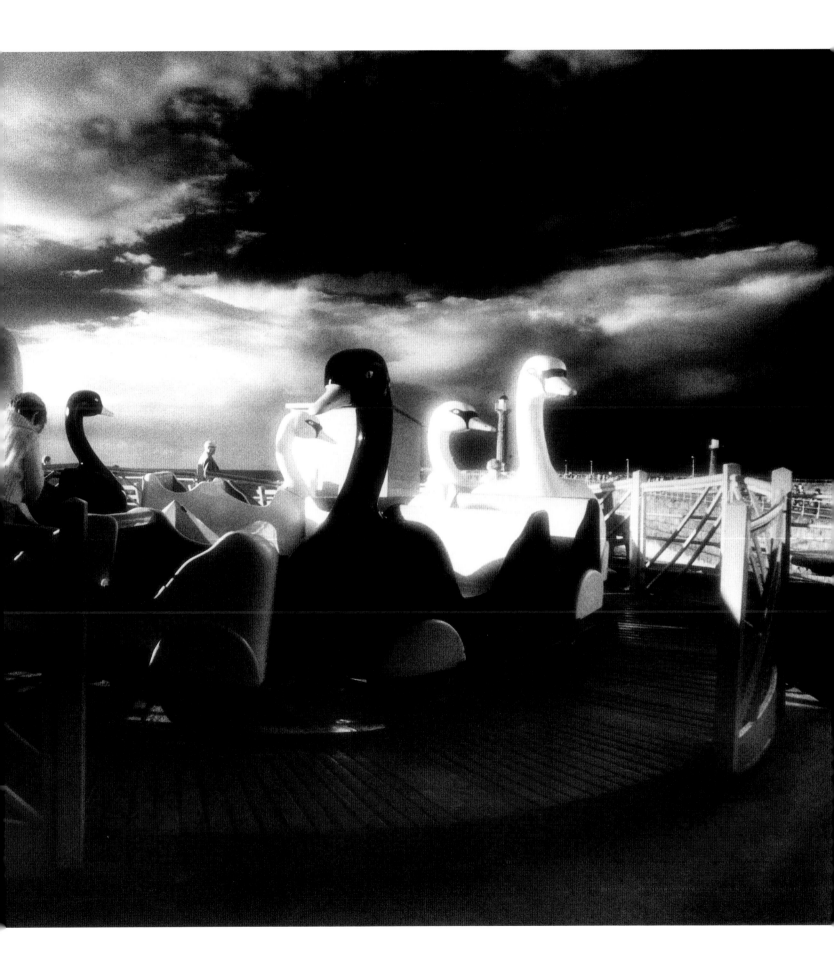

WUTHERING HEIGHTS

YOU KNOW, I WAS WILD AFTER SHE DIED, AND ETERNALLY, FROM DAWN TO DAWN, PRAYING HER TO RETURN TO ME – HER SPIRIT – I HAVE A STRONG FAITH IN GHOSTS; I HAVE A CONVICTION THAT THEY CAN, AND DO EXIST, AMONG US! THE DAY SHE WAS BURIED THERE CAME A FALL OF SNOW. IN THE EVENING I WENT TO THE CHURCHYARD. IT BLEW BLEAK AS WINTER – ALL AROUND WAS SOLITARY: I DIDN'T FEAR

that her fool of a husband would wander up the den so late – and no one else had business to bring them there.

Being alone, and conscious two yards of loose earth was the sole barrier between us, I said to myself, 'I'll have her in my arms again! If she be cold, I'll think it is this north wind that chills me; and if she be motionless, it is sleep.'

I got a spade from the tool-house and began to delve with all my might – it scraped the coffin; I fell to work with my hands; the wood commenced cracking about the screws, I was on the point of attaining my object, when it seemed

that I heard a sigh from someone above, close at the edge of the grave, and bending down. 'If I can only get this off,' I muttered, 'I wish they may shovel in the earth over us both!' and I wrenched at it more desperately still. There was another sigh, close at my ear. I appeared to feel the warm breath of it displacing the sleet-laden wind. I knew no living thing in flesh and blood was by – but as certainly as you perceive the approach to some substantial body in the dark, though it cannot be discerned, so certainly I felt that Cathy was there, not under me, but on the earth.

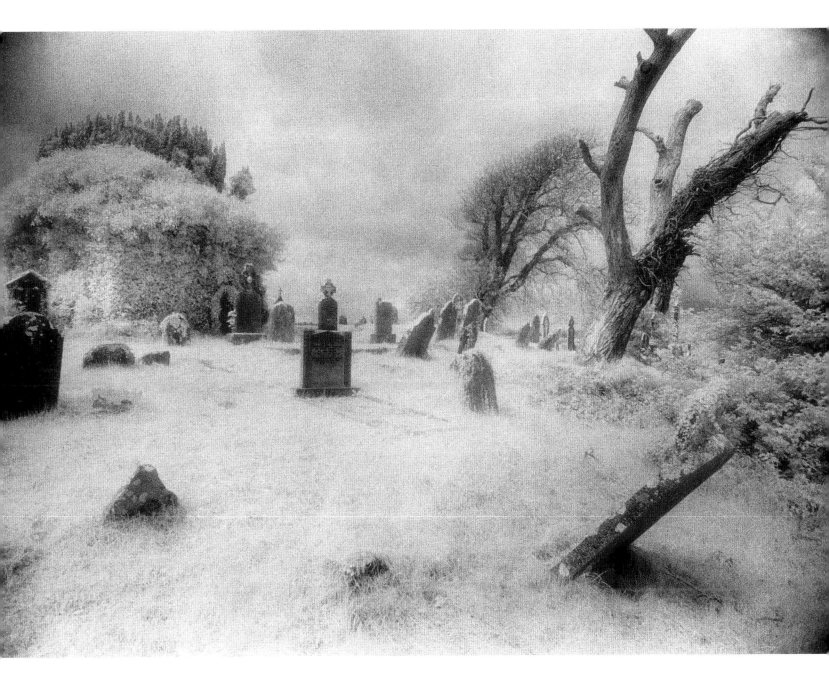

A sudden sense of relief flowed, from my heart, through every limb. I relinquished my labour of agony, and turned consoled at once, unspeakably consoled. Her presence was with me; it remained while I re-filled the grave, and led me home. You may laugh, if you will, but I was sure I should see her there. I was sure she was with me, and I could not help talking to her.

I looked round impatiently – I felt her by me – I could almost see her, and yet I could not! I ought to have sweat blood then, from the anguish of my yearning, from the fer-vour of my supplications to have but one glimpse! I had not one. She showed herself, as she often was in life, a devil to me! And, since then, sometimes more, and sometimes less, I've been the sport of that intolerable torture!

… It was a strange way of killing, not by inches, but by fractions and hair-breadths, to beguile me with the spectre of hope, through eighteen years!

From *Wuthering Heights*
by Emily Brontë, 1847

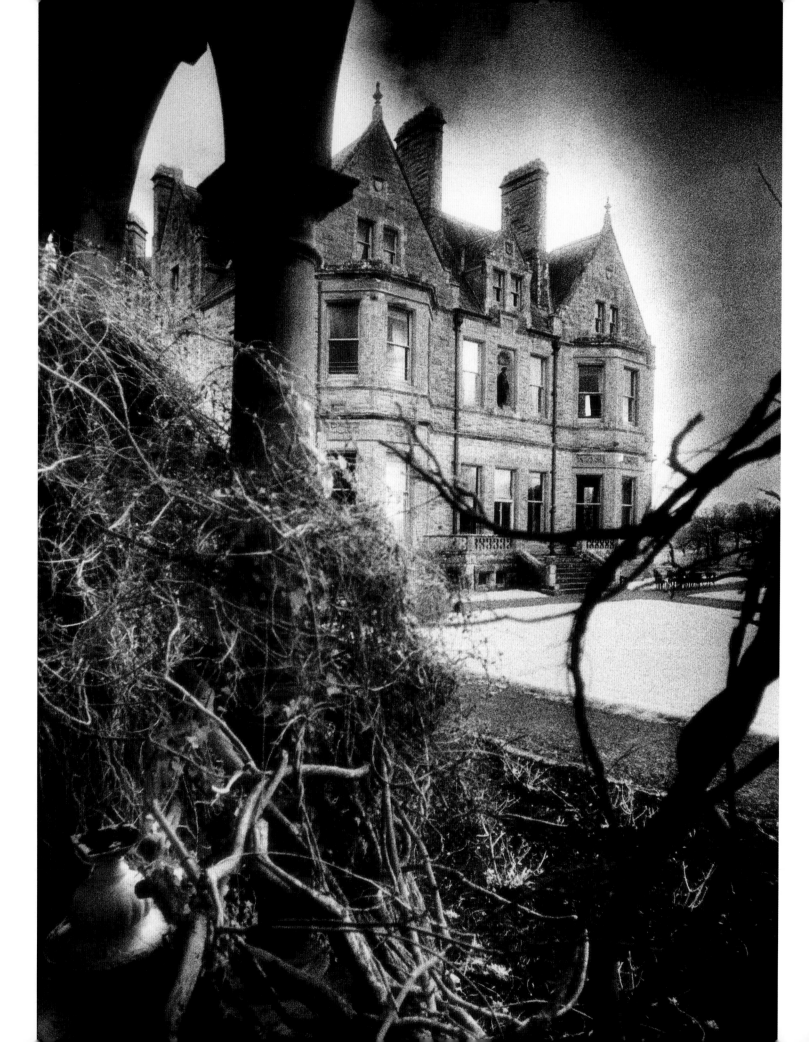

CASTLE LESLIE

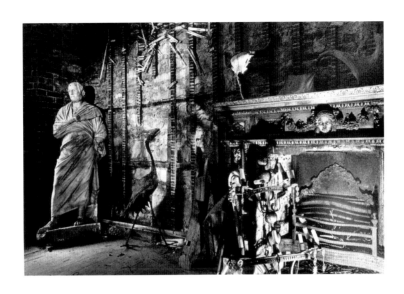

SURROUNDED BY THE ANCIENT WOODS OF TRUAGH, WHICH DATE BACK TO CELTIC TIMES, CASTLE LESLIE'S PARKLANDS AND LAKES RETAIN ALL THE MYSTERY AND GRANDEUR OF A BYGONE ERA. HOME TO THE LESLIE FAMILY FOR OVER THREE HUNDRED YEARS, THE PRESENT HOUSE REPLACED A TOWER HOUSE BUILT BY BISHOP JOHN LESLIE IN 1664.

The castle has many ghosts and the family have always embraced the supernatural. Sir Shane Leslie, the third baronet, was an author and poet who wrote extensively on the subject:

'There is no need to pursue ghosts or to discern unwilling spirits. If they are part of the invisible texture around us, they can find their way to us. If they come to a careful researcher, armed with some pre-knowledge, they must take the consequences.

The object of this book is to collect instances of ghosts, apparitions and messages from the other or twilight world.'
(From *Shane Leslie's Ghost Boo*k by Sir Shane Leslie, 1955)

The austere exterior of the house contrasts with the magnificent flights of architectural fantasy in the interior. Here the halls, galleries and walls are adorned with ancient weapons, stags' heads and portraits of generations of Leslies, alongside bizarre statues and macabre heirlooms such as the blood-soaked cloth that received the head of James, Earl of Derwentwater, who was executed in 1715 during the Jacobite rebellion.

I was told by a member of the family that the now derelict billiard room was an area of the house of which they had always been afraid when children, as they had heard footsteps and groans there at night. Interestingly I saw strange 'dancing lights' in my camera lens when photographing here, which I couldn't explain.

The long arched gallery that runs parallel to the cloisters is filled with frescoes of family members and mysterious classical figures that were painted by the first baronet, Sir John Leslie, the talented artist of the pre-Raphaelite school who built the present castle.

Another haunted room in the castle is a bedroom known as Norman's Room. This contains a four-poster bed dating back to 1617, and guests sleeping in it have woken in the middle of the night to feel a powerful energy bearing down on them. Norman Leslie, a war hero, was killed in Belgium during World War I, but his spirit appeared in the castle two nights before his death.

John Norman Leslie or Jack, as he is affectionately known, the fourth baronet, is an intelligent, sensitive man. He told me that he believed in the supernatural but had always felt at peace with the spirits that haunt the castle, although he had experienced evil in other houses that he

had visited. Once, when a young boy, he had been staying with his cousins at Brede Place, a badly haunted house in England, and one night when he was playing on the stairs that led to the attic he was passed by a tall, pallid figure to whom he nervously said goodnight. The next morning at breakfast he was told that the attic was an empty room that had been locked for many years.

I have been told many ghost stories over the years but have tended to believe those that are somehow different, that don't fall into any particular pattern. The people who have experienced them are for the most part reluctant to discuss them, as they are content to have experienced this other dimension and don't expect to be taken seriously in our sceptical world. I believe that another realm, a spirit world, runs parallel to our own so-called real world, and that sometimes, when the conditions are right, we can see into and become part of this supernatural domain.

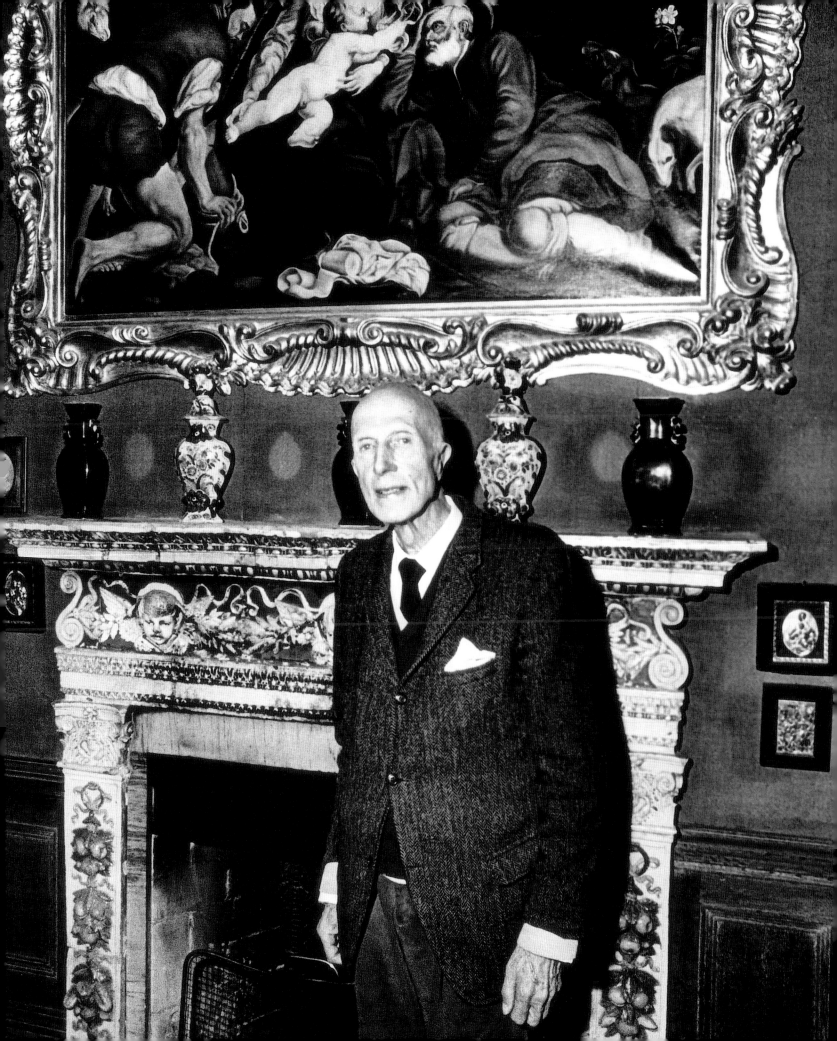

THE FAMILIAR

PERHAPS NOT THE LEAST STRANGE OF THE MANY CIRCUMSTANCES CONNECTED WITH MY NARRATIVE WAS THE FACT THAT THE SUBJECT OF THE FEARFUL INFLUENCES I AM ABOUT TO DESCRIBE, WAS HIMSELF, FROM THE DELIBERATE CONVICTION OF YEARS, AN UTTER DISBELIEVER IN WHAT WAS USUALLY TERMED PRETERNATURAL AGENCIES.

It was considerably past midnight when Mr Barton took his leave, and set out upon his solitary walk homeward. He had now reached the lonely road, with its unfinished dwarf walls tracing the foundations of the projected row of houses on either side – the moon was shining mistily, and its imperfect light made the road he trod but additionally dreary – that utter silence which has in it something indefinably exciting, reigned there, and made the sound of his steps, which alone broke it, unnaturally loud and distinct.

He had proceeded thus some way, when he, on a sudden, heard other footfalls, pattering at a measured pace, and, as it seemed, about two-score steps behind him.

The suspicion of being dogged is at all times unpleasant: it is, however, especially so in a spot so lonely: and this suspicion became so strong in the mind of Captain Barton, that he abruptly turned about to confront his pursuer, but, though there was quite sufficient moonlight to disclose any object upon the road that he traversed, no form of any kind was visible there.

The steps that he had heard could not have been the reverberation of his own, for he stamped his foot upon the ground, and walked briskly up and down, in the vain attempt to awake an echo; though by no means a fanciful person therefore, he was at last fain to charge the sounds upon his imagination, and treat them as an illusion. Thus satisfying himself, he resumed his walk, and before he had proceeded a dozen paces, the mysterious footfalls were again audible from behind, and this time, as if with the special design of showing that the sounds were not the responses of an echo – the steps sometimes slackened nearly to a halt, and sometimes hurried for six or eight strides to a run, and again abated to a walk.

Captain Barton, as before, turned suddenly round, and with the same result – no object was visible above the desert-

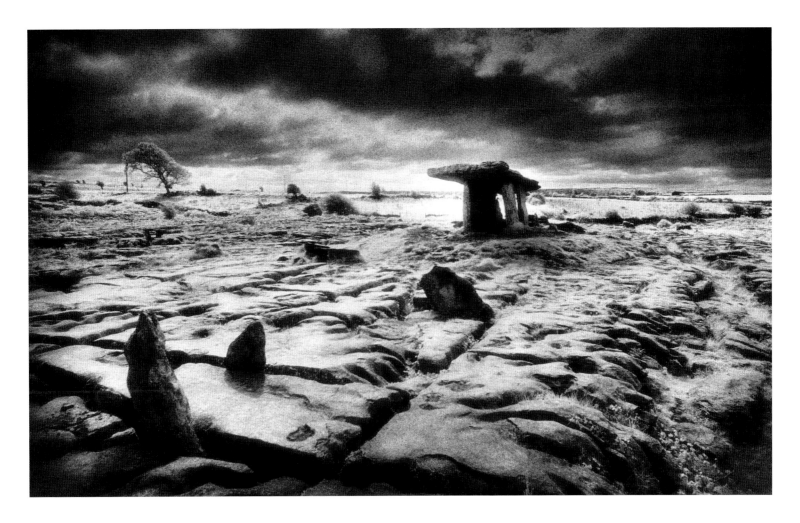

ed level of the road. He walked back over the same ground, determined that, whatever might have been the cause of the sounds which had so disconcerted him, it should not escape his search. The endeavour, however, was unrewarded.

In spite of all his scepticism, he felt something like a superstitious fear stealing fast upon him, and with these unwonted and uncomfortable sensations, he once more turned and pursued his way. There was no repetition of these haunting sounds, until he had reached a point where he had last stopped to retrace his steps – here they were resumed – and with sudden starts of running, which threatened to bring the unseen pursuer up to the alarmed pedestrian.

Captain Barton arrested his course as formerly – the unaccountable nature of the occurrence filled him with vague and disagreeable sensations – and yielding to the excitement that was gaining upon him, he shouted sternly,

'Who goes there?' The sound of one's own voice, thus exerted, in utter solitude, and followed by total silence, has in it some unpleasantly dismaying, and he felt a degree of nervousness which, perhaps, from no cause had he ever known before.

To the very end of this solitary street the steps pursued him – and it required a strong effort of stubborn pride on his part to resist the impulse that prompted him every moment to run for safety at the top of his speed. It was not until he had reached his lodging, and sat by his own fireside, that he felt sufficiently reassured to rearrange and reconsider in his own mind the occurrences which had so decomposed him. So little a matter, after all, is sufficient to upset the pride of scepticism and vindicate the old simple laws of nature within us.

From *The Familiar* by Joseph Sheridan Le Fanu, 1872

RANNOCH MOOR

DESOLATE RANNOCH MOOR IN THE SCOTTISH HIGHLANDS IS A DANGEROUS WILDERNESS OF PEAT
BOGS, ANCIENT FORESTS AND MURKY WATERS SURROUNDED BY DARK AND FORBIDDING MOUNTAINS.
FOR CENTURIES IT HAS BEEN A HAVEN FOR OUTLAWS AND CRIMINALS FORCED TO HIDE IN THE
CAVES WHERE WITCHES ONCE PRACTISED THE BLACK ARTS.

On the south-eastern shore of Loch Rannoch stands the mysterious, brooding presence of the Hill of the Fairies, or in Gaelic, Schiehallion Hill. Its summit is often shrouded in an impervious mist; on its lower slopes passing travellers have been followed by a terrifying dog-like shadow, which materialises from nowhere. In Celtic folklore such an apparition is often associated with places of otherworld power, as symbolic guardians of the supernatural. Strange monsters are said to inhabit the dark waters of the many deep lakes and pools.

As the sun sets here one experiences both fear and wonder, a sense of standing on the very shores of the unknown.

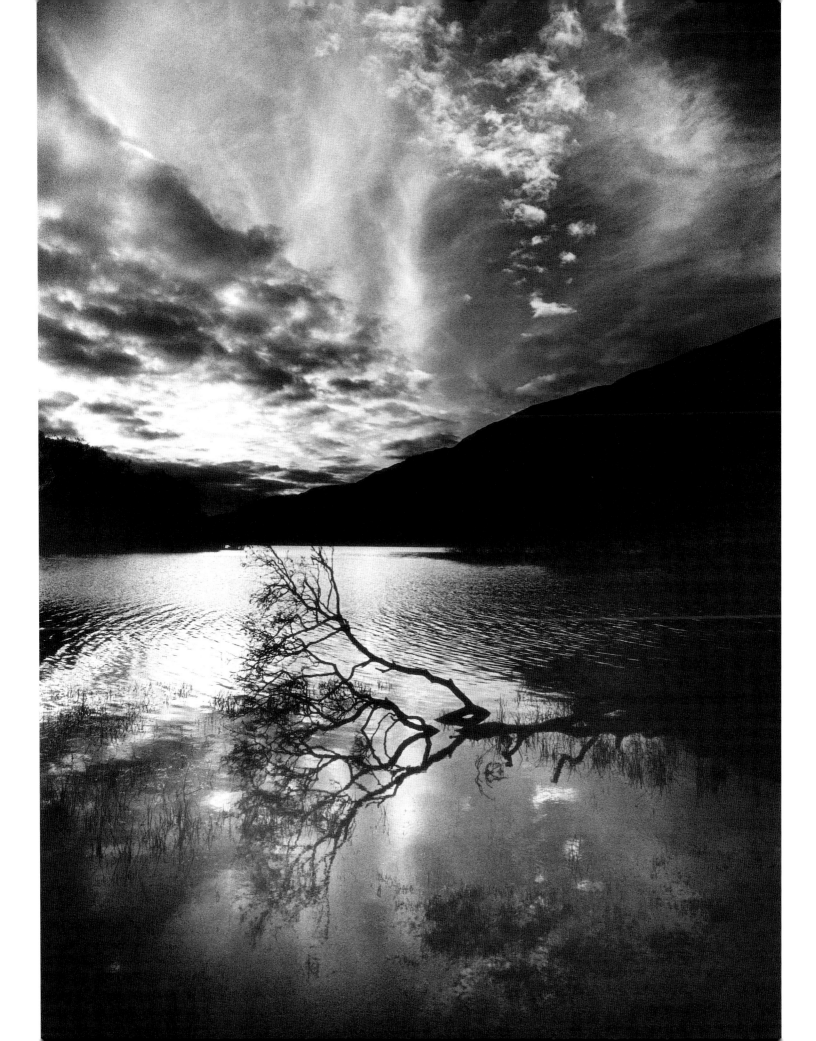

DR SEWARD'S DIARY

As he spoke Van Helsing's eyes never blinked, but his hand came out and met mine and gripped it hard. He did not, however, betray himself; he nodded slightly, and said: 'Go on,' in a low voice. Renfield proceeded: – 'He came up to the window in the mist, as I had seen him often before; but he was solid then – not a ghost, and his eyes were fierce like a man's

when angry. He was laughing with his red mouth; the sharp white teeth glinted in the moonlight when he turned to look back over the belt of trees, to where the dogs were barking. I wouldn't ask him to come in at first, though I knew he wanted to – just as he had wanted all along. Then he began promising me things – not in words but by doing them.' He was interrupted by a word from the Professor: –

'How?'

'By making them happen; just as he used to send in the flies when the sun was shining. Great big fat ones with steel and sapphire on their wings; and big moths, in the night, with skull and cross-bones on their backs.' Van Helsing nodded to him as he whispered to me unconsciously: –

'The *Acherontia* atropos of the Sphinges – what you call the "Death's-head moth!"' The patient went on without stopping.

'Then he began to whisper: "Rats, rats, rats! Hundreds, thousands, millions of them, and every one a life; and dogs to eat them, and cats too. All lives! all red blood, with years of life in it; and not merely buzzing flies!" I laughed at him, for I wanted to see what he could do. Then the dogs howled,

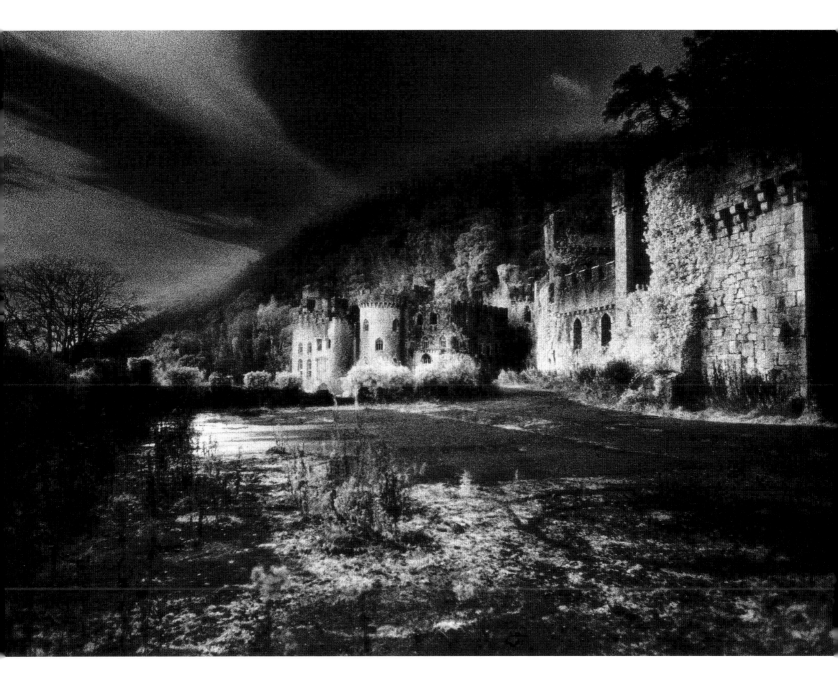

away beyond the dark trees in His house. He beckoned me to the window. I got up and looked out, and He raised his hands, and seemed to call out without using any words. A dark mass spread over the grass, coming on like the shape of a flame of fire; and then He moved the mist to the right and left, and I could see that there were thousands of rats with their eyes blazing red – like His, only smaller. He held up his hand, and they all stopped; and I thought He seemed to be saying: "All these lives will I give you, ay, and many more and greater, through countless ages, if you will fall down and worship me!" And then a red cloud, like the colour of blood, seemed to close over my eyes; and before I knew what I was doing, I found myself opening the sash and saying to Him: "Come in, Lord and Master!" The rats were all gone, but He slid into the room through the sash, though it was only open an inch wide – just as the Moon herself has often come in through the tiniest crack, and has stood before me in all her size and splendour.'

From 'Dr Seward's Diary', *Dracula* by Bram Stoker, 1897

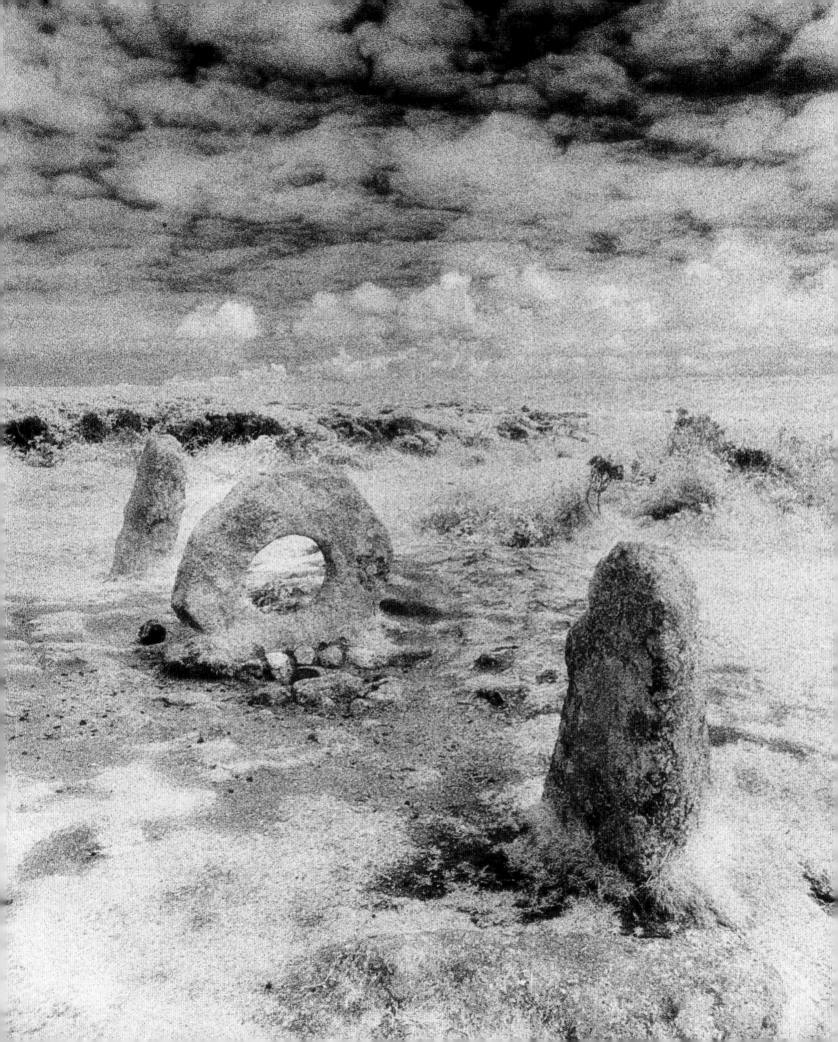

THE GOLDEN AGE

A WHILE AGO I WAS IN THE TRAIN, AND GETTING NEAR SLIGO. THE LAST TIME I HAD BEEN THERE SOMETHING WAS TROUBLING ME, AND I HAD LONGED FOR A MESSAGE FROM THOSE BEINGS OR BODILESS MOODS, OR WHATEVER THEY BE, WHO INHABIT THE WORLD OF SPIRITS. THE MESSAGE CAME, FOR ONE NIGHT I SAW WITH BLINDING DISTINCTIVENESS A BLACK ANIMAL, HALF WEASEL,

half dog, moving along the top of a stone wall, and presently the black animal vanished, and from the other side came a white weasel-like dog, his pink flesh shining through his white hair and all in a blaze of light; and I remembered a peasant belief about two faery dogs who go about representing day and night, good and evil, and was comforted by the excellent omen. But now I longed for a message of another kind, and chance, if chance there is, brought it, for a man got into the carriage and began to play on a fiddle made apparently of an old blacking-box, and though I am quite unmusical the sounds filled me with the strangest emotions. I seemed to hear a voice of lamentation out of the Golden Age. It told me that we are imperfect, incomplete, and no more like a beautiful woven web, but like a bundle of cords knotted together and flung into a corner. It said that the world was once all perfect and kindly, and that still the kindly and perfect world existed, but buried like a mass of roses under many spadefuls of earth. The faeries and the more

innocent of the spirits dwelt within it, and lamented over our fallen world in the lamentation of the wind-tossed reeds, in the song of the birds, in the moan of the waves, and in the sweet cry of the fiddle. It said that with us the beautiful are not clever and the clever are not beautiful, and that the best of our moments are marred by a little vulgarity, or by a pin-prick out of sad recollection, and that the fiddle must ever lament about it all. It said that if only they who live in the Golden Age could die we might be happy, for the sad voices would be still; but alas! alas! they must sing and we must weep until the eternal gates swing open.

We were now getting into the big glass-roofed terminus, and the fiddler put away his old blacking-box and held out his hat for a copper, and then opened the door and was gone.

From 'The Golden Age', *The Celtic Twilight*
by W. B. Yeats, 1893

W H A T W A S I T ?

ON THE EVENING IN QUESTION, THE TENTH OF JULY, THE DOCTOR AND MYSELF DRIFTED INTO AN UNUSUALLY METAPHYSICAL MOOD. WE LIT OUR LARGE MEERSCHAUMS, FILLED WITH FINE TURKISH TOBACCO, IN THE CORE OF WHICH BURNED A LITTLE BLACK NUT OF OPIUM, THAT, LIKE THE NUT IN THE FAIRY TALE, HELD WITHIN ITS NARROW LIMITS WONDERS BEYOND THE REACH, OF KINGS; WE PACED TO

and fro, conversing. A strange perversity dominated the currents of our thought. They would not flow through the sun-lit channels into which we strove to divert them. For some unaccountable reason, they constantly diverged into dark and lonesome beds, where a continual gloom brooded. It was in vain that, after our old fashion, we flung ourselves on the shores of the East, and talked of its gay bazaars, of the splendours of the time of Haroun, of harems and golden palaces. Black afreets continually arose from the depths of our talk, and expanded, like the one the fisherman released from the copper vessel, until they blotted everything bright from our vision. Insensibly, we yielded to the occult force that swayed us, and indulged in gloomy speculation. We had talked some time upon the proneness of the human mind to mysticism, and the almost universal love of the terrible, when Hammond suddenly said to me, 'What do you consider to be the greatest element of terror?'

The question puzzled me. That many things were terrible, I knew. Stumbling over a corpse in the dark; beholding, as I once did, a woman floating down a deep and rapid river, with wildly lifted arms, and awful, upturned face, uttering, as she drifted, shrieks that rent one's heart, while we, the spectators, stood frozen at a window which overhung the river at a height of sixty feet, unable to make the slightest effort to save her, but dumbly watching her last supreme agony and her disappearance. A shattered wreck, with no life visible, encountered floating listlessly on the ocean, is a terrible object, for it suggests a huge terror, the proportions of which are veiled. But it now struck me, for the first time, that there must be one great and ruling embodiment of fear – a King of Terrors, to which all others must succumb. What might it be? To what train of circumstances would it owe its existence?

'I confess, Hammond,' I replied to my friend, 'I never considered the subject before. That there must be one Something more terrible than any other thing, I feel. I cannot attempt, however, even the most vague definition.'

'I am somewhat like you, Harry,' he answered. 'I feel my capacity to experience a terror greater than anything yet conceived by the human mind – something combining in fearful and unnatural amalgamation hitherto supposed incompatible elements. The calling of the voices in Brockden Brown's novel of *Wieland* is awful; so is the picture of the Dweller of the Threshold, in Bulwer's *Zanoni*; but,' he added, shaking his head gloomily, 'there is something more horrible still than these.'

'Look here, Hammond,' I rejoined, 'let us drop this kind of talk, for heaven's sake! We shall suffer for it, depend on it.'

'I don't know what's the matter with me tonight,' he replied, 'but my brain is running upon all sorts of weird and awful thoughts. I feel as if I could write a story like Hoffman, tonight, if I were only master of a literary style.'

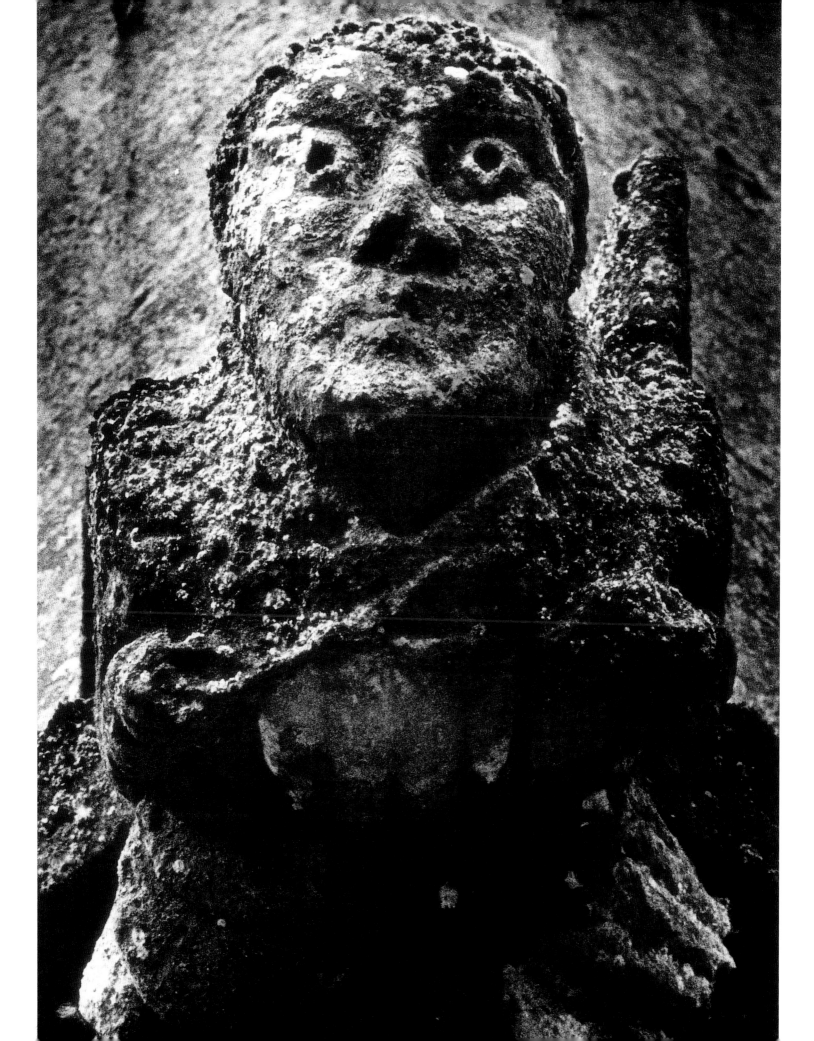

'Well, if we are going to be Hoffmanesque in our talk, I'm off to bed. Opium and nightmares should never be brought together. How sultry it is! Good-night, Hammond.'

'Good-night, Harry. Pleasant dreams to you.'

'To you, gloomy wretch, afreets, ghouls, and enchanters.'

We parted, and each sought his respective chamber. I undressed quickly and got into bed, taking with me, according to my usual custom, a book, over which I generally read myself to sleep. I opened the volume as soon as I had laid my head upon the pillow, and instantly flung it to the other side of the room. It was Goudon's *History of Monsters*, a curious French work, which I had lately imported from Paris, but which, in the state of mind I had then reached, was anything but an agreeable companion. I resolved to go to sleep at once; so, turning down my gas until nothing but a little blue point of light glimmered on the top of the tube, I composed myself to rest.

The room was in total darkness. The atom of gas that still remained alight did not illuminate a distance of three inches round the burner. I desperately drew my arm across my eyes, as if to shut out even the darkness, and tried to think of nothing. It was in vain. The confounded themes touched on by Hammond in the garden kept obtruding themselves on my brain. I battled against them. I erected ramparts of would-be blankness of intellect to keep them out. They still crowded upon me. While I was lying still as a corpse, hoping that by a perfect physical inaction I should hasten mental repose, an awful incident occurred. A Something dropped, as it seemed, from the ceiling, plump upon my chest, and the next instant I felt two bony hands encircling my throat, endeavouring to choke me.

From *What Was It?* by Fitz-James O'Brien, 1889

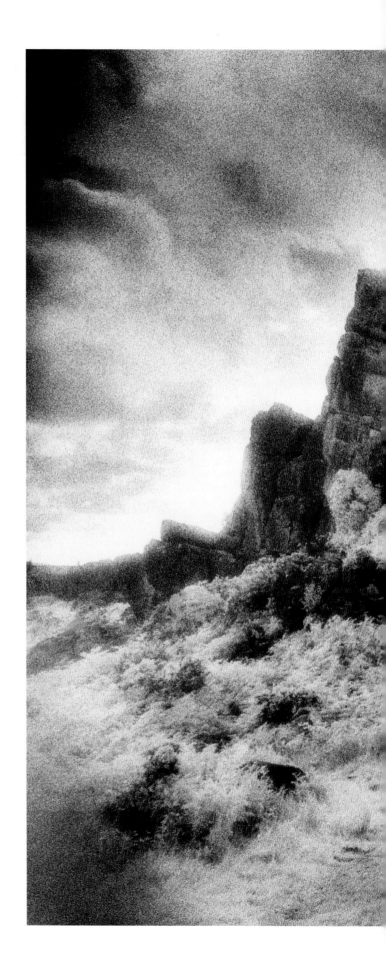

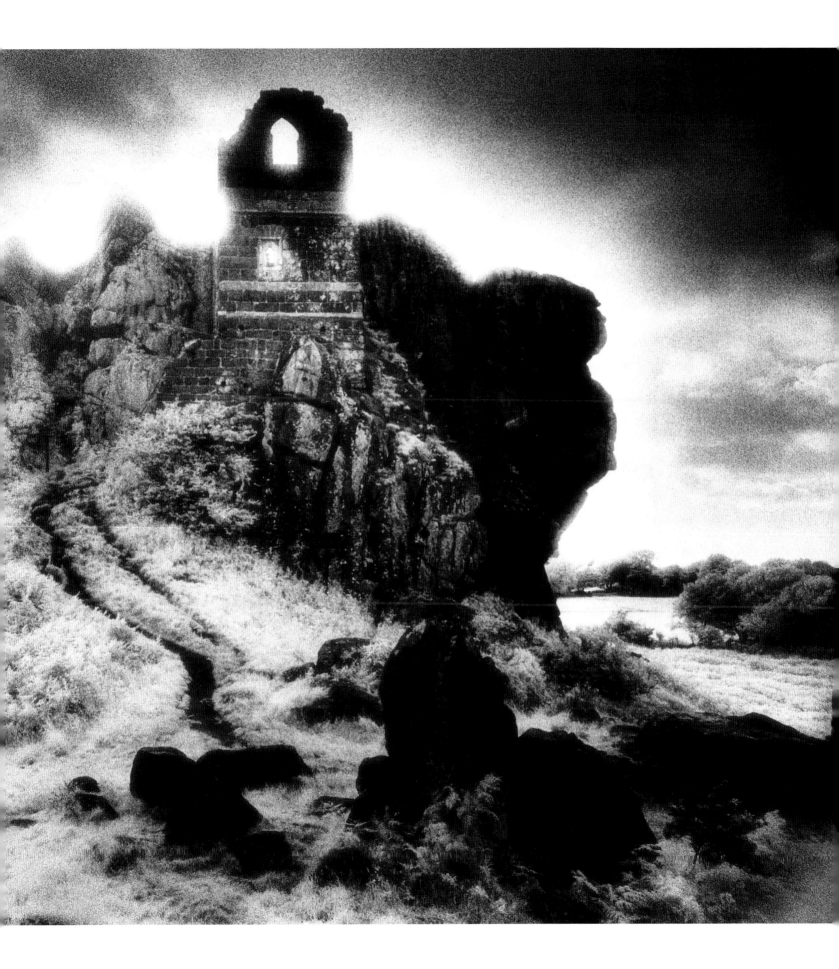

LEAP CASTLE

Known universally as the most haunted house in all Ireland, Leap Castle was once the principal seat of the powerful and warlike O'Carrolls, Princes of Ely. It stands on a vast, ancient rock guarding a strategic pass through the wild Slieve Bloom Mountains. My first visit was for a book I was compiling called *In Ruins: The Once Great Houses of Ireland*, and

I can distinctly remember my initial feelings of fear and fascination. Nowhere had ever before held for me so many suggestions of the supernatural.

The O'Carrolls were the last clan to surrender to the British in the seventeenth century and their fearsome reputation left behind a legacy of intrigue and murder, as brother fought brother for control of their lands. Local people are still in awe of their castle and are fearful of the many ghosts that haunt it. Above the main hall of the great fourteenth-century tower is what is known as the Bloody Chapel, where one-eyed Tadgh O'Carroll slew his brother at the altar and where, late at night, passers-by on the main road have seen a window of the room suddenly illuminated by a strange light. In one corner of this chamber was a

spiked oubliette, a secret dungeon into which unsuspecting prisoners were thrown through a trap door and conveniently forgotten. Three cartloads of bones were extracted from here after the house was destroyed by the IRA in a fire in 1922. Below the keep a network of deep dungeons were hewn into the rock, containing bricked-up passages and secret chambers. Several human skeletons were found here, too.

The last owners of the castle before the IRA burnt it were the Anglo-Irish Darby family, who obtained the estate when Jonathan Darby married the daughter of an O'Carroll chieftain in the seventeenth century. A staunch royalist, he was known as the Wild Captain and is said to have hidden a fabulous hoard of treasure in the castle with the help of two servants whom he then murdered, before he himself was

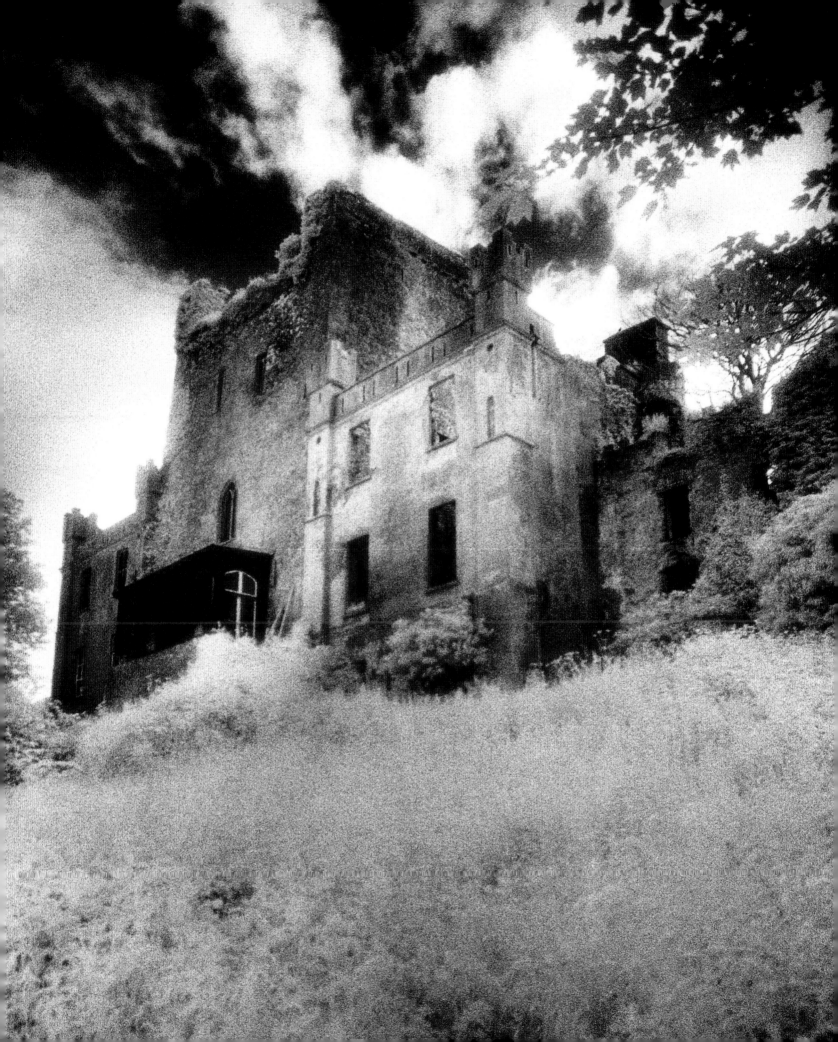

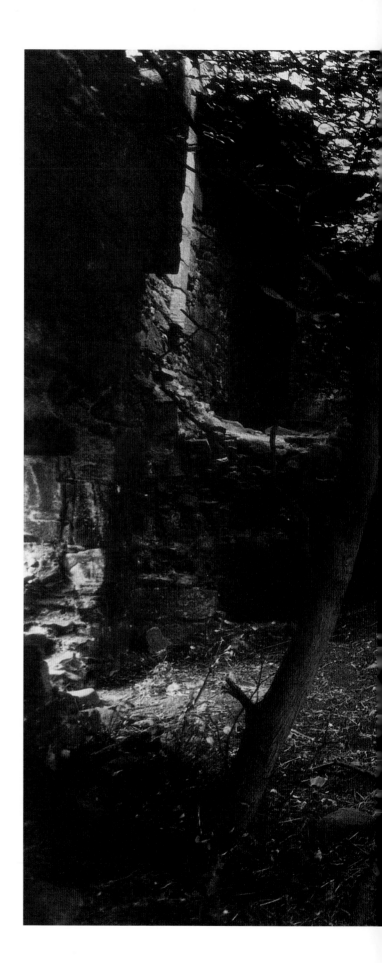

falsely imprisoned for treason. When he was released many years later, his mind was so deranged that he couldn't remember where he had hidden the chest and his insane ghost is still said to be searching for it.

During the period of the Darby's residence, overnight guests frequently experienced the terrifying spectre of a tall female figure dressed in what seemed to be a red gown, with her right hand raised menacingly above her head, seemingly illumined from within. Unfortunate visitors always awoke suddenly in the middle of the night, prior to this nightmarish vision, with an extraordinary and violent cold feeling in the region of their heart. But the strangest and most demonic apparition in the castle is a foul-smelling elemental, half-human, half-beast, which haunts the tower stair and is believed to be the embodiment of all the horrific and evil deeds that have taken place here.

The present owner is the accomplished musician, Sean Ryan, who told me that amongst the spirits he and his family currently experience are those of two little girls, Emily and Charlotte, who lived at the castle during the seventeenth century. Charlotte has a badly deformed leg, almost turned backwards, and is seen hobbling around the hall calling Emily's name. They know that Emily fell from a tower at the south-east corner of the castle because guests have seen her fall re-enacted. Occasionally there is a governess with

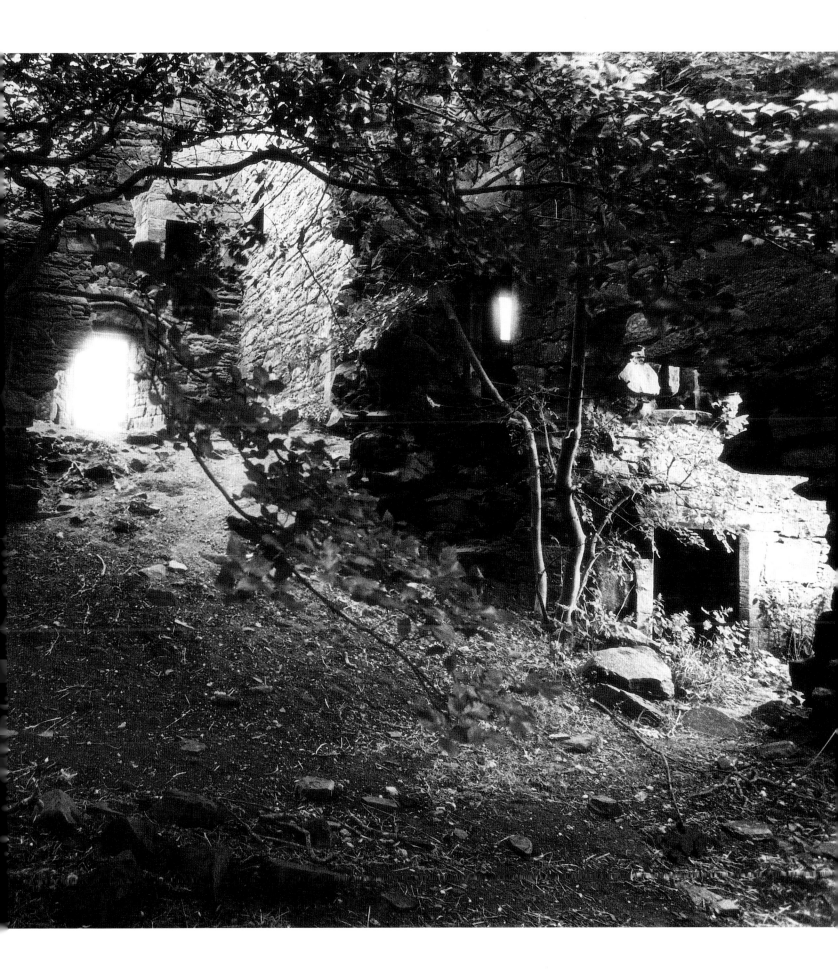

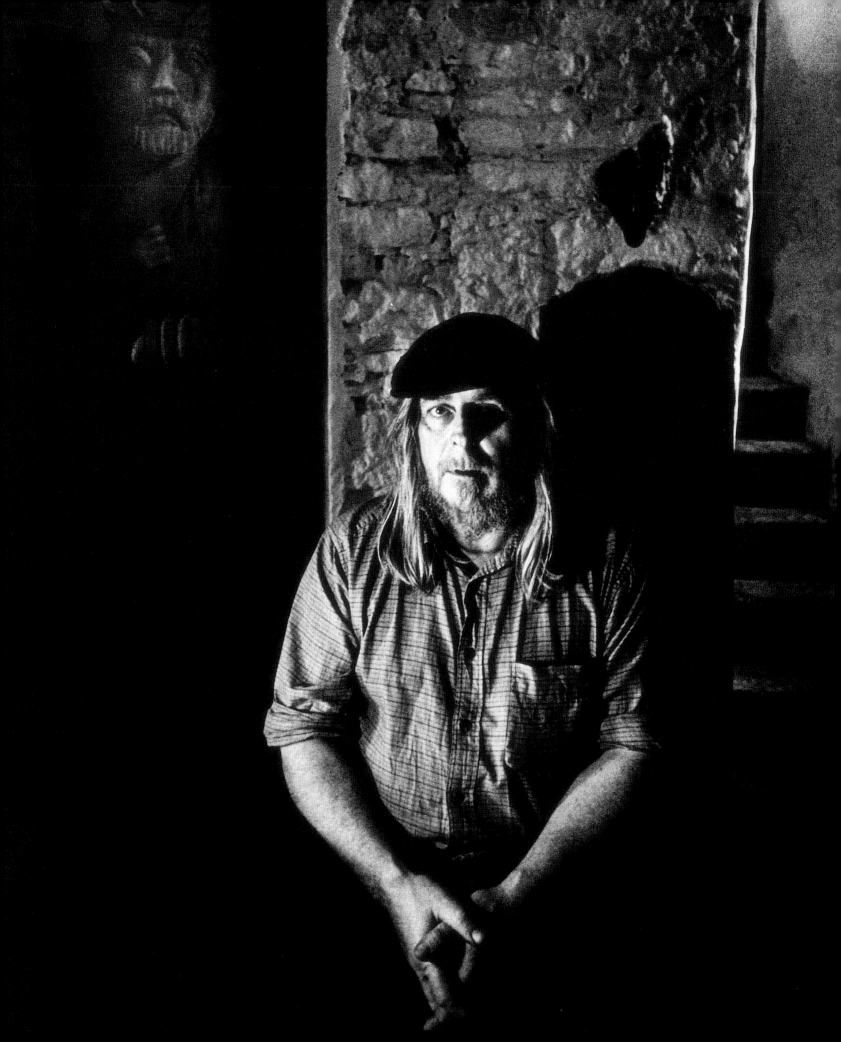

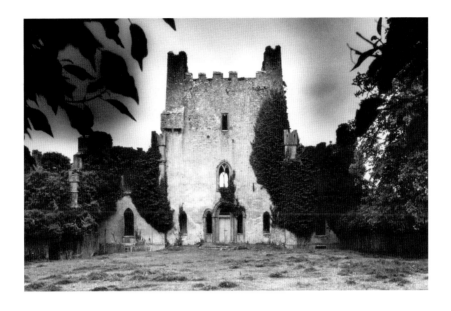

them. Sean thinks that she is a sad spirit trying to get a message across as she appears more to visitors. He would like to help her pass on.

More disturbing was the arrival one day of two elderly ladies of American-Indian descent, whose ancestors had married into the O'Carroll clan. As they entered the castle they felt the presence of the two girls and became alarmed, even more so when they went up to the Bloody Chapel which they found very hard, especially near the oubliette. They said that several spirits were huddled in the corners of the room, terrified that the ongoing alterations to the castle meant that it was reverting to the old regime under which they had suffered. Sean asked the ladies to assure them that this was not the case.

I had previously spoken with Peter Gerrard, who owned the castle for a short period in the 1970s and still lives nearby. He told me that after the fire, the Darbys left Ireland never to return, giving the mansion to an old lady – a family retainer – who later died of a gangrenous leg. After it changed hands once more he bought it as an investment, but his wife always felt uncomfortable there and feared for their children. Peter's mother had been a friend of Cicely O'Carroll Darby and was once invited to spend the night at the castle for a dance. She told him afterwards that she hadn't slept well and continually felt that something or someone was hovering over the end of her bed. He added that he thought the whole area around Leap was evil and that nothing good had befallen anyone who owned it.

THE NOVEL OF
THE BLACK SEAL

THIS STATEMENT BY WILLIAM GREGG, F.R.S., ETC.

IT IS MANY YEARS SINCE THE FIRST GLIMMER OF THE THEORY WHICH IS NOW ALMOST, IF NOT QUITE, REDUCED TO FACT DAWNED ON MY MIND. A SOMEWHAT EXTENSIVE COURSE OF MISCELLANEOUS AND OBSOLETE READING HAD DONE A GREAT DEAL TO PREPARE THE WAY, AND, LATER, WHEN I BECAME SOMEWHAT OF A SPECIALIST, AND IMMERSED MYSELF IN THE STUDIES KNOWN AS ETHNOLOGICAL,

I was now and then startled by facts that would not square with orthodox scientific opinion, and by discoveries that seemed to hint at something still hidden from all our research. More particularly I became convinced that much of the folk-lore of the world is but an exaggerated account of events that really happened, and I was especially drawn to consider the stories of the fairies, the good folk of the Celtic races. Here, I thought I could detect the fringe of embroidery and exaggeration, the fantastic guise, the little people dressed in green and gold sporting in the flowers, and I thought I saw a distinct analogy between the name given to this race (supposed to be imaginary) and the description of their appearance and manners. Just as our remote ancestors called the dreaded beings 'fair' and 'good' precisely because they dreaded them so they had dressed them up in charming forms, knowing the truth to be the very reverse. Literature, too, had gone early to work, and had lent a powerful hand in the transformation, so that the playful elves of Shakespeare are already far removed from the true original, and the real horror is disguised in a form of prankish mischief. But in the older tales, the stories that used to make men cross themselves as they sat around the burning logs, we tread a different stage; I saw a widely opposed spirit in certain histories of children and of men and women who vanished strangely from the earth. They would be seen by a peasant in the fields walking towards some green and rounded hillock, and seen no more on earth; and there are stories of mothers who have left a child quietly sleeping,

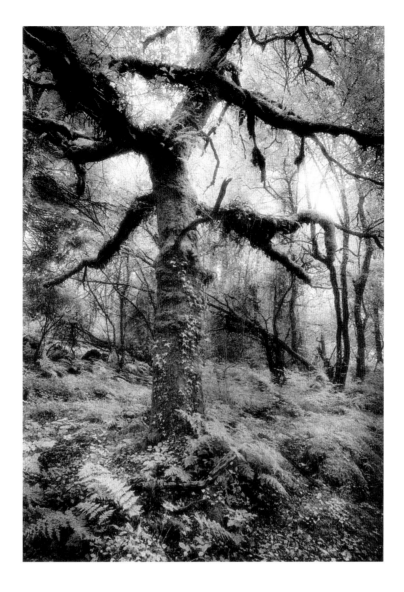

with the cottage door rudely barred with a piece of wood, and have returned, not to find the plump and rosy little Saxon, but a thin and wizened creature, with sallow skin and black, piercing eyes, the child of another race. Then, again, there were myths darker still; the dread of witch and wizard, the lurid evil of the Sabbath, and the hint of demons who mingled with the daughters of men. And just as we have turned the terrible 'fair folk' into a company of benignant, if freakish, elves, so we have hidden from us the black foulness of the witch and her companions under a popular diablerie of old women and broomsticks, and a comic cat with tail on end. So the Greeks called the hideous furies benevolent ladies, and thus the northern nations have followed their example. I pursued my investigations, stealing odd hours from other and more imperative labours, and I asked myself the question: Supposing these traditions to be true, who were the demons who are reported to have attended the Sabbaths? I need not say that I laid aside what I may call the supernatural hypothesis of the Middle Ages, and came to the conclusion that fairies and devils were of one and the same race and origin; invention no doubt, and the Gothic fancy of old days, had done much in the way of exaggeration and distortion; yet I firmly believe that beneath all this imagery there was a black background of truth.

From *The Novel of the Black Seal*
by Arthur Machen, 1895

ALONE

From childhood's hour I have not been
As others were – I have not seen
As others saw – I could not bring
My passions from a common spring.
From the same source I have not taken
My sorrow; I could not awaken
My heart to joy at the same tone;
And all I lov'd, I lov'd alone.
Then – in my childhood – in the dawn
Of a most stormy life – was drawn
From ev'ry depth of good and ill
The mystery which binds me still:
From the torrent, or the fountain,
From the red cliff of the mountain,
From the sun that 'round me roll'd
In its autumn tint of gold
From the lightning in the sky
As it pass'd me flying by –
From the thunder and the storm,
And the cloud that took the form
(When the rest of Heaven was blue)
Of a demon in my view.

'Alone' by Edgar Allan Poe, 1830

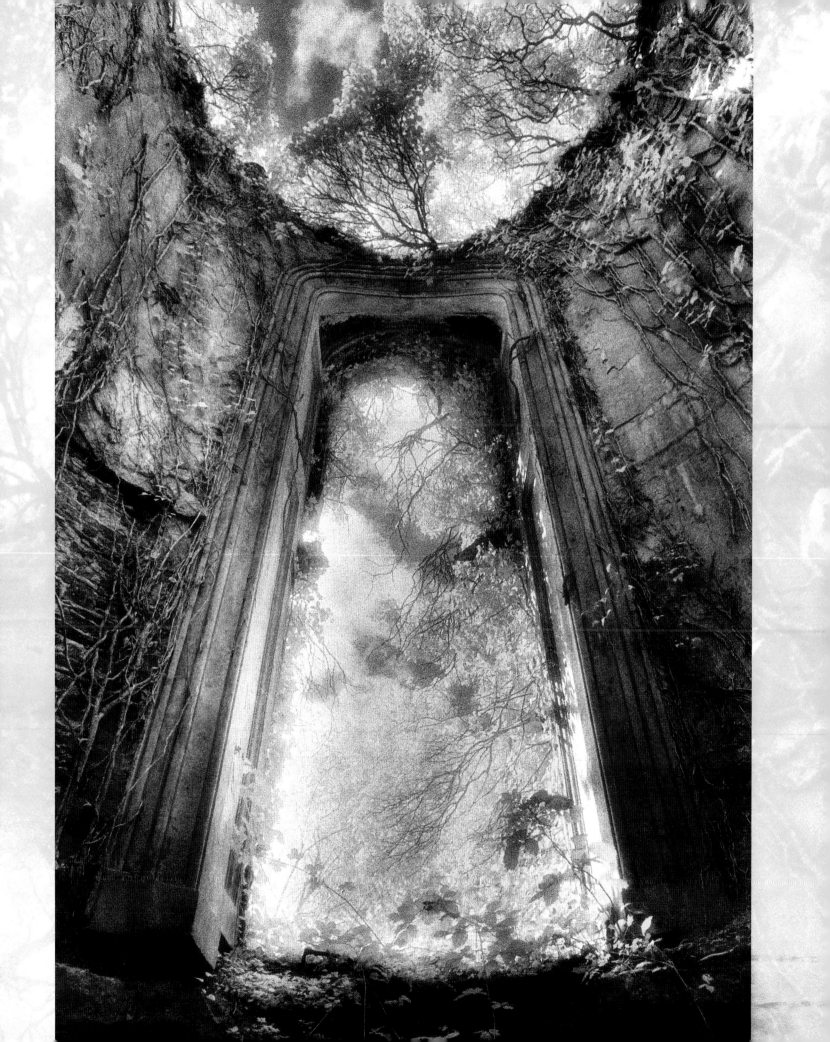

THE PHOTOGRAPHS

PAGE 5
St Michael's Mount, Cornwall,
England

PAGE 8
Gargoyle, St Peter's Church,
Winchcombe, Gloucestershire,
England

PAGE 9
High Cross, Moone,
County Kildare, Ireland

PAGE 10
Craig Hall, Perthshire, Scotland

PAGE 11
'Druid's Altar',
County Cork, Ireland

PAGES 12 & 13
Carriogunell Castle,
County Limerick, Ireland

PAGE 14
Demon Asmodeus,
Church of St Mary Magdalen,
Rennes-le-Château, Languedoc,
France

PAGE 15
Forelacka Burial Ground,
Slieve Bloom Mountains,
County Offaly, Ireland

PAGES 16 & 17
Crawford Priory, Fife, Scotland

PAGE 18
Glamis Castle, Angus, Scotland

PAGE 20
Satyr from the 'Devil Gates',
Glamis Castle

PAGE 21
Portrait of Patrick, Third Earl
of Strathmore and Kinghorne
(1643-95)

PAGE 22
Whitby Abbey, North Yorkshire,
England

PAGE 23
Graveyard, Whitby,
North Yorkshire, England

PAGE 24
Detail from an urn, Belvoir
Castle, Leicestershire, England

PAGE 25
Figure, Toddington Manor,
Gloucestershire, England

PAGE 26
Duntulm Castle, Isle of Skye,
Scotland

PAGE 29
Statue, Kanitz-Kyausche
Mausoleum, Sachsen, Germany

PAGES 30 & 31
Carbury Castle and Graveyard,
County Kildare, Ireland

PAGE 32
Cornelia Bayley, Great Chamber,
Plas Teg, Clwyd, Wales

PAGE 34
Broken frieze, gardens,
Plas Teg

PAGE 35
Plas Teg

PAGE 36
Statue, Duncombe Park,
North Yorkshire, England

PAGE 37
Castlerigg Stone Circle,
Cumbria, England

PAGE 38
Cadaver, Stamullen Graveyard,
County Meath, Ireland

PAGES 40 & 41
Thirlwall Castle,
Northumberland, England

PAGE 42
Detail from mausoleum,
Père Lachaise Cemetery, Paris,
France

PAGE 43
Norber Rocks, Yorkshire,
England

PAGE 44
'Haunted Staircase', Charleville
Forest, County Offaly, Ireland

PAGE 45
Charleville Forest

PAGE 46
Broken steps, gardens,
Charleville Forest

PAGE 46 & 47
Ruined stables,
Charleville Forest

PAGE 49
Gnarled tree, Black Mountains,
Wales

PAGES 50 & 51
Celtic heads, Dysert O'Dea,
County Clare, Ireland

PAGE 53
Kitty's Steps, Lydford Gorge,
Devon, England

PAGE 54
Funerary monument,
Notre Dame, Paris, France

PAGE 55
Poltalloch House, Argyllshire,
Scotland

PAGE 56
Detail from a frieze, Stiftskirche
St Peter, Petersberg, Sachsen-
Anhalt, Germany

PAGE 57
Cheesewring, Bodmin Moor,
Cornwall, England

PAGES 58 & 59
'Old' Castle Hackett,
County Galway, Ireland

PAGE 61
Figure, Toddington Manor,
Gloucestershire, England

PAGE 62
Gnarled tree, Litterluna,
County Offaly, Ireland

PAGE 65
Crosspoint Cemetery,
Belmullet, County Mayo,
Ireland

PAGE 66
Pagan figure, Boa Island,
County Fermanagh,
Northern Ireland

PAGE 67
Passage grave, Slieve Na
Calliagh, Loughcrew Hills,
County Meath, Ireland

PAGE 69
Ecclescrieg House,
Aberdeenshire, Scotland
PAGE 70
Cadaver, St Peter's Churchyard,
Drogheda, County Meath,
Ireland
PAGE 72
Detail from a mural, Castle
Leslie, County Monaghan,
Ireland
PAGE 73
Castleboro House,
County Wexford, Ireland
PAGE 75
Causeway, Holy Island,
Northumberland, England
PAGE 76
Giles Perceval (1842–1914)
PAGE 77
Interior, Rathkill House,
County Sligo, Ireland
PAGES 78 & 79
Rathkill House
PAGE 81
Statue, Almenêches, Normandy,
France
PAGE 83
Milton Lockhart House,
Lanarkshire, Scotland
PAGES 84 & 85
Melrose Abbey, Roxburghshire,
Scotland

PAGES 86 & 87
Figure, Melrose Abbey
PAGE 88
Double-headed figure,
Mirepoix, Pyrénées, France
PAGES 90 & 91
Fairground, Whitby,
North Yorkshire, England
PAGE 92
Detail from tomb,
Père Lachaise Cemetery, Paris,
France
PAGE 93
Kilcomin Graveyard,
County Tipperary, Ireland
PAGE 94
Castle Leslie,
County Monaghan, Ireland
PAGE 95
Billiard Room, Castle Leslie
PAGE 96
Detail from the fireplace,
Billiard Room, Castle Leslie
PAGE 97
Sir John Leslie, or 'Jack',
the fourth baronet
PAGE 98
Grotesque figures, Chapter
House, Lincoln Cathedral,
England
PAGE 99
Poulnabrone Dolmen,
The Burren, County Clare,
Ireland

PAGE 100
Detail from an urn, Belvoir
Castle, Leicestershire, England
PAGE 101
Loch Rannoch, Perthshire,
Scotland
PAGE 102
Figure, Toddington Manor,
Gloucestershire, England
PAGE 103
Gwrych Castle, Abergele,
North Wales
PAGE 104
Men-an-Tol or 'Holed Stone',
Morvah, Cornwall, England
PAGE 107
Gargoyle, St Peter's Church,
Winchcombe, Gloucestershire,
England
PAGES 108 & 109
Hermit's Chapel, Roche Rock,
Bodmin Moor, Cornwall,
England
PAGE 110
Louise Ashby, Peter Gerrard's
mother
PAGE 111
Leap Castle, County Offaly,
Ireland
PAGE 112
Peter Gerrard
PAGES 112 & 113
Interior, Leap Castle
PAGE 114
Sean Ryan

PAGE 115
Leap Castle
PAGE 116
'Green Man', Old Radnor
Church, Radnorshire, Wales
PAGE 117
Woods on the edge of
Dartmoor, Devon, England
PAGE 119
Gothic window, Castle Bernard,
County Cork, Ireland
PAGE 122
Pagan figures, White Island,
Lower Lough Erne, County
Fermanagh, Northern Ireland
PAGE 125
Minard Castle, County Kerry,
Ireland
PAGE 126
Nevern Graveyard,
Pembrokeshire, Wales
PAGE 127
Gargoyle, St Peter's Church,
Winchcombe, Gloucestershire,
England
PAGE 128
Detail from a mural,
Castle Leslie,
County Monaghan, Ireland

BIOGRAPHIES

JONATHAN AYCLIFFE

Jonathan Aycliffe is a pseudonym for the Irishman Denis MacEoin. His first full-length ghost story, the chilling *Naomi's Room*, established Aycliffe as a modern master of the supernatural. Intelligent and provocative, his haunting, mesmerising narrative takes us to places our imagination has never dared to venture before. Other works include *The Vanishment*, *Whispers in the Dark*, *The Lost* and *The Matrix*, a truly terrifying portrayal of one man's obsession with arcane occult powers that release an evil surpassing all earthly horror.

Born in Belfast in 1949, Aycliffe attended Trinity College, Dublin, Edinburgh University and King's College, Cambridge. An early interest in Egyptology led to a wider passion for the Middle East and time spent in Morocco and Iran. Recently he has held the post of Honorary Fellow in the Centre for Middle East and Islamic studies at Durham University. He lives in North-umberland with his wife Beth, a distinguished homeopath.

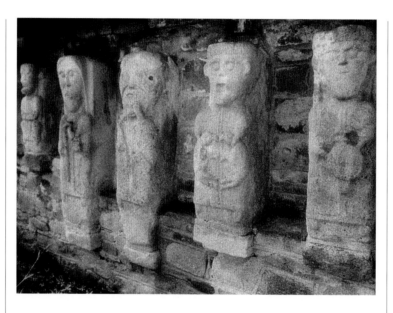

WILLIAM BLAKE

The Irishman James Blake emigrated to England in the eighteenth century and set up a business as a hosier in London. In 1757 he had a son, William Blake, the visionary genius who through his poetry, painting and engraving revealed a fantasy world that heralded the supremacy of the imagination over the rationalism of science and materialism. From his early years he claimed to have visions of angels and ghosts, composing his first mystical poems at the age of twelve.

His principal work, *The Marriage of Heaven and Hell*, was a revolt against the established values of his time. Described by many of his critics as a harmless lunatic who had evolved his own all-encompassing myth, he approved of free love and sided with many of the radicals of his age, dedicating his life to his prophetic works. He died in 1827 and was buried in an unmarked grave at Bunhill Fields in London.

EMILY BRONTË

The extraordinarily powerful gothic novel *Wuthering Heights* by Emily Brontë has become a lexicon of popular culture on a par with Stoker's *Dracula* and Shelley's *Frankenstein*. The three Brontë sisters, Charlotte, Emily and Anne, were the daughters of Patrick Brontë, an Irish clergyman who had emigrated to England in 1802. He married a Cornish woman, and was assigned to the parish of Haworth on the remote, bleak Yorkshire Moors, an untamed landscape of rocky streams and gnarled trees. Here the family found themselves strangers in a strange land, their wild, poetic Celtic roots at odds with the dour and melancholic realism of their Anglo-Saxon neighbours. Cut off from the outside world, their daughters' suppressed fantasies and passions, born of a terrible loneliness, sought an outlet and they turned to writing, inspired by their parent's tales of their Celtic past.

Each produced a masterpiece: Charlotte, *Jane*

Eyre; Anne, *The Tenant of Wildfell Hall*; and Emily, most affected by her desolate surroundings, *Wuthering Heights* – a romantic saga of dream-like intensity, a dark uncensored realm haunted by ghosts and necrophilia. Suffering an early death by consumption in 1848, Emily died, wrote the poet Matthew Arnold, 'baffled, unknown, self-consumed'.

LORD BYRON

Born in 1788, George Gordon, Lord Byron, was the only child of Catherine Gordon, whose husband 'Mad Jack' Byron had gambled their fortune away. The turbulent history of this branch of the wild and unruly Gordon clan is now part of Scottish folklore, and the romantic poet and womaniser was to live up to their decadent reputation. Handsome and witty, with an air of melancholy, he was lame from birth and plagued by a wildly fluctuating weight. On inheriting the title and property of his great uncle, he was educated at Dulwich,

Harrow and Cambridge University, where he ran up great debts and caused controversy with his bisexual adventures.

Success came in 1812 when he published the first two cantos of *Childe Harold's Pilgrimage*. By now adored by London society, he had a tempestuous love affair with the beautiful but unfortunate Lady Caroline Lamb, who famously described him as 'Mad, bad and dangerous to know.' After an unhappy marriage rumours rose of his incest with his half-sister and he left England never to return. He travelled throughout Europe, with his scandalous reputation preceding him. Whilst staying in Venice he proudly proclaimed that he had made love to two hundred different women on consecutive evenings. It was in Italy that he began *Don Juan*, his satiric masterpiece. In Greece he contracted a fever from which he never recovered, and he died there in 1824. Funeral services were held throughout

the land, but only his heart stayed in that country, his body was returned to England to the family vault.

SIR ARTHUR CONAN DOYLE

Sir Arthur Conan Doyle is chiefly remembered as the creator of the world's most famous fictional detective, Sherlock Holmes. However, he also wrote seventeen other novels and numerous short stories, many of them with a supernatural theme. Indeed Holmes's cases often contained suggestions of unearthly horrors, such as the terrifying dog in *The Hound of the Baskervilles*, which feed our appetite for wonder under the guise of science and rationality.

Born in Edinburgh in 1859, the Doyles were a prosperous Irish-Catholic family who had a prominent position in the art world. Arthur's mother had a passion for books and was a master storyteller. His father was a chronic alcoholic who, apart from fathering a brilliant son, was the only member of the

family to fail, ending his days in a lunatic asylum, where he drew and spoke to fairies.

Conan Doyle was also fascinated by the paranormal and in 1917 declared himself a convinced spiritualist, dedicating his remaining years to researching otherworldly phenomena. He died in 1930, discredited as a serious author by his crusade. The paradox is that almost no one takes his spiritualism seriously, whilst nearly everyone wants to believe that Sherlock Holmes was – or is – real.

ROBERT GRAVES

Robert Graves led a life of extremes, living each day as if it were his last; believing that it was the artist's mission to explore the limits of his imagination. His Irish father, Alfred Perceval Graves, was a Gaelic scholar and Robert, who was born in London in 1895, was greatly influenced by his love of Celtic poetry and myth. His mother, Amelia von Ranke Graves, was the daughter of a German professor of Scottish ancestry.

After a turbulent adolescence, Graves attended Oxford University and later fought in the First World War, an experience that greatly traumatised him. During his life he published more than 140 books, including fifty-five collections of poetry, despite a series of dramatic and often painful love affairs. His most remarkable work was *The White Goddess*, a research into the labyrinth of primitive supernatural myth. He concluded that this terrifying and protean deity – the muse of poets whom she inspires and destroys – has her place in every religion, and in demonology. The last decade of his life was lost in silence and senility, and he died in Majorca in 1985 at the age of ninety.

ARTHUR MACHEN

The son of an Anglican priest, Arthur Machen was born in 1863 in the small Welsh village of Caerleon-on-Usk. For this solitary child this borderland between England and Wales became the boundary between our world and another far stranger realm. The rolling hills and ancient woods of his Celtic roots inspired him to write lyrical horror stories portraying the dark pagan terrors that hide behind the mysterious beauty of nature, elementary evil that outlasts time.

Amongst his most famous stories are *The Great God Pan* and the autobiographical novel *The Hill of Dreams*. By turns a journalist and translator during his lifetime, his own work was largely ignored by the critics until after his death in 1947.

CHARLES MATURIN

Born in 1782 of Huguenot descent, the eccentric Irish clergyman Charles Robert Maturin began to write his lurid gothic novels shortly after his ordination into the Protestant faith. The most famous of these was *Melmoth The Wanderer*, a gruesome, but romantic horror story that was to influence the work of Baudelaire and Balzac. Maturin was the great-uncle of Oscar Wilde, who adopted the pseudonym of Sebastian Melmoth, his favourite character, when he was released from prison and fled to Paris, a broken man.

For much of his life Maturin's career fluctuated, but he was always flamboyantly dressed, even in extremes of poverty. His passion was dancing and the ballroom was his temple of inspiration. Notably absent-minded, he would often arrive at parties on the wrong day and was said to have sent the manuscript for Melmoth in several packages, the pages unnumbered and with no connecting words. He died in 1824 at the age of forty-two, a popular, but often shocking figure.

FITZ-JAMES O'BRIEN

Much of the childhood of the visionary Fitz-James O'Brien remains a mystery. Born in County Limerick in 1828, his father died when he was just twelve and he inherited a large sum of money, which he proceeded to squander in Dublin and then London. In January 1852 he emigrated to America and joined the ranks of bohemian artists in New York. Good times alternated with bad; fortune and elegance with poverty and a gypsy lifestyle; but through it all his devil-may-care attitude sustained him.

The author of prose, poetry and drama, O'Brien was a supreme fantasist. Amongst his better known works are *The Diamond Lens* and *The Wondersmith*, an extraordinary tale of wooden dolls who, animated by evil spirits, turn against their creators. But he met with only limited success in his lifetime and admitted to thinking often of suicide. Described as handsome, graceful and athletic, he enlisted on the Union side in the Civil War, but was mortally wounded in a skirmish with Confederate cavalry in 1862.

EDGAR ALLAN POE

The ghost of Edgar Allan Poe – the great romantic who burnt himself out in a blaze of tragic glory – still haunts America. Born Edgar Poe in Boston in 1809 of itinerant actor parents – an English mother and a

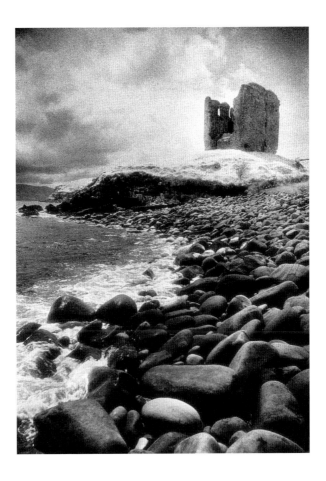

drunken Irish father – he was orphaned by the age of three and adopted by a Mr and Mrs John Allan, who then moved to Britain. He spent his formative schooldays in Scotland and London.

On his return to America his life was to follow an even more traumatic path. Every loving relationship he embarked upon was to end in tragedy, and to retain his sanity he began to write dark gothic tales such as *The Fall of the House of Usher* and *The Tell-Tale Heart*, as well as romantic and haunting poems like 'The Raven' and 'Annabel Lee'. But Poe's literary genius went unrecognised and he increasingly turned to alcohol and drugs to dim the pain. The mysterious events surrounding his death in 1849 mirrored one of his gothic tales – he died as he had lived – a haunted man.

JOSEPH SHERIDAN LE FANU

Joseph Sheridan Le Fanu was born in Dublin in 1814 to a wealthy clergyman. The family then moved to the Limerick countryside, where his childhood was imbued with ancient superstition and folklore. He graduated in law from Trinity College in 1837 and the following year his first written work, *The Ghost and the Bone-setter*, was published. He quickly became established as the leading exponent of the Victorian ghost story. Amongst his better known short stories are *Green Tea*, the

tale of a priest who is pursued by an evil spirit in the form of a monkey which no one else can see; *Carmilla*, the story of a vampire with erotic lesbian undertones; and *The Familiar*. His novels were less successful, except for *Uncle Silas*, one of the most chilling psychological thrillers ever written. The death of his wife in 1858 depressed him greatly and, pouring his pessimism into his horror stories, he became a virtual recluse, earning him the nickname the 'Invisible Prince'. He died in 1873, as elusive as his ghosts.

ROBERT LOUIS STEVENSON

Robert Louis Stevenson was born in Edinburgh in 1850, his parent's only child. Intelligent but sickly, his devoted nurse 'Cummy' is said to have fed his lively imagination with stories from the Bible and Scottish history and these tales, which kept him awake at night, became a source of his own writing. In his youth Stevenson was unable to tolerate his respectable background, instead being bewitched by the back streets of Edinburgh and the 'dregs of humanity' he found there. In 1875 he abandoned his studies at Edinburgh University for France to seek out the company of other young writers and artists.

During his short life he went on to travel the world, defying convention, and he eventually became known as one of the greatest writers of the nineteenth century. The author of such children's classics as *Kidnapped* and *Treasure Island*, he also wrote several ghost stories. *The*

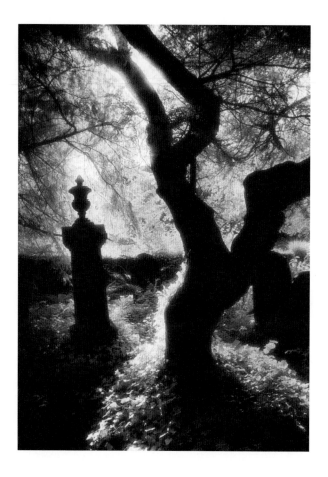

Strange Case of Dr Jekyll and Mr Hyde, his most famous work and a nightmarish tale of degeneration, good and evil, came to him in a dream.

He died on the South Sea Island of Samoa in 1894 – the victim of a brain haemorrhage.

BRAM STOKER

As a child, Bram Stoker is said to have been entranced by his mother's eerie tales of Irish folklore. Born in 1847 in Clontarf, north of Dublin, the creator of the world's most terrifying ghost story, *Dracula*, graduated from Trinity College in 1876, later working as a civil servant, journalist and theatre critic in Dublin and London.

The author of eighteen books – novels, short stories and biographies – some of his other supernatural tales such as *The Burial of the Rats* and *The Judge's House* are truly chilling, but none could equal his unique creation, the vampire *Count Dracula*. He died of syphilis in London in 1912.

LADY JANE FRANCESCA WILDE

Lady Jane Francesca Wilde, *née* Elgee, was born to a Wexford solicitor in 1821. An ardent Nationalist, she wrote poetry and prose under the pen name Speranza, her most famous work being *Ancient Legends, Mystic Charms & Superstitions of Ireland*. She was an obsessive collector of Irish mythology and gothic tales, and married the eccentric Irish antiquary Sir William Wilde, who shared her fascination for Ireland's past.

After his death in 1876 she moved to London in much reduced circumstances, where she is said to have lived in darkness, the curtains continually drawn. She died in 1896, a year after her son Oscar – the brilliant poet and playwright – was imprisoned.

W. B. YEATS

'The mystical life is the centre of all that I do and all that I think and all that I write.' These are the words of the great Irish poet and playwright W. B. Yeats, for whom the real world was the realm of the occult. Along with his fellow writers in the genre, Arthur Machen, Bram Stoker and Algernon Blackwood, he belonged to the Hermetic Order of the Golden Dawn, a secret occult society that actually practised alchemy and magic. Supernatural terror haunts every period of his poetry and in his book, *The Celtic Twilight*, he collected a selection of short stories of demons, fairies and ghosts from Irish folklore.

Born in 1865 in Dublin, his father was a lawyer who later became a pre-Raphaelite painter. A great romantic, Yeats had affairs with many intriguing women. His great love was Maud Gonne, an actress and revolutionary who became a major influence in his life and imagination. But he married Georgie Hyde-Lee in 1917 and they collaborated on his occult book *A Vision*. In the same year he bought Thoor Ballylee, a derelict Tower House in County Galway that became a central symbol in his later poetry. He died in France in 1939.

BIBLIOGRAPHY

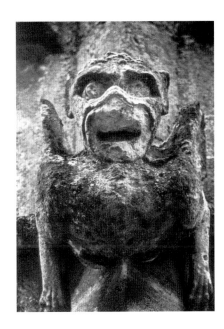

Geoffrey Ashe, *Mythology of the British Isles* (Methuen, London 1990)

Jonathan Aycliffe, *The Matrix* (HarperCollins, London 1994)

Phyllis Bentley, *The Brontës* (Home & Van Thal Ltd, London 1947)

William Blake, *The Marriage of Heaven and Hell* (Oxford Paperbacks, Oxford, 1795)

Emily Brontë, *Wuthering Heights* (Thomas Newby, London 1847)

Lord Byron: the Poetical Works (John Murray, London 1851)

Sir Arthur Conan Doyle, *The Hound of the Baskervilles* (Wordsworth Editions Ltd, London 1999)

Frank Delaney, *The Celts* (Hodder & Stoughton Ltd, London 1986)

Myles Dillon and Nora Chadwick, *The Celtic Realms* (Weidenfeld & Nicolson, London 1967)

Robert Graves, *Complete Poems* (Carcanet Press Ltd, Manchester 1997)

Robert Graves, *The White Goddess* (Faber & Faber Ltd, London 1948)

Shane Leslie, *Shane Leslie's Ghost Book* (Hollis & Carter Ltd, London 1955)

Arthur Machen, *The House of Souls* (Grant Richards, London 1906)

Arthur Machen, *Tales of Horror and the Supernatural* (The Richards Press, London 1949)

Colin Manlove, *Scottish Fantasy Literature* (Canongate Academic, Edinburgh 1994)

Charles Maturin, *Melmoth the Wanderer* (Archibald Constable, London 1820)

John Michell, *The Earth Spirit* (Thames & Hudson Ltd, London 1975)

Nigel Pennick, *The Sacred World of the Celts* (Thorsons, London 1997)

Stuart Piggott, *The Druids* (Thames & Hudson Ltd, London 1968)

Edgar Allan Poe, *The Works of Edgar Allan Poe*, 6 volumes (George Routledge & Sons, London 1896)

T. G. E. Powell, *The Celts* (Thames & Hudson Ltd, London 1958)

John Sharkey, *Celtic Mysteries* (Thames & Hudson Ltd, London 1975)

Joseph Sheridan Le Fanu, *In a Glass Darkly* (Oxford University Press, Oxford 1993)

Peter Somerville-Large, *Irish Eccentrics* (Hamish Hamilton Ltd, London 1975)

Robert Louis Stevenson, *The Strange Case of Dr Jekyll and Mr Hyde* (Longmans Green, London 1886)

Bram Stoker, *Dracula* (Archibald Constable & Company, London 1897)

Charles Thomas, *Celtic Britain* (Thames & Hudson Ltd, London 1986)

Peter Tremayne, *Irish Masters of Fantasy* (Wolfhound Press, Dublin 1979)

Lady Jane Francesca Wilde, *Ancient Legends, Mystic Charms & Superstitions of Ireland* (Ward & Downey, London 1887)

Edited by William Winter, *The Poems and Stories of Fitz-James O'Brien* (Boston 1881)

W. B. Yeats, *The Celtic Twilight* (Colin Smythe Ltd, Buckinghamshire 1981)

W. B. Yeats, *The Collected Poems of William Butler Yeats* (Macmillan, London 1950)

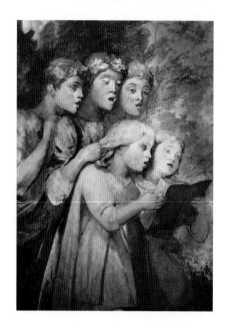

ACKNOWLEDGEMENTS

My thanks to the following for their help in compiling this book
and the film of the same title: Dudley Stewart, Sean Ryan,
Sir John Leslie, Cornelia Bayley, Lachie and Nicky Rattray,
the Earl and Countess of Strathmore, Nick Browne, Deidre Carr,
Gray Levett of Gray's of Westminster, Jason Figgis, Ann P. Murray,
Alan Foley, Dave Burke, Jonathan Figgis, Daniel Figgis,
Paolo Greco, John Hurt, Doug Zwick, Mark Holmes,
Paddy Gibbons, Kitty Lee-Groves, Anne and Peter Figgis.

For the production and design of this book:
Andrew Barron, Nick Ross, Barbara Boote and Catherine Hill.

Finally, to my wife Cassie, for her patience and support.

Kodak Professional

A special thank you to Clare Bruce of Kodak Ltd for
supplying high speed infrared film.

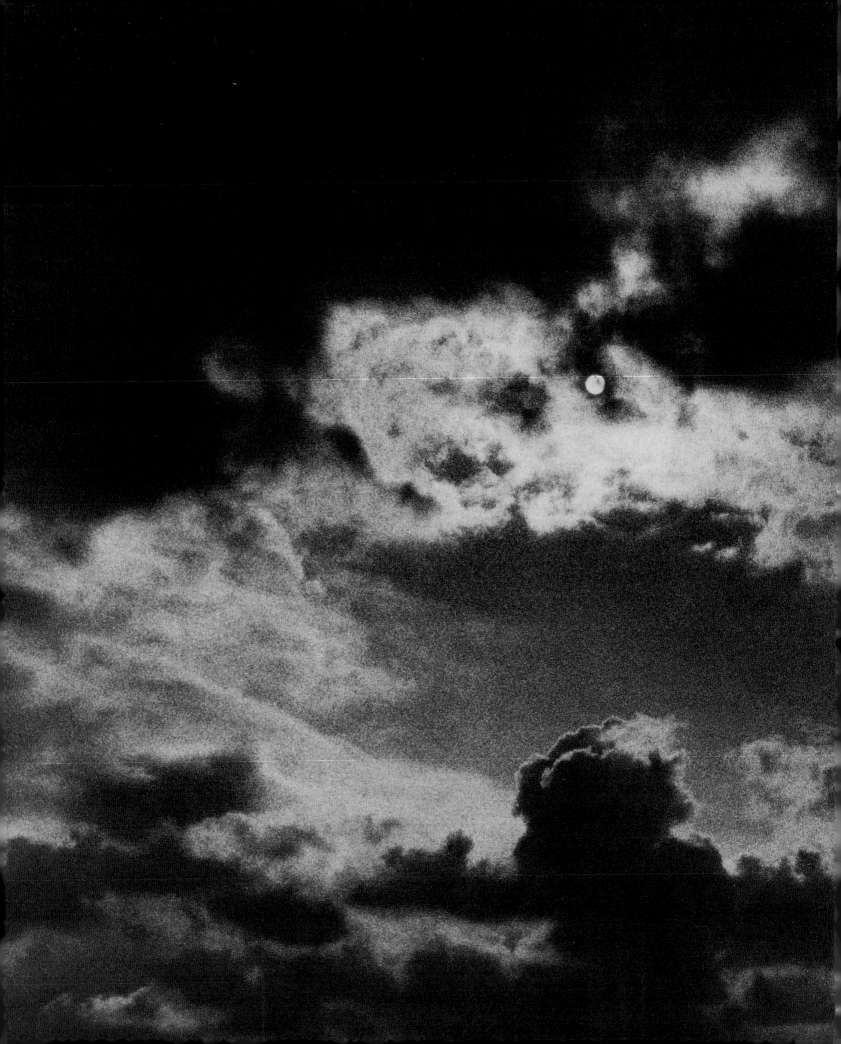

Order Of Battle

OPERATION OVERLORD

Gold & Juno Beaches

6 June 1944
Christopher Chant

Ravelin

SHAEF
Supreme Headquarters Allied Expeditionary Forces

Convinced that the only way to defeat Germany in World War II was to land major forces on the north coast of Europe and then start a major offensive drive toward Germany with steadily strengthening forces, the Allies had long wanted to undertake an assault landing in the north of France. The Allies were also pressured in this direction by the USSR, which wanted to see some of the weight taken off its forces on the Eastern Front by the opening of a 'second front'. The landing was approved as Operation 'Overlord' during the May 1943 'Trident' inter-Allied conference in Washington, D.C., after British and American planners had realized that earlier plans such as the 1942 'Sledgehammer' and 1943 'Round-up' possessed little chance of success against strong and ably led German forces. Resisting Soviet demands for an early 'second front', the Allies had decided to wait until they had established in the UK the right blend and strength of forces that would provide assurance of a decisive stroke.

Detail planning for Overlord was undertaken by Supreme Headquarters Allied Expeditionary Forces (SHAEF) teams under supervision by the Combined Chiefs-of-Staff Committee, an inter-Allied body. In mid-January 1944 General Dwight D. Eisenhower, an American officer, was selected to head SHAEF with a British officer, Air Chief Marshal Sir Arthur Tedder, as his deputy and another American officer, Lieutenant General Walter Bedell Smith, as his chief-of-staff. Two British officers, Admiral Sir Bertram Ramsay and Air Chief Marshal Sir Trafford Leigh-Mallory, were nominated as commanders of the associated naval and air forces. General Sir Bernard Montgomery was given command of the invasion force proper, the Allied 21st Army Group. There had been US pressure for joint command, with Montgomery leading the Anglo-Canadian

forces and Lieutenant General Omar N. Bradley the US forces, but Eisenhower sensibly demanded a single commander for the landing, consolidation and break-out from the lodgement. It was appreciated, however, that the arrival in France of additional troops for the drive through France after the break-out would require the creation of separate Anglo-Canadian and US army groups commanded by Montgomery and Bradley, whereupon Eisenhower would assume direct command in France.

Allied thoughts had at first envisaged a landing in the Pas-de-Calais for its good terrain across a relatively narrow crossing, but it soon became clear that this complied with German expecta-tions. Generalfeldmarschall Gerd von Rundstedt and Generalfeldmarschall Erwin Rommel, the German supreme commander in the West and commander-in-chief of Army Group 'B' respec-tively, had placed in this region Generaloberst Hans von Salmuth's powerful German Fifteenth Army with 14 first-line infantry and five Panzer divisions, together with another three infantry and two Panzer divisions refitting or forming. Allied thoughts thus turned farther to the west, where the beaches of Normandy (between le Havre to the east and Cherbourg to the west) offered adequate sites for the landing against the Generaloberst Friedrich Dollmann's German Seventh Army with 14 first-line divisions (12 infantry and two parachute) and a 13th infantry division forming.

Normandy was also attractive because the crossing from England was the next shortest after that to the Pas-de-Calais, it lay within fighter range of southern England and it was suitable for the tactics in which the Allied formations had been trained.

Above: **An excellent choice to lead the Allied invasion forces, General Dwight D. Eisenhower combined a level of overall military competence with political skills and the ability to select the most effective subordinates.**

Left: **Montgomery with his senior commanders: front row, left to right Keller of Canadian 3rd Div, Bucknall of XXX Corps, Crerar of First Army, Dempsey of Second Army, Broadhurst of No.83 Group, RAF, Ritchie of XII Corps; back row, left to right Thomas of 43rd Div, Graham of 50th Div, O'Connor of VIII Corps, Barker of 49th Div, Crocker of I Corps, Bullen-Smith of 51st Div, McMillan of 15th Div, Roberts of 11th Armoured Div, Gale of 6th Airborne Div and Erskine of 7th Armoured Div.**

Planning for Overlord
Gold and Juno Beaches

The COSSAC plan was the first real plan for the Normandy landings, and was named for the Chief-of-Staff Supreme Allied Commander staff under Lieutenant General Sir Frederick Morgan. Dating from late 1943, this plan was disapproved by Eisenhower and Montgomery. The US commander objected because the plan called for a landing on a narrow front by just three divisions with a mere two more as floating reserve, did not permit a rapid build-up in the beach-head, and made no provision for the capture of Cherbourg on the Cotentin peninsula. Eisenhower was sure that the early seizure of a major port was vital for the arrival of the follow-on forces and the supplies essential for the beach-head to be maintained against the Germans' inevitable counteroffensive.

Montgomery also objected to the COSSAC plan for the narrowness of the landing it envisaged, especially as some 12 divisions were to land on the same beaches by D+12 with 12 more divisions arriving in the following 12 days. Montgomery foresaw total congestion in the beach areas, which would totally disrupt Allied operations and provide ideal targets for German air (and missile) attack. Montgomery did not just criticize the COSSAC plan, but went one step further in suggesting his own ideal concept. This was based on a broad-front landing made only after the destruction of German air capabilities by a major Allied air offensive. In overall terms, therefore, Montgomery demanded that the Anglo-Canadian and US armies should each have their own group of landing beaches, the beaches in each group each being allocated to a single corps for the landing of its assault and follow-up divisions. Montgomery also opined that the beaches should be far enough apart that each corps would have freedom of tactical action in developing its beach-head before the entire army group linked into a cohesive formation and moved rapidly to secure at least two major ports or groups of smaller ports, one for each army.

Eisenhower saw the importance of Montgomery's suggestions, and the COSSAC plan was reworked with the British commander's thinking. The Overlord plan thus added two more beaches, in the form of Sword Beach at Lion-sur-Mer on the left and Utah Beach at les Dunes de Varreville on the right, so that the assault could be effected by five divisions to join the three airborne divisions that would already have landed, against just two of the four divisions in General Erich Marcks' German LXXXIV Corps. The revised plan meant that eight Allied divisions would be attacking three German divisions, whereas the COSSAC plan had envisaged three Allied divisions pitted against two German divisions. Other advantages of the revised plan were the availability of seven follow-up divisions, and the fact that the assault area's westward

The build-up in the southern part of England and Wales required the assembly of the Allied assault divisions in the southern counties of England within easy reach of their south-coast embarkation ports as close as possible to the assault areas in Normandy, while the assembly areas allocated to the assault corps' follow-up divisions were slightly farther north but still within short distance of the selected embarkation ports. The divisions of the follow-up corps were farther inland or, in the case of one British and one Canadian corps, in the south-east corner of England, which was within easy reach of embarkation ports but where their presence would suggest to the Germans the likelihood of an invasion across the Straits of Dover into the Pas-de-Calais.

extension to include Utah Beach on the Cotentin peninsula opened the way for a rapid northern advance through the peninsula to Cherbourg, even if the Germans held the line of the River Vire to prevent other Allied forces from moving west into the Cotentin peninsula.

The revised plan was undoubtedly superior to the COSSAC plan, but it also meant that Overlord had to be delayed from early May to early June 1944, the precise date of the invasion being determined by the need for a full or almost full moon for the nocturnal delivery of the three airborne divisions, coinciding with low water shortly after dawn so that the Allied air forces could provide tactical air support for the airborne forces and deal with any last German gun emplacements before the assault proper began at low water. This last was necessary as the Germans had developed the number and capability of the mines and obstacles on the beaches, and these would be visible only at low water. These factors militated for an invasion between 5 and 7 June 1944, weather permitting, so detailed plans were worked out by Montgomery's 21st Army Group staff, and troops began to move up toward their loading areas.

The Allied assault forces were gathered in Southern England and the south of Wales for their embarkation. On the eastern side of the Allied assault were the three beaches to be attacked by the Anglo-Canadian divisions of the British Second Army's two forward corps. The western two-thirds of this area were the responsibility of the Canadian 3rd Infantry Division of British I Corps (Juno Beach on the left) and British 50th Infantry Division of the British XXX Corps (Gold Beach on the right).

British Second Army

The primary formation assigned for the assault on the Overlord landings' eastern sector was the British Second Army. This was commanded by Lieutenant General Sir Miles Dempsey, a 48-year-old officer who had created his reputation as commander of British XIII Corps in General Sir Bernard Montgomery's British Eighth Army in the conquest of Sicily during July and August of the previous year. Dempsey was thus known as a steady and capable leader who was appreciated by his superiors and also admired by his subordinates. Among his most admirable traits was getting to know his troops: this meant that his battle plans were created to exploit his troops' strengths while taking account of their limitations.

The overall plan for Operation Overlord established the task of the British Second Army as the landing of three infantry divisions, each supported by its own specially trained armoured brigade, on separate Sword, Juno and Gold Beaches as the leading elements of the army's left-hand British I Corps and right-hand British XXX Corps. The objective of the three divisions was to link up with each other and also with US V Corps' US 1st Infantry Division on Omaha Beach, in order to create a consolidated lodgement by the end of D-Day. This lodgement was to extend in width between Cabourg at the mouth of the River Dives in the east and Isigny at the mouth of the River Vire in the west, and to be some six miles deep on average: key objectives for the first day's fighting included the cities of Bayeux and Caen. The lodgement was planned to provide the area for the arrival and deployment of follow-up divisions so that this Allied foothold in France could then be expanded to the south without delay. The flanks of the lodgement area (including Utah Beach for US VII Corps on the eastern side of Cotentin peninsula) were thought to be vulnerable to German counter-attack and

were to be secured by airborne units.

The arrival of these airborne formations was to be the first stage of the Allied operation, so it was only after the British 6th Airborne Division had landed from the air to the south-east of Sword Beach that the three infantry divisions of the seaborne assault forces were to arrive in three echelons. In the assault wave, British I Corps of Lieutenant General J.T. Crocker was to land on Juno Beach with Major General R.F.L. Keller's Canadian 3rd Infantry Division (gathered in Sussex and embarked at Shoreham), supported by the Canadian 2nd Armoured Brigade. British XXX Corps of Lieutenant General G.C. Bucknall was to land on Gold Beach with Major General D.A.H. Graham's British 50th (Northumbrian) Infantry Division (gathered in Hampshire and embarked at Portsmouth), supported by the British 8th Armoured Brigade. Armoured support of a specialized nature was to be provided for these Canadian and British formations by the 'funnies' of Major General Sir Percy Hobart's British 79th Armoured Divison, which was under army group command with two of its brigades divided into regimental units for allocation to subordinate formations. In the follow-up wave Juno Beach would receive British I Corps' other organic element in the form of Major General D.C. Bullen-Smith's British 51st (Highland) Infantry Division (gathered in Essex and embarked at Southend), and Sword Beach was to witness the arrival of British XXX Corps' other organic elements in the forms of Major General G.W.E.J. Erskine's British 7th Armoured Division and Major General E.H. Barker's British 49th (West Riding) Infantry Division, (both of them gathered in northern Essex and Suffolk for embarkation at Felixstowe). The British I and XXX Corps were then to be reinforced by British VIII and XII Corps.

Lieutenant General Sir Miles Dempsey was an ideal choice as commander of the British Second Army as he was an unassuming yet highly capable commander who inspired confidence in his subordinates and superiors alike. He was also a good foil for General Sir Bernard Montgomery, whose plans were turned into clear operational schemes.

BRITISH SECOND ARMY
(Lieutenant General Sir Miles Dempsey)

BRITISH I CORPS
(Lieutenant General J.T. Crocker)

3rd Infantry Division
[landed on 'Sword' Beach]
(Major General G.T. Rennie)

6th Airborne Division
[landed east of 'Sword' Beach]
(Major General R.N. Gale)

51st (Highland) Infantry Division
[landed on 'Sword' Beach]
(Major General D.C. Bullen-Smith)

Canadian 3rd Infantry Division
(Major General R.F.L. Keller)

BRITISH XXX CORPS
(Lieutenant General G.T. Bucknall)

50th (Northumbrian) Infantry Division
(Major General D.A.H. Graham)

49th (West Riding) Infantry Division
[landed on 'Gold' Beach after D-Day]
(Major General E.H. Barker)

7th Armoured Division
[landed on 'Gold' Beach after D-Day]
(Major General G.W.E.J. Erskine)

British XXX Corps

British XXX Corps was led by Lieutenant General G.C. Bucknall, who had commanded the British 5th Infantry Division in the Sicilian campaign of July and August 1943. Bucknall had then been elevated to command British I Corps for the Normandy landing, but was later switched to British XXX Corps. Bucknall had played a major part in the evolution of the tactics for beach-head support of the landed units by craft equipped with guns and rockets, or carrying tanks and self-propelled artillery that could fire while afloat.

The area allocated to British XXX Corps for D-Day was the most westerly of the British Second Army's beaches. The corps was to land its single assault division on Gold Beach, which was the stretch of the Normandy coast extending between Port-en-Bessin in the west and la Rivière in the east. After it had landed, the assault division was to extend flanking units to the east and west (the latter in the form of No.47 [Royal Marine] Commando) to establish physical links with the Canadian and US landings on Juno and Omaha Beaches, which were separated from Gold Beach by just one mile and some 14 miles respectively. The corps was then to ensure that the landed forces pressed inland to reach their first-day objective, which was a line running from southeast to north-west about one mile inland from the main road linking Bayeux, another of its D-Day objectives, with Isigny and Caen.

The first line of German defence to be faced by British XXX Corps' assault units was of course the artillery fire that would be directed at their ships and then their landing craft as they approached the coast; next the landing craft and their loads had to negotiate the obstacles and mined beach defences below the high-water mark; and finally the landed troops and supporting fighting vehicles had to brave the Germans' lighter artillery, mortars and machine guns firing from any strongpoints that survived the pounding they were to receive from Allied bombers and bombarding warships.

The defence in the Juno Beach sector was entrusted to General Erich Marcks' LXXXIV Corps of Generaloberst Friedrich Dollman's Seventh Army within Generalfeldmarschall Erwin Rommel's Army Group 'B' under Generalfeldmarschall Gerd von Rundstedt, the OB West (Supreme Commander in the West). The two units of the German LXXXIV Corps that would be encountered by the men of British XXX Corps were the 915th Grenadier Regiment of Generalleutnant Walter Krauss's German 352nd Infantry Regiment and the 726th Grenadier Regiment of Generalleutnant Wilhelm Richter's German 716th Infantry Regiment. The 352nd Infantry Division had been created in October and November 1943 from elements of the 268th and 321st Infantry Divisions, and was assigned a non-static role mainly on the western side of the Cotentin peninsula. The 716th Infantry Division had been must-

ered in April 1941 from older personnel, and in the following month had been allocated to a static role in the Caen sector. Here the division had remained ever since, taking a major part in preparing the area's defences.

The assault area allocated to British XXX Corps' British 50th (Northumbrian) Infantry Division was Gold Beach, the westernmost of the Anglo-Canadian landing areas. The British 50th Infantry Division was not to land across the full width of Gold Beach, but rather in the narrower sector between Arromanches-les-Bains and la Rivière. In this region there are no offshore rocky outcroppings, and the shore is basically sandy though there are vehicle-trapping patches of soft clay. Behind the foreshore proper are sandy dunes, the narrow coastal road, and then a movement-inhibiting region with large areas of marshy grassland divided by many dykes. The whole of the assault area was well protected: along the coast proper were continuous belts of mines and barbed wire, and while the western half of the assault area was defended by major strongpoints at le Hamel and Asnelles-sur-Mer plus a smaller strongpoint near les Roquettes, the eastern half was similiarly protected by the defences of la Rivière itself and by major strongpoints located at Hable de Heurtot on the coast and at Mont Fleury and Ver-sur-Mer slightly farther inland. The strongpoints were surrounded by minefields and barbed wire entanglements, and contained light and medium artillery, mortars and machine guns in concrete and steel pillboxes all protected by a network of weapon pits.

Lieutenant General G.C. Bucknall led British XXX Corps with capability if not distinction during the Normandy campaign, but was succeeded on 4 August 1944 by Lieutenant General B.G. Horrocks, who had become one of Montgomery's favoured commanders in North Africa.

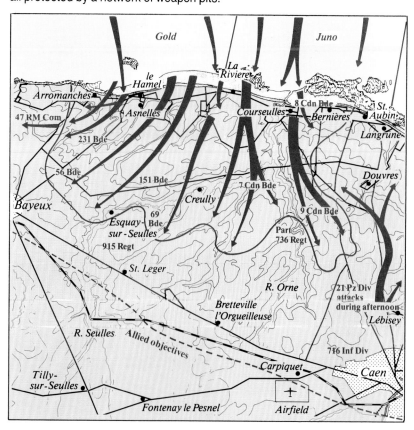

British 50th (Northumbrian) Infantry Division

The formation entrusted with the landing on Gold Beach was the British 50th (Northumbrian) Infantry Division commanded by Major General D.A.H. Graham. While the British 3rd Infantry Division, the most easterly of the British Second Army's triplet of seaborne assault formations, was to land over Sword Beach on a narrow one-brigade front to provide the concentration of force for a rapid advance to the city of Caen that was the day's single most important Anglo-Canadian objective, the British 50th Infantry Division and the Canadian 3rd Infantry Division to the west were each to land on a comparatively broad two-brigade front.

The assault of the British 50th Infantry Division was thus to be made by side-by-side brigades: the 69th Infantry Brigade (with the 151st Infantry Brigade following) on the left over the 'King' assault area and the 231st Infantry Brigade (with the attached 56th Infantry Brigade following) on the left over the 'Jig' assault area.

The British 50th Infantry Division was a formation with some pedigree, for it was already in existence at the beginning of World War II on 3 September 1939 as a first-line Territorial Army division with brigades based on battalions from Yorkshire and County Durham. The formation was constituted as a motorized division for enhanced mobility, but after its return from the debâcle of the French campaign, the division was reorganized as a conventional infantry division in June 1940 and remained as such up to December 1944, when it was reorganized as an infantry (reserve) division until August 1945, when the divisional headquarters ceased to control its units and moved to Norway for a period as the Headquarters British Land Forces Norway.

The British 50th Infantry Division was commanded by Major General G. Le Q. Martel at the war's start, when its two rather than the standard three components were the 150th Infantry Brigade and the 151st Infantry Brigade. It was with these two brigades that the division moved to France from 20 January 1940 as part of the British Expeditionary Force, and more specifically as a component of the BEF's British II Corps from 29 March 1940. The division saw action on the Ypres and Comines canal sector between 26 and 28 May before falling back to Dunkirk, from which it was evacuated to England on 2 June 1940. The division was re-formed in the UK, and was raised to full three-brigade strength on 1 July 1940 by the arrival of the 69th Infantry Brigade. The division remained in the UK to 22 April 1941, command being assumed from 13 December 1940 by Major General W.H.C. Ramsden, and in this period the division came under control successively of the I Corps, War Office, V Corps and GHQ Home Forces.

The division sailed for Egypt on 23 April 1941, arriving under command of the GHQ British Troops in Egypt on 14 June 1941. After little

50th (NORTHUMBRIAN) INFANTRY DIVISION
(Major General D.A.H. Graham)

69th Infantry Brigade
(Brigadier F.Y.C. Knox)

151st Infantry Brigade
(Brigadier R.H. Senior)

231st Infantry Brigade
(Brigadier Sir A.G.B. Stanier, Bart.)

56th Infantry Brigade [under command for the assault phase]
(Brigadier E.C. Pepper)

8th Armoured Brigade [under command for the assault phase]
(Brigadier H.F.S. Cracroft)

Major General D.A.H. Graham led the British 50th (Northumbrian) Infantry Division through the Normandy campaign, and then returned to this formation on 27 November 1944 after an absence from 17 October.

more than one month the division was moved to Cyprus, later moves taking it to Iraq during November 1941 and Syria during January 1942 under the command of HQ British Troops in Iraq and the British Ninth Army respectively. The British 50th Infantry Division returned to Egypt in mid-February 1942 under command of the GHQ Middle East Forces, and was then allocated at various times to the British XIII, XXX and X Corps within the British Eighth Army. As part of this army, the British 50th Infantry Division played a major part in the North African campaign in battles such as Gazala (26 May-21 June 1942), Mersa Matruh (26-30 June 1942), Defence of the El Alamein Line (1-27 July 1942), El Alamein (23 October-4 November 1942), Mareth (16-23 March 1943), Akarit (6-7 April 1943) and Enfidaville (19-29 April 1943). The division remained with the British Eighth Army for the first battle of the Sicilian campaign, the Landings in Sicily (9-12 July 1943).

The British 50th Infantry Division was then pulled out of the line but remained in Sicily until 19 October 1943, when it sailed for the UK as one of the experienced formations allocated to Operation Overlord. The division reached the UK on 6 November 1943 as part of the British XXX Corps until after the Normandy landing. The division was taken under command of the British VIII Corps on 26 September 1944, the British XXX Corps on 1 October 1944, and the Canadian II Corps on 9 November 1944 before becoming part of the British 21st Army Group reserve on 2 December 1944. On 13 December 1944 the division was taken under War Office control for the rest of the war, the Divisional HQ being posted to Norway on 25 August 1945. Apart from the Normandy landing, the division's only other battle in this period was the Nederrijn (17-27 September 1944).

Changes in the British 50th Infantry Division

50th Infantry Division – Divisional Troops

during the period after the fall of France included a number of commanders and a few modifications to the composition of its organic infantry brigades. On 7 July 1942 Major General J.S. Nicols assumed command, and later divisional commanders were Major General S.C. Kirkman from 14 April 1943, Brigadier K.C. Davidson (acting) from 14 September 1943, Kirkman once more from 22 September 1943, Major General D.A.H. Graham from 19 January 1944, Major General L.O. Lyne from 17 October 1944, Brigadier Sir A.G.B. Stanier, Bart. (acting) from 22 November 1944, and Graham once more from 27 November 1944. While the 69th Infantry Brigade and 151st Infantry Brigade remained with the division from their arrival, the 150th Infantry Brigade was removed between 21 June 1941 and 13 August 1941, and then again between 28 November 1941 and 21 February 1942. The 150th Infantry Brigade was captured by the Germans on 1 June 1942, and the division's three-brigade strength was restored only on 27 April 1943 with the advent of the 168th Infantry Brigade, which was replaced from 10 October 1943 by the 231st Infantry Brigade that then remained a major part of the division until 31 July 1945.

At this point it is illuminating to consider the standard organization of the British infantry division at the time of Operation Overlord. The organization was based on an overall personnel strength of 18,347 all ranks, 4,330 vehicles together with 226 trailers, and weapons that included items ranging in size from pistols to self-propelled 40mm AA guns. The division's vehicles included 983 solo motorcycles, 495 miscellaneous cars, 31 Daimler, Humber MkIV, AEC or Staghound armoured cars armed with a 2-pounder, 37mm, 75mm or 37mm gun respectively, 32 Daimler or Humber light reconnaissance cars, 595 Universal (or Bren) Carriers, 52 ambulances, 881 15-cwt trucks, 1,056 3-ton trucks and 205 miscellaneous tractors. The weapons included 1,011 pistols, 11,254 Lee Enfield rifles, 6,525 Sten sub-machine guns, 1,262 Bren light machine guns, 40 Vickers Mk I medium/heavy machine guns, 359 mortars (283 2-in, 60 3-in and 16 4.2-in weapons), 436 PIAT anti-tank weapons, 125 anti-aircraft guns (71 20mm towed, 36 40mm towed and 18 40mm self-propelled equipments), and 182 guns (72 towed 25-pounder gun/howitzers, 32 towed 17-pounder anti-tank guns and 78 towed 6-pounder anti-tank guns).

Control of the division was undertaken from the Divisional HQ, where the commander and his staff enjoyed the support of specialists of several types as well as the Divisional HQ Defence and Employment Platoon and the Divisional Field Security Section. Subordinate to the Divisional HQ were the formation's three organic infantry brigades, the organic divisional troops, and in the case of major operations any attached infantry, armour specialist units. Each infantry

ORGANIC DIVISIONAL TROOPS

HQ 50th Infantry Division

Royal Armoured Corps
two squadrons of the 61st Reconnaissance Regiment

Royal Artillery
90th Field Regiment (Self-Propelled)
357th, 358th and 465th Batteries [other two field regiments of divisional artillery did not land until a later date]
102nd Anti-Tank Regiment
99th and 288th Batteries [107th and 289th Batteries did not land until the afternoon of D+1]
25th Light Anti-Aircraft Regiment
82nd Battery

Royal Engineers
233rd, 295th and 505th Field Companies
235th Field Park Company [formed specialist detachments, manning bulldozers etc.]

Royal Signals
50th Divisional Signals

Infantry
2nd Battalion, The Cheshire Regiment (Machine Gun)

Royal Army Medical Corps
149th, 186th and 200th Field Ambulances
22nd Field Hygiene Section

Military Police Corps
50th Divisional Provost Company

The Cheshire Regiment

brigade was based on a Brigade HQ with its own Infantry Brigade HQ Ground Defence Platoon, three infantry battalions and one non-armoured Light Aid Detachment 'Type A'.

The infantry battalion had an establishment strength of 35 officers and 786 other ranks in one support company and four rifle companies. The support company comprised a mortar platoon with six 3-in mortars, a carrier platoon with 13 Universal (or Bren) Carriers, an anti-tank platoon with six towed 6-pounder guns, and an assault pioneer platoon. The rifle company had five officers and 122 other ranks together, and comprised a company HQ (with three PIAT anti-tank weapons) and three platoons. Each platoon had one officer and 36 other ranks, and comprised a platoon HQ (with one 2-in mortar) and three sections. The section comprised 10 men and one Bren light machine gun, and was the British army's smallest tactical unit.

The capabilities of the three infantry brigades for sustained operations were limited by their lack of specialized equipment and heavy weapons, but this deficiency was remedied by the allocation of such support from the divisional assets known as the organic divisional troops

UNITS UNDER COMMAND FOR THE ASSAULT PHASE

Royal Armoured Corps
Second (Westminster Dragoons) County of London Yeomanry
two troops of the 141st Royal Tank Regiment

Royal Artillery
86th Field Regiment (Self-Propelled)
 341st, 342nd and 462nd Batteries
147th Field Regiment (Self-Propelled)
 413rd, 431st and 511th Batteries
73rd Anti-Tank Regiment
 198th and 234th Batteries
93rd Light Anti-Aircraft Regiment
 320th Battery
HQ 120th Light Anti-Aircraft Regiment
 394th and 395th Batteries
HQ 113rd Heavy Anti-Aircraft Regiment
 152nd Anti-Aircraft Operations Room
 one troop of the 356th Searchlight Battery
 one flight of the 662nd Air Observation Post Regiment [ground staff only, with the aircraft following on D+2]

Royal Engineers
HQ 6th Assault Regiment
 81st and 82nd Assault Squadrons
 73rd and 280th Field Companies

Royal Army Medical Corps
203rd Field Ambulance
168th Light Field Ambulance

Royal Marines
1st Royal Marine Armoured Support Regiment
No.47 Royal Marine Commando

Miscellaneous
GHQ Liaison Regiment

and controlled by Divisional HQ specifically for the support of subordinate units on the basis of any specific 'as and when' requirement.

In descending order of precedence, the elements of the organic divisional troops were provided by the Royal Armoured Corps, Royal Artillery, Corps of Royal Engineers, Royal Corps of Signals, Infantry, Royal Army Service Corps, Royal Army Medical Corps, Royal Army Ordnance Corps, Corps of Royal Electrical and Mechanical Engineers, and Corps of Military Police. The task of the Royal Armoured Corps in this context was rapid reconnaissance of the type vital to the control of operations at divisional level, and the divisional organic troops included an armoured reconnaissance regiment with its own armoured Light Aid Detachment 'Type A'. The Royal Artillery provided artillery fire support as well as divisional protection against armoured and air attack. The RA's primary contribution was effected, through the HQ Division Royal Artillery, by three field regiments equipped with towed 25-pounder gun/howitzers. Each regiment comprised three batteries (each of two troops of four 25-pounder weapons) for a regimental strength

of 24 25-pounder equipments with 172 rounds of ammunition (144 HE, 16 smoke and 12 armour-piercing) for each weapon; each regiment also had its own non-armoured Light Aid Detachment 'Type A'. Other divisional assets were one anti-tank regiment and one AA regiment. The anti-tank regiment had a total of 48 guns in four batteries (each comprising one troop of 6-pounder and two troops of 17-pounder towed guns) and a non-armoured Light Aid Detachment 'Type A'. The AA regiment had 54 guns in three batteries (each comprising three troops of six 40mm self-propelled guns) and a Workshop 'Type A'.

The Royal Engineers provided all types of engineering support: its primary contribution was thus provided through the HQ Division Royal Engineers by one field park company, three field parks and one divisional bridging platoon supported by their own non-armoured Light Aid Detachment 'Type A'. The Royal Signals provided comprehensive communication facilities to higher as well as lower echelons via the Divisional Signals (28 officers and 700 other ranks) supported by its own non-armoured Light Aid Detachment 'Type B'.

The divisional infantry unit was designed to provide the infantry brigades with battlefield fire support heavier than could be generated by their own weapons, and comprised one specialized machine gun battalion (35 officers and 782 other ranks with one heavy mortar company of four platoons each with four 4.2-in mortars, and three machine gun companies each of three platoons with a total of 12 Vickers Mk I medium/heavy machine guns) supported by its own non-armoured Light Aid Detachment 'Type B'.

The Royal Army Service Corps provided transport capacity via the HQ Division RASC, and its main elements were the divisional troops company and three infantry brigade companies. The Royal Army Medical Corps was tasked with the treatment of battle and other casualties, and contributed three field ambulances, two forward dressing stations and one food hygiene section. The Royal Army Ordnance Corps was responsible for all ordnance matters, and provided one infantry division ordnance field park. A host of vital maintenance capabilities was generated by the Royal Electrical and Mechanical Engineers which provided, via the HQ Division REME, three infantry brigade workshops. The Military Police provided one divisional provost company for the traffic control and the maintenance of order. Finally there was the divisional postal unit, ranking low in the divisional pecking order perhaps but of singular importance in the maintenance of the men's morale.

The establishment of organic divisional troops was not always implemented in full or, as was the case in the British 50th Infantry Division and other formations involved in the Normandy landings, was supplemented for improved combat capabilities under specific operational conditions by additional elements from several branches of the army. In this respect the British 50th Infantry Division was typical, for though its organic divi-

sional troops were reduced from establishment strength (though the RA field regiments used self-propelled rather than towed equipments) to improve the division's 'tooth' to 'tail' ratio on D-Day, they were supplemented by units and also by sub-area units, both of them under command for the assault phase.

The former included two units of Major General Sir Percy Hobart's British 79th Armoured Division, the formation controlled at 21st Army Group level and used to provide specialized armour. The 2nd County of London Yeomanry (Westminster Dragoons) of the 30th Armoured Brigade was equipped with flail tanks for the clearance of paths through minefields, and the 141st Regiment, RAC, of the 31st Tank Brigade was equipped with several types of specialized vehicles.

The assault landing capabilities of the British 50th Infantry Division were also improved by the attachment of the 56th Infantry Brigade from the 21st Army Group troops, and of the 8th Armoured Brigade from British XXX Corps troops. The former was a standard infantry brigade with a strength of three battalions. The latter had two rather than the standard three armoured regiments, namely the 4th/7th Royal Dragoon Guards and the Nottinghamshire Yeomanry because its third armoured unit, the 24th Lancers, did not arrive until after D-Day. The armoured brigade had a notional personnel strength of about 3,400 all ranks in three regiments. The fighting vehicle strength was about 190 Sherman medium tanks and 33 Stuart (otherwise 'Honey') light tanks. Like the other independent armoured brigades attached to infantry divisions for Operation Overlord, the 8th Armoured Brigade was trained primarily for close co-operation with its associated infantry division during the assault phase, though it was also capable of operating within the context of the armoured divisions once these had been delivered to play their part in the development and exploitation of the Normandy lodgement, when mobility would become increasingly of paramount importance.

The sub-area units under command of the British 50th Infantry Division for the assault phase of Overlord were concerned with the organization of matters on the beach. Control of incoming and outgoing ships and craft was the responsibility of Royal Navy parties commanded by a beachmaster, but the movement of men, equipment and supplies across and off the congested beaches was an army responsibility. At first the army organization was the 'beach group', a loosely organized unit soon some 4,000 to 5,000 men strong complete with its Royal Navy and Royal Air Force attachments. The 'beach groups' on each assault beach were soon joined into a 'beach sub-area' for each divisional area. Each of these beach groups contained RE, RASC, RAMC and other specialist units as well as one or more infantry battalions.

One of the battalion commanders was also the beach group commander, and his first task was

SUB-AREA UNITS UNDER COMMAND FOR THE ASSAULT PHASE

No.104 Beach Sub-Area HQ and Signal Section
9th and 10th Beach Groups

Royal Engineers
69th, 89th, 90th and 183rd Field Companies
21st and 23rd Stores Sections
51st and 74th Mechanical Equipment Sections
1043rd Port Operating Company
953rd and 961st Inland Water Transport Operating Companies

Infantry
2nd Battalion, The Bedfordshire and Hertfordshire Regiment
6th Battalion, The Border Regiment

Royal Army Service Corps
305th, 536th and 705th General Transport Companies
2nd and 5th Detail Issue Depots
244th Petrol Depot

Royal Army Medical Corps
3rd and 10th Casualty Clearing Stations
3rd, 25th, 31st, 32nd and 35th Field Dressing Stations
Nos 41, 42, 47 and 48 Field Surgical Units
22nd and 23rd Port Detachments

Royal Army Ordnance Corps
7th, 10th and 36th Ordnance Beach Detachments

Royal Electrical and Mechanical Engineers
24th and 25th Beach Recovery Sections
XXX Corps Workshop [including two composite workshops and one Light Recovery Section]

Military Police Corps
240th and 243rd Provost Companies

Pioneer Corps
75th, 173rd, 209th and 280th (Pioneer) Companies

The Bedfordshire & Hertfordshire Regiment

The Border Regiment

the elimination of any German positions bypassed by the assault forces as they pushed inland, for such positions could and did inflict serious losses on the men ensuring the arrival of the equipment and stores required as the front line was pushed further inland. Once the pockets of German resistance had been overwhelmed, the beach group commander used his men to provide working parties for the support of the specialist units unloading stores, vehicles and equipment, clearing beach defences and wreckage, recovering drowned or damaged vehicles, establishing dumps and depots, developing beach exits and lateral roads, establishing medical facilities, and controlling traffic flow on and off the beach.

On Gold Beach, overall control was exercised by the 104th Beach Sub-Area with the 9th Beach Group (based on one battalion of The Hertfordshire Regiment) as its primary beach group and the 10th Beach Group (based on one battalion of The Border Regiment) as its reserve.

69th Infantry Brigade

The 69th Infantry Brigade was already in existence at the start of World War II on 3 September 1939 as a second-line Territorial Army brigade, a duplicate of the British 50th (Northumbrian) Infantry Division's 150th Infantry Brigade. The brigade was administered by the 50th Infantry Division between 11 September and 1 October 1939, and was then allocated to the British 23rd (Northumbrian) Infantry Division, which was the second-line Territorial Army duplicate of the British 50th Infantry Division, and began to function on 2 October 1939. The 69th Infantry Brigade became a full part of the British 50th Infantry Division on 1 July 1940, and remained with this division to 1 August 1945, when it came under command of the East & West Riding District. From December 1944, the brigade was organized as a reserve infantry brigade and played no further active part in World War II.

The 69th Infantry Brigade was commanded from 11 September 1939 by Brigadier Viscount Downe and its three infantry battalions, which remained unchanged throughout World War II, were the 5th Battalion, The East Yorkshire Regiment (Duke of York's Own) and the 6th and 7th Battalions, The Green Howards (Alexandra, Princess of Wales's). The brigade's only other component at this time was the 69th Infantry Brigade Anti-tank Company, reflecting the fear of German tank (or Panzer) division that had been instilled in the British army by the tactically adventurous use made of such formations by the German army in the Polish campaign. It was later appreciated that as the brigades were intended for use only within a divisional framework, superior anti-tank capability could be offered by a divisional anti-tank regiment (with a total of 48 6- and later 17-pounder guns) provided by the Royal Artillery, and the infantry brigade anti-tank company was removed on 1 January 1941. The only other change to the 69th Infantry Brigade's basic constitution was effected in North Africa, with the allocation between 16 May 1943 and 31 December 1943 of the 69th Infantry Brigade Support Company to provide enhanced capability in the type of fighting typical of the later stages of the North Africa campaign, when divisions often fought with their brigades too far separated for effective support from divisional assets. The same rationale was also true of the fighting in Tunisia and Sicily, where it was the difficult nature of the terrain that often made it impossible for brigades to receive support from the division's organic troops.

The East Yorkshire Regiment (Duke of York's Own)

The Green Howards (Alexandra, Princess of Wales)

It was as a component of the British 23rd Infantry Division that the brigade moved to France on 25 April 1940. Serving under the overall command of the British Expeditionary Force, the brigade and its parent formation had little time to acclimatize themselves before the unleashing of the German onslaught against the Low Countries and France on 10 May 1940. The brigade saw action on the St. Omer and la Bassée sector (23-29 May 1940), and shortly after that time the brigade was evacuated to the UK from Dunkirk on 31 May.

Command of the brigade was assumed on 24 June 1940 by Brigadier J.A. Barstow, succeeded in an acting capacity by Lieutenant Colonel C.F.R. Brown from 27 December 1940 and Lieutenant Colonel M.R. Steal from 7 January 1941. A new brigadier arrived just two days later in the form of Brigadier G.W.E.G. Erskine, who took the brigade to Egypt between 30 May and 20 July 1941 as an element of the British 50th Infantry Division. The brigade was then involved in its parent division's movements to Cyprus, Iraq and Syria before it returned to North Africa on 19 February 1942.

The brigade had been commanded in an acting capacity since 6 February 1942 by Lieutenant Colonel F.E.A. McDonnell, but Brigadier L.L. Hassall arrived on 21 February 1942 and was followed on 26 June 1942 by Brigadier E.C. Cooke-Collis. The brigade's battles during this period were those of its parent division, namely Gazala (26 May-21 June 1942), Mersa Matruh (26-30 June 1942), Defence of the Alamein Line (1-27 July 1942), El Alamein (23 October-4 November 1942), Mareth (16-23 March 1943), Akarit (6-7 April 1943) and Enfidaville (19-29 April 1943). With the Germans and Italians defeated in North Africa, the Allies moved across the Mediterranean to invade Sicily. The brigade was involved in the Landing in Sicily (9-12 July 1943), but was then pulled out of line. The brigade returned to the UK with the British 50th Infantry Division, this journey by sea lasting from 18 October to 7 November 1943.

Command was assumed by Brigadier F.Y.C. Knox on 18 January 1944, and it was under Knox's leadership that the brigade embarked for Operation Overlord on 3 June 1944. The brigade remained in north-west Europe until 13 December 1944, and its only other battle in this period was that of the division at the Nederrijn (17-27 September 1944).

It was after the Nederrijn fighting that command was assumed by Brigadier J.M.K. Spurling on 29 October 1944 and then by Brigadier W.R. Cox on 2 December 1944, and it was under this latter commander that the 69th Infantry Brigade returned to the UK on 14 December 1944 for reorganization as a reserve infantry brigade. The unit saw no further action in World War II, and its commanders in this declining stage of its existence were Lieutenant Colonel C.F. Hutchinson (acting) from 8 January 1945, Brigadier Sir A.G.B. Stanier, Bart. from 14 February 1945 and Brigadier E.C. Cooke-Collis from 1 March 1945.

69th INFANTRY BRIGADE
(Brigadier F.Y.C. Knox)

5th Battalion, The East Yorkshire Regiment (Duke of York's Own)
6th Battalion, The Green Howards (Alexandra, Princess of Wales's)
7th Battalion, The Green Howards (Alexandra, Princess of Wales's)

151st Infantry Brigade

The 151st Infantry Brigade was already in existence at the start of World War II on 3 September 1939 as first-line Territorial Army brigade, the partner of the 150th Infantry Brigade in the two-brigade British 50th (Northumbrian) Infantry Division. The brigade remained with this division to 29 October 1942, when it was allocated to the New Zealand 2nd Infantry Division for the period up to 3 November 1942 when it was reallocated to the Australian 9th Infantry Division for just two days before coming under command of British XXX Corps on 6 November 1942 for six days. The brigade rejoined the British 50th Infantry Division on 11 November 1942 and remained with this formation until 1 August 1945, when it came under command of the East & West Riding District. From December 1944, the brigade was organized as a reserve infantry brigade.

On the outbreak of war on 3 September 1939, the 151st Infantry Brigade was commanded by Brigadier J.A. Churchill and its three infantry battalions were the the 6th, 8th and 9th Battalions, The Durham Light Infantry. The first two battalions remained with the brigade throughout the war, but on 4 December 1944 the 9th Battalion, The Durham Light Infantry was replaced by the 1/7th Battalion, The Queen's Royal Regiment (West Surrey). The brigade's only other component in the early part of the war was the 151st Infantry Brigade Anti-tank Company, reflecting the fear of German tank (or Panzer) divisions that had been instilled in the British army by the tactically adventurous use made of such formations by the German army in the Polish campaign. The anti-tank company joined the brigade on 7 December 1939. It was later appreciated that as the brigades were intended for use only within a divisional framework, superior anti-tank capability could be offered by a divisional anti-tank regiment provided by the Royal Artillery, and the infantry brigade anti-tank company was removed on 1 January 1941. The only other change to the 151st Infantry Brigade's basic constitution was effected in North Africa with the allocation between 16 May 1943 and 31 December 1943 of the 151st Infantry Brigade Support Company to provide enhanced capability in the type of fighting typical of the later stages of the North Africa campaign, when divisions often fought with their brigades too far separated for effective support from divisional assets. The same rationale was also true of the fighting in Tunisia and Sicily, where it was the difficult nature of the terrain that often made it impossible for brigades to receive support from the division's organic troops.

It was as a component of the British 50th Infantry Division that the brigade moved to France on 1 February 1940. Serving under the overall command of the British Expeditionary Force, the brigade and its parent formation were soon caught up in the German onslaught against the Low Countries and France launched on 10 May

151st INFANTRY BRIGADE
(Brigadier R.H. Senior)

6th Battalion, The Durham Light Infantry
8th Battalion, The Durham Light Infantry
9th Battalion, The Durham Light Infantry

The Durham Light Infantry

1940. The brigade saw action on the Ypres and Comines canal sector (26-28 May 1940) and was then pulled back to Dunkirk, from where it was evacuated by sea to the UK on 1 June 1940.

Command of the brigade was assumed on 22 February 1941 by Brigadier H. Redman, who took the brigade to Egypt between 22 May and 8 July 1941. The brigade was then involved in its parent division's movements to Cyprus and Iraq (25 July 1941 to 11 February 1942) before it returned to North Africa on 21 February 1942.

The brigade had been commanded in an acting capacity since 11 December 1941 by Lieutenant Colonel C.W. Beart, but Brigadier J.S. Nichols arrived on 25 January 1942 and was followed on 5 July 1942 by Brigadier J.E.S. Percy, though two acting commanders in this period had been Lieutenant Colonel M.K. Jackson (21-26 June 1942) and Lieutenant Colonel M.N. Dewing (26 June-5 July 1942). The brigade's battles during this period were those of its various parent divisions, namely Gazala (26 May-21 June 1942), Mersa Matruh (26-30 June 1942), Alam el Halfa (30 August-7 September 1942) and El Alamein (23 October-4 November 1942). A new commander arrived on 10 November 1942 in the person of Brigadier D.M.W. Beak, succeeded on 25 March 1943 by Brigadier R.H. Senior, and under these two leaders the brigade's battles were Mareth (16-23 March 1943) and Akarit (6-7 April 1943). With the Germans and Italians defeated in North Africa, the Allies moved across the Mediterranean to invade Sicily. The brigade was involved in the Landing in Sicily (9-12 July 1943), but was then pulled out of the line. The brigade returned to the UK with the British 50th Infantry Division, this journey by sea lasting from 17 October to 7 November 1943.

It was under Senior's leadership that the brigade embarked for Operation Overlord on 3 June 1944. Senior was wounded on D-Day and replaced in acting command by Lieutenant Colonel R.P. Lidwill until the arrival of Brigadier B.B. Walton on 10 June 1944. Walton was wounded on 16 June 1944, whereupon Lidwill again assumed temporary command until the arrival of Brigadier D.S. Gordon on 17 June 1944. The brigade remained in north-west Europe until 14 December 1944, and its only other battle in this period was that of the division at the Nederrijn (17-27 September 1944).

Command of the brigade was assumed in December 1944 by Brigadier J.F. Walker, and it was under his command that the 151st Infantry Brigade returned to the UK on 14 December 1944 for reorganization as a reserve infantry brigade. The unit saw no further action in World War II.

231st Infantry Brigade

The unit that became the 231st Infantry Brigade already existed at the start of World War II as a Regular army unit in Malta Command. Commanded by Brigadier L.H. Cox, this Malta Infantry Brigade was responsible for the defence of this British island bastion in the middle of the Mediterranean right athwart Italy's lines of communication with its forces in North Africa. At the beginning of the war on 3 September 1939, the Malta Infantry Brigade comprised the 2nd Battalion, the Devonshire Regiment, the 1st Battalion, The Dorset Regiment, the 2nd Battalion, The Queen's Own Royal West Kent Regiment and the 2nd Battalion, The Royal Irish Fusiliers. On 1 February 1940 the brigade's strength was increased to six battalions by the addition of the 1st and 2nd Battalions, The King's Own Malta Regiment. Further changes in 1940 were the addition of the 8th Battalion, The Manchester Regiment and the 3rd Battalion, The King's Own Malta Regiment on 20 May and 1 July respectively, and the departure of the 2nd Battalion, The Royal Irish Rangers, the 1st and 2nd Battalions, The King's Own Malta Regiment, and the 8th Battalion, The Manchester Regiment on 6 August. This meant that the brigade was back to four-battalion strength when it was renamed as the Southern Infantry Brigade on 7 August 1940.

The year 1941 saw further change with the arrival of the 1st Battalion, The Hampshire Regiment on 21 February, the departure of the 2nd Battalion, The Queen's Own Royal West Kent Regiment on 27 July, the arrival of the 8th Battalion, The King's Own Royal Regiment (Lancaster) and two changes in command, the last in the form of Brigadier The O'Donovan and Brigadier K.P. Smith on 28 September and 24 December respectively.

The year 1942 saw only two changes when the 8th Battalion, The King's Own Royal Regiment (Lancaster) departed on 12 May and the brigade was renamed as the 1st (Malta) Infantry Brigade on 14 July.

The year 1943 saw more changes. On 5 January the brigade regained the 2nd Battalion, The King's Own Malta Regiment but on 29 March, the eve of its departure for Egypt by sea now that the Axis threat to Malta was effectively over, once again lost this battalion together with the same regiment's 3rd Battalion. The brigade was re-designated as the 231st Infantry Brigade on 1 April and reached Egypt two days later under command of the GHQ Middle East Forces. On 26 April the brigade was allocated to British XXX Corps, and on 1 May became the 231st Independent Brigade Group with three Royal Artillery units (165th Field Regiment, 300th Anti-tank battery and 352nd Light Anti-Aircraft Battery), one unit of the Royal Engineers (66th Field Company replaced on 7 August by the 295th Field Company), the Royal Army Medical Corps' 200th Field Ambulance, and the 231st Independent Infantry Brigade Group Support Company.

The Devonshire Regiment

The Hampshire Regiment

The Dorset Regiment

This last was an innovation by the GHQ MEF to provide enhanced capability in the type of fighting typical of the later stages of the North Africa campaign, when divisions often fought with their brigades too far separated for effective rapid support from divisional assets. The same rationale was also true of the fighting in Tunisia and Sicily, where it was the difficult nature of the terrain that often made it impossible for brigades to receive support from the division's organic troops. Command changes in the same year saw the arrival of Brigadier R.E. Urquhart on 19 May, Brigadier A.D. Ward on 19 September, Brigadier G.W.B. Tarleton on 9 October and Brigadier G. Murray on 11 December. The brigade took part in the Landing in Sicily (9-12 July 1943) as part of the British 51st (Highland) Infantry Division and the Adrano fighting (29 July-3 August 1943) as part of the Canadian 1st Infantry Division.

After seven days under command of the British 78th Infantry Division, the brigade was passed to the British 50th (Northumbrian) Infantry Division on 13 August, was in Italy for the period between 8 and 23 September 1943 under command of the British 5th Infantry Division and then British XIII Corps, and on 24 September returned to Sicily as the 231st Infantry Brigade without its support elements but with the 231st Infantry Brigade Support Company, which was finally removed on 31 December 1943. In Sicily the brigade finally became a full component of the British 50th Infantry Division, and was shipped to the UK with this division in the period between 19 October and 6 November 1943.

On 23 February 1944, command was assumed by Brigadier Sir A.G.B. Stanier, Bart., who led the brigade in the Normandy landing. The brigade's only other fighting was in the Nederrijn battle (17-27 September 1944). During the north-west Europe campaign the brigade remained part of the British 50th Infantry Division, but was at times subordinated to other British formations such as the Guards Armoured Division, the 7th Armoured Division and the 53rd Infantry Division. The 2nd Battalion, The Devonshire Regiment departed on 30 November and was replaced from 4 December by the 1/6th Battalion, The Queen's Royal Regiment (West Surrey). The brigade returned to the UK on 14 December 1944, and saw no further operational service in World War II. Command of the brigade was assumed by Brigadier J.D. Russell on 14 February 1945, and the brigade finally left the British 50th Infantry Division only on 1 August 1945, when it was taken under command of the Northumbrian District.

56th Infantry Brigade

By comparison with most of the other British infantry brigades involved in Operation Overlord on 6 June 1944, the 56th Infantry Brigade was extremely young as its headquarters had been formed only on 15 February 1944, less than four months before D-Day. The brigade's first commander was Brigadier E.C. Pepper, who arrived to assume command at the new headquarters only on 27 February. At this time the brigade was subordinate to the GHQ Home Forces, but on 25 February was allocated to the headquarters of the British 21st Army Group as part of the army group organic troops.

The role envisaged for these army group troops was allocation on 'as and when' requirement basis to any of the army group's formations needing additional strength for the complex and difficult tasks facing them in the Normandy landing against German forces thought to contain a high proportion of high-grade troops including many veterans of the fighting in North Africa and Italy as well as on the Eastern Front. It was also foreseen that such army group formations and units would also be required for the subsequent consolidation and expansion of the beach-head into a lodgement capable of accepting the considerably larger forces needed for the breakout into mainland France and the drive into the Low Countries and Germany.

At the time of its formation, the 56th Infantry Brigade lacked the three infantry battalions that would be its essential fighting constituents, but these arrived on 2 March 1944 in the form of the 2nd Battalion, The South Wales Borderers, the 2nd Battalion, The Gloucestershire Regiment and the 2nd Battalion, The Essex Regiment. These three battalions then remained with the 56th Infantry Brigade for the rest of World War II in Europe: thus the only later change was the departure of the 2nd Battalion, The South Wales Borderers on 25 April 1945 for replacement just three days later on 28 April by the 7th Battalion, The Royal Welch Fusiliers, and then the final reversal of this position on 13 June 1945 when the 2nd Battalion, The South Wales Borderers returned to supplant the 7th Battalion, The Royal Welch Fusiliers.

Brigadier Pepper led the 56th Infantry Brigade in the Normandy landing, when the unit was attached to the British 50th (Northumbrian) Infantry Division. The brigade had been allocated to this formation so that the division, making the most western of the Anglo-Canadian landings, would have an infantry strength of four rather than the standard three brigades. This meant that each of its two assault brigades would be followed by a reserve brigade to maintain overall strength and thus impetus right across the division's front in the formation's task of advancing inland, taking Bayeux and linking up in the west with the two most easterly of the four US regimental combat teams landed on Omaha Beach.

The 56th Infantry Brigade was attached to the

The South Wales Borderers

The Gloucestershire Regiment

The Essex Regiment

British 50th Infantry Division with effect from 4 April 1944, and embarked with the rest of this formation on 3 June 1944. The brigade spent an uncomfortable period in the English Channel as this was subsiding from its gale-lashed exuberance of the embarkation period, and then played its part in the British 50th Infantry Division's operations in Normandy until 10 June. The brigade was then reallocated to the British 7th Armoured Division until 12 June, when it was restored to the British 50th Infantry Division until 15 June before a further attachment to the British 7th Armoured Division. This second attachment to the armoured formation lasted to 17 June, when the 56th Infantry Brigade passed to the control of British XXX Corps, which released it to the British 59th Infantry Division on 5 August 1944. This attachment was also short-lived, for on 20 August 1944 the 56th Infantry Brigade finally found a permanent 'home' as it became an organic element of the British 49th Infantry Division, a situation that lasted to the end of World War II. It was with the British 49th Infantry Division that the brigade saw its only other fighting of the European campaign, namely the Scheldt campaign (1 October-8 November 1944).

On 4 July 1944, Pepper had been succeeded in command of the 56th Infantry Brigade by Brigadier M.S. Ekin, who was killed on 4 November 1944 in the course of the fighting in the Scheldt campaign. As an interim measure, command passed to Lieutenant Colonel M. Lewis until 9 November and the arrival of Brigadier W.F.H. Kempster. Command passed as a temporary measure to Lieutenant Colonel T.H. Wilsey between 3 and 9 December, when Kempster arrived back to resume command. On 20 January 1945 Lieutenant Colonel R.H.C. Bray took over in temporary command of the brigade pending the arrival of a new commander, who was Brigadier R.H. Senior. This officer arrived on 23 January 1945 and remained in command to 14 August 1945 with the exception of the brief period between 27 January and 6 February 1945, when Bray was again left in temporary command. Senior's replacement on 14 August 1945 was Brigadier K.G. Exham.

The 56th Infantry Brigade remained in northwest Europe after the end of hostilities with Germany on 8 May 1945 as part of the British occupation forces charged with maintaining order and starting the lengthy process of restoring essential services to areas that had been devastated by years of bombing and the final land campaigns of the war.

56th INFANTRY BRIGADE
(Brigadier E.C. Pepper)

2nd Battalion, The South Wales Borderers
2nd Battalion, The Gloucestershire Regiment
2nd Battalion, The Essex Regiment

8th Armoured Brigade

The 8th Armoured Brigade came into being in Palestine on 1 August 1940 by the redesignation of the 6th Cavalry Brigade, which had existed at the beginning of World War II as a first-line unit of the Territorial Army. Commanded by Brigadier L.S. Lloyd, the 8th Armoured Brigade was a component of the 10th Armoured Division, which had been created from the 1st Cavalry Division on the same date. The brigade's initial strength comprised The Nottinghamshire Yeomanry, The Staffordshire Yeomanry and The Royal Scots Greys (2nd Dragoons). The brigade remained in Palestine to 16 February 1942, and commanders later in this period were Colonel R.C. Cooney (acting) from 2 October 1941 and Brigadier E.C.N. Custance from 21 October 1941.

On 19 February 1942 the brigade arrived in Egypt under command of the GHQ Middle East Forces, but once more came under 10th Armoured Division command on 27 March 1942 for the North African campaign, in which it was bolstered by the arrival on 14 March 1943 of its motorized infantry component in the form of the 1st Battalion, The Buffs (Royal East Kent Regiment). On 30 June 1942 the brigade lost The Greys, who were replaced on 12 July 1942 by the 3rd Battalion, The Royal Tank Regiment. In this form the brigade saw action in the fighting at Alam el Halfa (30 August-7 September 1942) and El Alamein (23 October-4 November 1942). In the last six days of the Battle of El Alamein the brigade was under command of the 1st Armoured Division, but reverted to the 10th Armoured Division between 4 and 21 November 1942.

As the North African fighting moved into its final stages, the 8th Armoured Brigade became a corps unit controlled successively by British X Corps (21-26 November 1942), British XXX Corps (26 November 1942-14 March 1943), New Zealand II Corps (14 March-5 April 1943) and British X Corps (5 April-17 September 1943). The only command change during this period was the arrival of Brigadier C.B.C. Harvey on 24 January 1943, and the only unit change was the replacement of the 1st Battalion, The Buffs on 1 July 1943 by the 7th Battalion, The Rifle Brigade. The brigade's fighting in the later stages of the North African campaign was seen at Medenine (6 March 1943), the Tebaga Gap (21-30 March 1943), Akarit (6-7 April 1943), Enfidaville (19-29 April 1943) and Tunis (5-12 May 1943).

On 18 September 1943 the 8th Armoured Brigade was taken under command of the British Troops in Egypt, and on 4 October 1943 received a new commander in the form of Brigadier O.L. Prior-Palmer, succeeded on 12 November 1943 by Colonel R.C. Joy (acting). A compositional change at this time was the loss of the 7th Battalion, The Rifle Brigade on 3 November 1943. Under Joy's command and War Office control, the brigade was shipped to the UK between 18 November and 11 December 1943, as an

4/7th Royal Dragoon Guards

The Nottinghamshire Yeomary

independent armoured brigade.

The brigade was allocated to British XXX Corps from 12 December 1943 and as such was now earmarked for use in Operation Overlord. The 8th Armoured Brigade trained for this task under the command from 19 January 1944 of Brigadier J.H. Anstice, who was succeeded on 18 March 1944 by Brigadier H.F.S. Cracroft. Changes in the brigade's composition during this period included the departure of two armoured units, namely the 3rd Battalion, The Royal Tank Regiment and The Staffordshire Yeomanry on 6 and 13 February 1944 respectively, and their replacement by the 24th Lancers and 4th/7th Royal Dragoon Guards on 8 and 27 February 1944 respectively. The brigade also regained its motorized infantry battalion on 11 March 1944 with the arrival of the 12th Battalion, The King's Royal Rifle Corps. It was in this form (The Nottinghamshire Yeomanry, 24th Lancers, 4th/7th Royal Dragoon Guards and 12th Battalion, The King's Royal Rifle Corps) that the brigade sailed for Normandy on 5 June 1944, though only two armoured regiments saw action on D-Day.

The 8th Armoured Brigade continued in North-West Europe for the rest of the war, and its further battles in this period were the Odon (25 June-2 July 1944), Mont Pinçon (30 July-9 August 1944), the Nederrijn (17-27 September 1944) and the Rhineland (8 February-10 March 1945). During this time the brigade remained under command of British XXX Corps, except between 13 December 1944 and 1 February 1945, when it was allocated to British XII Corps.

Command changes in the later stages of the war against Germany included Colonel A.D.R. Wingfield (acting) from 3 July 1944, Lieutenant Colonel R.G. Byron (acting) from 18 July 1944 and Brigadier G.E. Prior-Palmer from 29 July 1944. The brigade's only unit change in this time was the replacement of the 24th Lancers by the 13th/18th Royal Hussars (Queen Mary's Own) on 29 July 1944.

At the time of its creation out of the 6th Cavalry Brigade, the 8th Armoured Brigade had been established on Basic Organization No.IV, with 166 tanks but without its motorized infantry battalion. In February 1942 this was revised to Basic Organization No.VI with 164 gun tanks and 12 AA tanks but without the Royal Artillery and Royal Engineers units that were currently unavailable in the Middle East. The brigade was later brought up to No.VII standard with 193 gun tanks and 24 AA tanks and remained as such until February 1945, when it was revised as an Armoured Brigade 'Type A' with 223 gun tanks, eight observation post tanks and 20 AA tanks.

THE BATTLES

69th Infantry & 8th Armoured Brigades

The 69th Infantry Brigade was landed on the 'King' assault area as the left-hand half of the British 50th Infantry Division's two-brigade landing on Gold Beach, and in the first phase of the operation put ashore the 5th East Yorks on the left and the 6th Green Howards on the right. The assault of these two infantry battalions was supported by the Sherman Duplex Drive amphibious tanks of the 4th/7th Dragoon Guards of the 8th Armoured Brigade and the Centaur tanks of one battery of the 1st Royal Marine Armoured Support Regiment. Further weight was added to the landing by the specialized breaching vehicles of two units from the British 79th Armoured Division (the AVREs of one squadron of the 1st Assault Brigade's 6th Engineer Assault Regiment and the flail tanks of one squadron of the 30th Armoured Brigade's Westminster Dragoons). The assault forces were backed by the 7th Green Howards and the self-propelled guns of the 86th Field Regiment, Royal Artillery.

The brigade was ferried to France by Assault Group G2 of Force G, and naval gunfire support was provided by Bombarding Force K as the transports halted and loaded the infantrymen into their assault landing craft while Royal Navy and Royal Engineer underwater obstacle clearance teams cleared the way to the beaches. The two leading battalions landed between la Rivière and a point just to the east of Hable de Heurtot. The main German defences were the strongpoints at la Rivière and Hable de Heurtot on the flanks, and at Mont Fleury in the centre.

The 5th East Yorks landed at 0730 hours near la Rivière, but was initially pinned under the seawall by the fire of the weapons in the German strongpoint. The battalion commander called for support, which was ably provided by destroyers and support craft. A flail tank of the Westminster Dragoons knocked out a German 88mm gun, and the 5th East Yorks could then move into the German strongpoint. Even so, it took several hours to clear the strongpoint and village at the cost of 90 British dead and wounded. Other elements of the battalion had meanwhile captured the strongpoint at the lighthouse near Mont Fleury and then moved on Ver-sur-Mer.

The 6th Green Howards had meanwhile landed farther to the west with the object of taking the German strongpoint at Hable de Heurtot. Ably supported by AVREs, the infantry took four pillboxes and two of the AVREs then crossed the sea wall to rout the rest of the German garrison. The 6th Green Howards now advanced inland toward Mont Fleury, capturing a battery whose guns had not fired after a pounding by bombers and the cruiser *Orion*'s guns.

The 69th Infantry Brigade's third battalion was the 7th Green Howards, and this landed without difficulty from 0820 hours and moved immediately

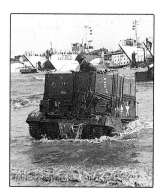

50th Infantry Division Bren carriers land on Gold Beach.

on Ver-sur-Mer just south of Mont Fleury on the River de Provence. The battalion found no resistance in Ver-sur-Mer and pushed forward to a battery just to its south. Crushed by bombing and a two-hour bombardment by the 6-in guns of the cruiser *Belfast*, the Germans surrendered: their four 105mm guns had fired only 87 rounds between them.

The 69th Infantry Brigade's task was now to push inland and cross the River Seulles in the region of St. Gabriel and Creully before securing the road between Caen and Bayeux near Ste. Croix Grand'Tonne. Through the afternoon and early evening the brigade's battalions pushed south with armoured support, but could not reach their objective and halted for the night in an arc extending between Creully and the southern bend of the River Seulles with its southernmost portion between Coulombs and Rucqueville.

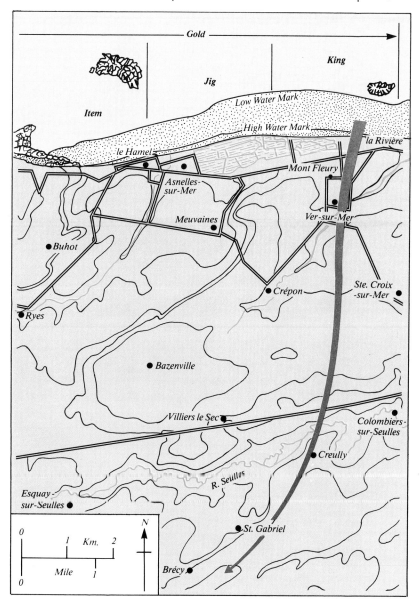

231st Infantry & 8th Armoured Brigades

The 231st Infantry Brigade was landed on the 'Jig' assault area as the right-hand half of the British 50th Infantry Division's two-brigade landing on Gold Beach, and in the first phase of the operation put ashore the 1st Dorsets on the left and the 1st Hampshire on the right. The assault of these two infantry battalions was supported by the Sherman Duplex Drive amphibious tanks of the Nottinghamshire Yeomanry from the 8th Armoured Brigade and the Centaur tanks of one battery from the 1st Royal Marine Armoured Support Regiment, and further support was added by breaching vehicles of two British 79th Armoured Division units (one squadron of the 1st Assault Brigade's 6th Engineer Assault Regiment with AVREs and one squadron of the 30th Armoured Brigade's Westminster Dragoons with flail tanks). The assault forces were backed by the 2nd Devons and the self-propelled guns of the 90th and 147th Field Regiments, Royal Artillery.

The two leading battalions landed between Hable de Heurtot and a point just to the east of le Hamel. The main German defences were the large strongpoints at le Hamel and Asnelles-sur-Mer, and a smaller strongpoint near les Roquettes.

The most important initial task for the 231st Infantry Brigade was the capture of le Hamel just to the west of 'Jig' assault area to open the way for its advance to Arromanches-les-Bains. A company of German infantry manned on le Hamel's west side, a number of fortified houses and entrenched positions inside barbed-wire and minefields, and on its east side a comparable but stronger complex.

The wind and tide carried the 1st Hampshire

Men of the 1st Battalion, The Hampshire Regiment in Arromanches on D-Day.

away from its landing area near le Hamel to a spot near les Roquettes, however, and the infantry landed before its Sherman DD support tanks. The Centaur tanks of the 1st Royal Marine Armoured Support Regiment were also late, and in the event only five of these 10 vehicles were landed, four of them soon being knocked out by German enfilading fire from le Hamel. Even so the infantry landed without undue casualties, overran les Roquettes and then turned west toward le Hamel, soon coming under a withering cross fire.

The 1st Dorsets landed farther east without great difficulty, consolidated in les Roquettes and then moved west via Meuvaines to bypass le Hamel and reach Buhot and Puits d'Herode. The brigade's third battalion, the 2nd Devon, started to land near le Hamel from 0820 hours. The battalion commander detached one of his companies to aid the 1st Hampshires in the fight for le Hamel while the rest of his unit moved round Asnelles to Ryes on the southern side of Arromanches.

Le Hamel fell only later in the day just as Ryes was taken and the German radar station at Arromanches was occupied. The 231st Infantry Brigade moved firmly into this town after a battery of four 105mm guns to its south had been silenced before firing a single shot, and the rest of the town was then seized in fighting that lasted to 2100 hours. La Rosière was taken during the evening, but Tracy-sur-Mer was still infested by German snipers and Brigadier Stanier halted his men for the night in an arc from le Hamel to Puits d'Herode with its western end beyond Arromanches, somewhat short of Longues and its battery, which were the brigade's ultimate objectives.

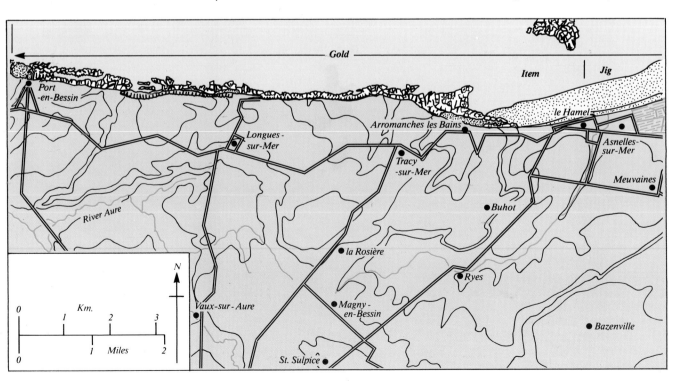

THE BATTLES

151st Infantry & 8th Armoured Brigades

The 151st Infantry Brigade was one of the British 50th Infantry Division's two reserve brigades, and its specific tasks for D-Day were backing the 69th Infantry Brigade and then of exploiting its landing with an advance to the right of the 69th Infantry Brigade. The 151st Infantry Brigade's task for the day was an advance to the south-west alongside the division's other reserve brigade, the 56th Infantry Brigade, with the objective of reaching and seizing, in the area between Bayeux and the River Seulles, the road and rail lines linking Bayeux with Caen. Here it would halt with the 69th and 59th Infantry Brigades on its left and right respectively.

The 151st Infantry Brigade started to land its three battalions (6th, 7th and 8th Durham Light Infantry) from about 1100 hours. Inland from the beach, the brigade deployed into two groups supported by the 90th Field Regiment, Royal Artillery. The right-hand groups set out from Meuvaines with the 9th DLI in the lead, and advanced south-west on a route paralleling the road from Crépon to Bayeux. The left-hand group was spearheaded by the 6th DLI with the support of one squadron of the 4th/7th Dragoon Guards, and moved just west of south from Crépon to Villiers-le-Sec before wheeling farther to the west in the direction of Bayeux.

The 69th and 151st Infantry Brigades were thus moving on slightly divergent axes, and ran into the 915th Grenadier Regiment and other elements of Generalleutnant Walter Krauss's German 352nd Infantry Division. The regiment was stationed in Bayeux and had been on the move since early morning. It was first ordered west to deal with an airborne landing reported between Carentan and the River Vire. When this landing proved illusory, the regiment was ordered back to Bayeux in preparation for a counter-attack to the north-east toward Crépon, to remedy the situation caused by the overwhelming of the battalion around Mont Fleury. Finally one of the regiment's battalions and a number of assault guns were diverted north to tackle the US landing on Omaha Beach. This left one Grenadier battalion, one fusilier battalion and 10 anti-tank guns as a battle group that reached the area between Villers-le-Sec and Bazenville at about 1600 hours. There followed some serious fighting before the Germans, having lost the Grenadier regiment's commander, were forced back across the River Seulles with only some 90 survivors who were combined with the survivors of the 726th Grenadier Regiment to improvise a defensive line between Coulombs and Asnelles-sur-Mer, both of which were already in British hands!

By about 2030 hours, the advance elements of the 151st Infantry Brigade had reached the road between Caen and Bayeux. Reconnaissance by the 4th/7th Dragoon Guards revealed a virtual total absence of opposition for at least 3,000 yards to the south-east in the direction of St. Leger, but the brigade was ordered to halt in a wide and deep arc north and therefore somewhat short of its objective. The 151st Infantry Brigade therefore ended D-Day between Sommervieu and Esquay-sur-Seulles.

This was perhaps sensible, for earlier in the evening the 69th Infantry Brigade had suffered some casualties in crossing the River Seulles at Creully, and then received news at 1830 that some 40 German armoured fighting vehicles were moving north between Rucqueville and Brécy. At about 1930 hours these German vehicles were tackled by the guns of the cruiser *Orion* and fell back after losing three of their number. Though scattered, the German tanks were a possible threat to the flank of any continued advance by the 151st Infantry Brigade.

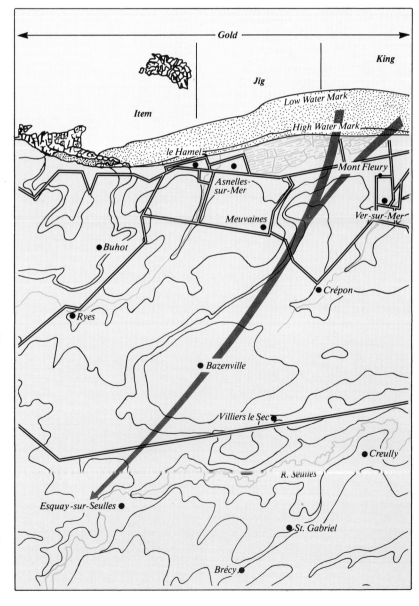

THE BATTLES

56th Infantry & 8th Armoured Brigades

As the 151st Infantry Brigade was landing over the 'King' assault area originally secured by the 69th Infantry Brigade, the 56th Infantry Brigade was similarly coming ashore over the 'Jig' assault area won earlier in the day by the 231st Infantry Brigade. Brought to France from the UK like its brother reserve brigade in the ships of Force G's Assault Group G3, the 56th Infantry Brigade started to land at about 1100 hours, and as quickly as possible made for its inland assembly area after extricating itself from the slowly reducing orderly chaos of the beach area. The three battalions that met at the assembly area were the 2nd South Wales Borderers, 2nd Glosters and 2nd Essex. The process proceeded smoothly, and soon after 1200 hours all four of the British 50th Infantry Division's brigades were ashore in Normandy. This is therefore a convenient point to recapitulate the divisional objectives for D-Day: on the right the 231st Infantry Brigade was moving west to take Arromanches-les-Bains and Longues, on the left the 69th Infantry Brigade was pushing south to seize the road and rail links between Caen and Bayeux near Ste.-Croix-Grand'Tonne, and between these two flank elements the two reserve brigades were now to push south-west with the object of taking the road and rail links between Caen and Bayeux around their crossings of the River Seulles (151st Infantry Brigade), and of capturing Bayeux and reaching the River Drome (56th Infantry Brigade).

The 56th Infantry Brigade moved off in two roughly parallel groups, one on each side of the road connecting Arromanches with Bayeux. The right-hand column was headed by the 2nd South Wales Borderers and passed through la Rosière without incident. As it approached Pouligny, the Germans fired the radar station and made off. The 2nd South Wales Borderers then veered slightly farther to the west, and reached Vaux-sur-Aure shortly before midnight. The area had been bombed and the nearby battery had been shelled by the cruiser *Argonaut*, and the 2nd South Wales Borderers found the area deserted by the Germans. The battalion secured the bridge over the River Aure in expectation of a continued advance on the following day, and then bedded down for the night.

The left-hand column of the 56th Infantry Brigade was headed by the 2nd Essex with the 2nd Glosters following. The 2nd Essex encountered only very light resistance as it pushed slowly forward, and by the early evening had reached St. Sulpice where it halted for the night. The 2nd Glosters stopped for the night at Magny slightly to the north. By the end of D-Day, therefore, the 56th Infantry Brigade was concentrated in the area between Vaux-sur-Aure and St. Sulpice after a virtually unopposed advance of

about three miles. Bayeux beckoned, but the 56th Infantry Brigade was not to be tempted.

Major General Graham had meanwhile arrived in the divisional beach-head and established his headquarters between Meuvaines and Crépon. Lieutenant General Bucknall had also visited the lodgement to witness events for himself, but had then returned to the command ship *Bulolo* as this offered better radio links than any forward HQ. Order was being created out of chaos on the divisional beach, and elements of the British 7th Armoured Division had started to concentrate in the area south of Ryes.

All in all, therefore, the British 50th Infantry Division had achieved much in the course of D-Day, though not as much as had been anticipated. The landings had proceeded well despite the chaos on the beaches, but the development had then followed too slowly and methodically. With hindsight it is possible to see that perhaps too much was asked of the assault divisions on the first day of Operation Overlord, but is it also possible to deduce that tactical commanders failed to exploit in full the opportunities they were offered. In the case of the British 50th Infantry Division, Bayeux and its links with Caen were still in German hands. So too was Arromanches, which was needed for the vast 'Mulberry' artificial harbour that was to be created for the reinforcement and sustenance of the British Second Army up to the time that a major port could be captured and brought into operation.

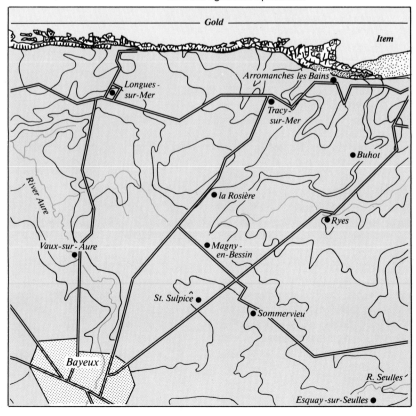

Canadian 3rd Infantry Division

The Canadian army formations that were to be deployed overseas in World War II were created as such during the war. Though these formations and units were planned on the basis of British operational tenets for use of the same tactical methods with basically the same weapons, the Canadians were able to organize their field formations in a fashion more orderly than the British had been able to achieve. Thus the Canadian 3rd Infantry Division that was given one of the most important tasks for Operation Overlord was made up of the 7th, 8th and 9th Infantry Brigades. Following the British practice of allocating a specially trained armoured brigade for the support of each infantry division in the assault phase, the Canadian 3rd Infantry Division was bolstered by the Canadian 2nd Armoured Brigade as well as specialist fighting vehicles of Major General Sir Percy Hobart's British 79th Armoured Division.

The Canadian army had received its baptism of fire against the Germans in 'Jubilee', the raid on Dieppe undertaken on 19 August 1942 by Major General J.H. Roberts' Canadian 2nd Infantry Division with British support. The operation was a failure that taught the Allies much about the problems of launching an invasion against strongly held defences, but offered little in the way of tactical lessons on fighting a sustained land campaign against the Germans. These lessons were learned in the Sicilian and southern Italian campaign of 1943 by Major General G.G. Simonds's Canadian 1st Infantry Division, which was later absorbed with the Canadian 5th Armoured Division into Lieutenant General H.D.G. Crerar's Canadian I Corps. The success of the Canadians in the Italian theatre is attested by the wholesale movement of senior officers from Italy to command many of the Canadian formations and units earmarked for Overlord.

Many Canadians had anticipated Canadian First Army involvement in Overlord. Senior officers were less optimistic, and were therefore not surprised when it was decided that the Canadian

Major General R.F.L. Keller led the Canadian 3rd Infantry Division up to 8 August 1944, when he was evacuated after being wounded by inaccurate bombing on the part of a unit of the US 8th Army Air Force. The bombs hit the Polish 1st Armoured Division and the Canadian 3rd Infantry Division, resulting in some 65 deaths and 250 wounded as well as the loss of four pieces of artillery, 55 vehicles and large quantities of ammunition.

First Army, without a commander between the departure of General Hon. A.G.L. McNaughton and the appointment of Crerar to this post in March 1944, was not to be used until after the landings. There was nonetheless to be Canadian involvement in Overlord as the Canadian 3rd Infantry Division was selected for an assault role within an Anglo-Canadian Second Army.

Commanded by Major General R.F.L. Keller since September 1942, the division was allocated to Overlord in July 1943 and thus did not move to Italy with the rest of Crerar's Canadian I Corps, instead being taken under command, together with the Canadian 2nd Armoured Brigade that was to provide its tank support, by the Canadian First Army. From 1 December 1943 the Canadian assault formation was 'associated' with the British I Corps but came under its command from 30 January 1944. The Canadian 3rd Infantry Division was to make the right-hand of the corps' two assault landings, and would thus be flanked on its left by the British 3rd Infantry Division of the same corps on Sword Beach and by the British 50th Infantry Division of the British XXX Corps on Gold Beach.

At this point it is illuminating to consider the standard organization of the Canadian infantry division at the time of Overlord. The organization was based on that of the British division with its overall personnel strength of 18,347 all ranks, 4,330 vehicles together with 226 trailers, and weapons that included items ranging in size from pistols to self-propelled 40-mm AA guns. The division's vehicles included 983 solo motorcycles, 495 miscellaneous cars, 31 armoured cars, 32 light reconnaissance cars, 595 Universal (or Bren) Carriers, 52 ambulances, 881 15-cwt trucks, 1,056 3-ton trucks and 205 miscellaneous tractors. The weapons included 1,011 pistols, 11,254 Lee Enfield rifles, 6,525 Sten sub-machine guns, 1,262 Bren light machine guns, 40 Vickers Mk I medium/heavy machine guns, 359 mortars (283 2-in, 60 3-in and 16 4.2-in weapons), 436 PIAT anti-tank weapons, 125 anti-aircraft guns (71 towed 20-mm, 36 towed 40-mm and 18 self-propelled 40-mm equipments), and 182 guns (72 towed 25-pounder gun/howitzers, 32 towed 17-pounder anti-tank guns and 78 towed 6-pounder anti-tank guns).

Control of the division was undertaken from the Divisional HQ, where the commander and his staff enjoyed the support of specialists of several types as weel as the Divisional HQ Defence and Employment Platoon and the Divisional Field Security Section. Subordinate to the Divisional HQ were the formation's three organic infantry brigades, the organic divisional troops, and in the case of major operations any attached units. Each infantry brigade was based on a Brigade HQ with its own Infantry Brigade HQ Ground Defence Platoon, three infantry battalions and one non-armoured Light Aid Detachment 'Type A'.

The infantry battalion had an establishment

CANADIAN 3rd INFANTRY DIVISION
(Major General R.F.L. Keller)

7th Infantry Brigade
(Brigadier E.W. Foster)

8th Infantry Brigade
(Brigadier K.G. Blackader)

9th Infantry Brigade
(Brigadier D.G. Cunningham)

2nd Armoured Brigade [under command for the assault phase]
(Brigadier R.A. Wyman)

4th Special Service Brigade [under command for the assault phase]
(Brigadier B.W. Leicester)

3rd Infantry Division – Divisional Troops

strength of 35 officers and 786 other ranks in one support company and four rifle companies. The support company comprised a mortar platoon with six 3-in mortars, a carrier platoon with 13 Universal (or Bren) Carriers, an anti-tank platoon with six towed 6-pounder guns, and an assault pioneer platoon. The rifle company had five officers and 122 officers and 122 other ranks together, and comprised a company HQ (with three PIAT anti-tank weapons) and three platoons. Each platoon had one officer and 36 other ranks, and comprised a platoon HQ (with one 2-in mortar) and three sections. The section comprised 10 men and one Bren machine gun.

The capabilities of the three infantry brigades for sustained operations were limited by these units' lack of specialized equipment and heavy weapons, but this deficiency was remedied by the allocation of such support from the divisional assets known as the organic divisional troops and controlled by Divisional HQ specifically for the support of subordinate units on the basis of an specific 'as and when' requirements.

In descending order of precedence, the elements of the organic divisional troops were provided by the Canadian Armoured Corps, Royal Canadian Artillery, Corps of Royal Canadian Engineers, Royal Canadian Corps of Signals, Canadian Infantry Corps, Royal Canadian Army

ORGANIC DIVISIONAL TROOPS

HQ Canadian 3rd Infantry Division

Royal Canadian Artillery
Canadian 12th Field Regiment (Self-Propelled)
 14th, 16th and 43rd Batteries
Canadian 13th Field Regiment (Self-Propelled)
 22nd, 44th and 78th Batteries
Canadian 14th Field Regiment (Self-Propelled)
 34th, 66th and 81st Batteries
Canadian 4th Light Anti-Aircraft Regiment
 32nd Battery

Royal Canadian Engineers
Canadian 6th, 16th and 18th Field Companies

Royal Canadian Signals
Canadian 50th Divisional Signals

Infantry
The Cameron Highlanders of Ottawa (Machine Gun)

Royal Canadian Army Medical Corps
14th, 22nd and 23rd Field Ambulances

Service Corps, Royal Canadian Army Medical Corps, Royal Canadian Ordance Corps, Royal Canadian Electrical and Mechanical Engineers, and Canadian Provost Corps, replaced in some instance by units from comparable British corps. The task of the Canadian Armoured Corps in this context was rapid reconnaissance of the type vital to the control of operations at divisional level, and the divisional organic troops included an armoured reconnaissance regiment with its own armoured Light Aid Detachment 'Type A'.

The Royal Canadian Artillery provided artillery fire support as well as divisional protection against armoured and air attack. The RCA's primary contribution was effected, through the HQ Division Royal Canadian Artillery, by three field regiments equipped with towed 25-pounder gun/howitzers. Each regiment comprised three batteries (each of two troops of four 25-pounder weapons) for a regimental strength of 24 25-pounder equipments with 172 rounds of ammunition (144 HE, 16 smoke and 12 armour-piercing) for each weapon; each regiment also had its own non-armoured Light Aid Detachment 'Type A'. Other divisional assets were one anti-tank regiment and one AA regiment. The anti-tank regiment had a total of 48 guns in four batteries (each comprising one troop of 6-pounder and two troops of 17-pounder towed guns) and a non-armoured Light Aid Detachment 'Type A'. The AA regiment had 54 guns in three batteries (each comprising three troops of six 40mm self-propelled guns) and a Workshop 'Type A'.

The Corps of Royal Canadian Engineers provided all types of engineering support: its primary

UNITS UNDER COMMAND FOR THE ASSAULT PHASE

Royal Armoured Corps
C Squadron of The Inns of Court Regiment

Royal Canadian Artillery and Royal Artillery
Canadian 19th Field Regiment (Self-Propelled)
 55th, 63rd and 99th Batteries
HQ 62nd Anti-Tank Regiment
 245th and 248th Batteries
Tactical HQ 80th Anti-Aircraft Brigade
HQ 114th Light Anti-Aircraft Regiment
 372nd and 375th Batteries
93rd Light Anti-Aircraft Regiment
 321st Battery [under command of the 114th Light Anti-Aircraft Regiment]
73rd Light Anti-Aircraft Regiment
 218th and 220th Batteries
two troops of the 474th Searchlight Battery
Nos 155 and 160 Anti-Aircraft Operations Rooms
A Flight of No.652 Air Observation Post Squadron [ground staff only]

Royal Canadian Engineers and Royal Engineers
26th and 80th Assault Squadrons
262nd Field Company
Canadian 5th Field Company

Royal Marines
HQ 2nd Royal Marine Armoured Support Regiment
 3rd and 4th Batteries
Detachment 30 of the Assault Unit, Royal Marines

contribution was thus provided through the HQ Division Royal Canadian Engineers by one field park company, three field parks and one divisional bridging platoon supported by their own non-armoured Light Aid Detachment 'Type A'. The Royal Canadian Corps of Signals provided communication facilities to higher as well as lower echelons via the Divisional Signals supported by its own non-armoured Light Aid Detachment 'Type B'.

The divisional infantry unit was designed to provide the infantry brigades with battlefield fire support heavier than could be generated by their own weapons, and comprised one machine gun battalion (35 officers and 782 other ranks with one heavy mortar company of four platoons each with four 4.2-in mortars, and three machine gun companies each of three platoons with a total of 12 Vickers Mk I medium/heavy machine guns) supported by its own non-armoured Light Aid Detachment 'Type B'.

The Royal Canadian Army Service Corps provided transport capacity via the HQ Division RCASC, and its main elements were the divisional troops company and three infantry brigade companies. The Royal Canadian Army Medical Corps was tasked with the treatment of battle and other casualties, and contributed three field ambulances, two forward dressing stations and one food hygiene section. The Royal Canadian Ordnance Corps was responsible for all ordnance matters, and provided one infantry division ordnance field park. A host of vital maintenance capabilities was generated by the Royal Canadian Electrical and Mechanical Engineers provided, via the HQ Division REME, three infantry brigade workshops. The Military Police provided one divisional provost company for the traffic control and the maintenance of order. Finally there was the divisional postal unit, ranking low in the divisional pecking order perhaps but of singular importance in the maintenance of the men's morale.

The establishment of organic divisional troops was not always implemented in full or, as was the case in the Canadian 3rd Infantry Division and other formations involved in the Normandy landings, modified or supplemented for improved combat capabilities under specific operational conditions by the replacement of towed equipment by more capable self-propelled equipments and by the addition of elements from several branches of the army. In this respect the Canadian 3rd Infantry Division was typical, for though its organic divisional troops were in some respects reduced from establishment strength in an effort to improve the division's 'tooth' to 'tail' ratio on D-Day, they were in other respects bolstered by greater numbers, superior equipment and additional units: there were, for instance, four rather than three RCA field regiments and these were equipped with US 'Priest' 105-mm self-propelled equipments rather than British 25-pounder towed guns. This core was also supplemented by units and also by sub-area units under command for the assault phase. The supple-

SUB-AREA UNITS UNDER COMMAND FOR THE ASSAULT PHASE

No.102 Beach Sub-Area HQ and Signal Section
7th and 8th Beach Groups

Royal Engineers
HQ 7th GHQ Troops Engineers
72nd, 85th, 184th and 240th Field Companies
19th and 20th Stores Sections
59th Mechanical Equipment Section
11th Port Operating Group
1034th Port Operating Company
966th Inland Water Transport Operating Company

Infantry
8th Battalion, The King's Regiment (Liverpool)
5th Battalion, The Royal Berkshire Regiment (Princess Charlotte of Wales's)

Royal Army Service Corps
HQ 30th Transport Column
199th and 282nd General Transport Companies
139th and 140th Detail Issue Depots
240th and 242nd Petrol Depot

Royal Army Medical Corps
32nd Casualty Clearing Station
1st, 2nd, 33rd and 34th Field Dressing Stations
Nos 33, 34, 45, 46 and 56 Field Surgical Units
Nos 13, 14 and 36 Field Transfusion Units
3rd and 4th Field Sanitary Sections
21st Port Detachment

Royal Army Ordnance Corps
15th Ordnance Beach Detachment
45th Ordnance Ammunition Company

Royal Electrical and Mechanical Engineers
22nd and 23rd Beach Recovery Sections

Military Police Corps
242nd and 244th Provost Companies

Pioneer Corps
58th, 115th, 144th, 170th, 190th, 225th, 243rd and 293rd (Pioneer) Companies

The King's Regiment (Liverpool)

The Royal Berkshire Regiment (Princess Charlotte of Wales')

mentary units were British as well as Canadian.

The former included elements of three units from the British 79th Armoured Division, the formation controlled at 21st Army Group level and used to provide specialized armour: the 22nd Dragoons of the 30th Armoured Brigade were equipped with flail tanks for the clearance of paths through minefields, and the 5th and 6th Engineer Assault Regiments of the 1st Assault Brigade & Assault Park Squadron, Royal Engineers were equipped with several types of specialized vehicles for a number of beach-head breaching and demolition tasks.

Later divisional commanders were Major Generals D.C. Spry and R.H. Keefler from 18 August 1944 and 23 March 1945 respectively.

7th Infantry Brigade

Commanded by Brigadier H.W. Foster, the 7th Infantry Brigade comprised the standard three infantry battalions, in this instance The Royal Winnipeg rifles, The Regina Rifle Regiment and the 1st Battalion, The Canadian Scottish Regiment. Like its partner brigades in the Canadian 3rd Infantry Division, the 7th Infantry Brigade was unblooded in combat but well trained in its basic role and well equipped as one of the two spearhead brigades of the Canadian assault landing on Juno Beach.

Controlled from the divisional headquarters (from September 1943 located at the Balmer Lawn Hotel at Brockenhurst in the New Forest area of Hampshire but moved during April 1944 to Otterbourne near Winchester in the same county), the 7th Infantry Brigade was put through an exhaustive programme of tactical training from the early summer of 1943, when the 3rd Canadian Infantry Division was retrained in the UK for use in Operation Overlord. This training combined practical and theoretical aspects of the amphibious operation that was to be essayed. The practical aspect was concerned with a host of factors ranging from the basic elements of the typical amphibious landing (embarkation, disembarkation, obstacle climbing, minefield clearance etc.) to more advanced elements of battlefield tactics (co-operation with other brigades within the division, effective use of the divisional troops, optimum deployment of attached armoured units, close air support, etc.). This training was performed in four distinct phases.

The first phase started in the early summer of 1943 in southern England with a combination of practical work (elementary amphibious practices) and a study of combined operations.

The second phase followed during August and September 1943 at the Combined Training Centres at Inverary and Castle Toward in Scotland. Here the brigade (initially in company groups but finally at brigade strength) learned the mechanics of an assault landing in exercises that involved actual landings from landing craft supported by artillery carried in other landing craft and fired on the move, and by smoke-screens laid by aircraft.

The third phase was undertaken in the English Channel from September 1943, and comprised more realistic assault landing training at brigade level with naval support from the Portsmouth-based Force J. This had been the naval force associated with the Dieppe operation of August 1942, and had been kept in existence since that time as a combined operations 'laboratory': the force was then allocated to the Canadian 3rd Infantry Division until after D-Day. A major event in this part of the training programme was Exercise 'Pirate' (16-19 October 1943), for this was relevant not just to the Canadian 3rd Infantry Division but to the whole of the 21st Army Group. The exercise saw the assault landing of the 7th Infantry Brigade in Studland Bay, Dorset, with

The Canadian Scottish Regiment

the rest of the Canadian 3rd Infantry Division (including the other infantry brigades and a combination of the organic divisional and attached troops) simulating the follow-up forces. The problems encountered in this major exercise had many ramifications for Overlord as a whole, resulting in a number of operational changes and the decision to implement as rapidly as possible the change from towed to self-propelled artillery equipments especially in those units assigned to the task of providing fire support from specially adapted landing craft. The Canadian 3rd Infantry Division's three organic and one attached field regiments started to exchange their 25-pounder towed gun/howitzers for 105mm 'Priest' self-propelled equipments during this month.

The fourth phase was undertaken from February 1944 and was involved with full-scale training in assault landings at divisional level. The most important element of this phase was Exercise 'Fabius' (early May 1944): this was divided into three sub-exercises in which Forces G, J and S landed the appropriate assault forces on the southern coast of England in a large-scale rehearsal for D-Day. The Canadian 3rd Infantry Division was landed at Bracklesham Bay in 'Fabius III', and though bad weather forced a termination of the exercise before its completion, many important last-minute lessons were learned, especially in the marshalling, embarkation and sailing of the assault forces.

The Canadian 3rd Infantry Division was to land its brigades in a 'two up and one down' arrangement with the 2nd Armoured Brigade divided into regimental groups for the support of the three infantry brigades. The 7th Infantry Brigade was one of the two leading brigades, and was to land on the left of the Canadian assault beach in the 'Mike' assault area. The brigade's landing was to be effected in the same 'two up and one down' arrangement, with the Regina Rifles on the left and the Winnipeg Rifles on the right followed by the Canadian Scottish. Underwater obstacles were to be cleared by Royal Navy and Royal Canadian Engineer teams, armoured support was to be provided by the Sherman Duplex Drive tanks of the 1st Hussars, the Centaur tanks of one battery of the 2nd Royal Marine Support Regiment, and the AVREs and flail tanks of one squadron of the 6th Engineer Assault Regiment, RE and detachments of the 22nd Dragoons respectively. Artillery support was to be provided by the 12th and 13th Canadian Field Regiments.

Later commanders were Brigadier J.G. Spragge from 26 August 1944 and Brigadier T.G. Gibson from 24 February 1945.

8th Infantry Brigade

Commanded by Brigadier K.G. Blackader, the 8th Infantry Brigade comprised the standard three infantry battalions, in this instance The Queen's Own Rifles of Canada, Le Régiment de la Chaudière and The North Shore (New Brunswick) Regiment. Like the two other brigades it partnered in the Canadian 3rd Infantry Division, the 8th Infantry Brigade was unblooded in combat but well trained in its basic role and well equipped as one of the two spearhead brigades of the Canadian assault landing on Juno Beach.

Controlled from the headquarters of the 3rd Infantry Battalion, which were located at the Balmer Lawn Hotel at Brockenhurst in the New Forest area of Hampshire from September 1943 but moved to Otterbourne near Winchester in the same county during April 1944, the 8th Infantry Brigade was brought up to full operational capability in a nicely conceived programme of tactical training between the early summer of 1943, when the 3rd Canadian Infantry Division was retained in the UK for use in Operation Overlord, and the early summer of 1944 just before the implementation of Overlord. This training combined practical and theoretical aspects of the amphibious operation that was to be launched against the German defences in North-West France. The practical aspect involved a whole series of factors ranging from the basic elements of the typical amphibious landing to more advanced elements of battlefield tactics. This training was undertaken in four separate but linked phases.

Undertaken in the southern part of England from the early summer of 1943, the first phase mixed practical work such as basic amphibious training with a measure of combined operations theory to acclimatize the troops to the concept of an amphibious assault.

The brigade then moved to Scotland and began the second phase of its specialized training during September 1943. Operating initially as companies but gradually evolving to full strength, the brigade learned in greater detail how to make an assault landing on an enemy-held coast. This process involved landings using operational adjuncts such as aircraft-laid smoke-screens and support fire from artillery embarked on landing craft and fired on the move as planned for the Normandy landing.

Moving south to the English Channel late in September 1943, the brigade began on the third phase of its training. This phase emphasized still greater operational reality in landings undertaken at brigade level and featuring naval support from the warships of the Royal Navy's Force J. Based at Portsmouth, this force had been created for the Jubilee operation of August 1942, when the Canadian 2nd Infantry Division and supporting British units had made their disastrously costly raid against the German-held northern French port of Dieppe. Since that time Force J had remained in being for the evaluation of the naval lessons of Jubilee and the creation of the right tactics for the support of the assault landing now planned for Normandy. Once the right type of naval tactics had been developed, Force J was once more allocated to a formation of the Canadian army, in this instance the Canadian 3rd Infantry Division, for D-Day. The most important single event in this part of the programme was Exercise 'Pirate' (16-19 October 1943) as this was relevant to the whole of the 21st Army Group and not just to the Canadian 3rd Infantry Division. In this exercise the 7th Infantry Brigade made a landing in Studland Bay, Dorset, with the rest of the Canadian 3rd Infantry Division (including the 8th Infantry Brigade, organic divisional troops and attached troops) simulating the follow-up forces. The exercise ran into many difficulties, and the solution of these problems was applied to the whole concept of Overlord. One of the most significant modifications was a change from towed to self-propelled artillery especially in units tasked with the provision of fire support from specially adapted landing craft. The Canadian 3rd Infantry Division's three organic and one attached field regiments started to exchange their 25-pounder towed gun/howitzers for 105mm 'Priest' self-propelled equipments during this month.

The fourth phase of the training was started in February 1944 and was concerned with full-scale training for divisional-level assault landings. The most important element of this phase was Exercise 'Fabius' early in May 1944, which provided important lessons in the marshalling, embarkation and sailing of the assault forces.

The Canadian 3rd Infantry Division was to land its brigades in a 'two up and one down' arrangement with the 2nd Armoured Brigade divided into regimental groups for the support of the three infantry brigades. The 8th Infantry Brigade was one of the two leading brigades, and was to land on the left of the Canadian assault beach in the 'Nan' assault area. The brigade's landing was to be effected in the same 'two up and one down' arrangement, with The North Shore Regiment on the left and The Queen's Own Rifles on the right followed by Le Régiment de la Chaudière. Underwater obstacles were to be cleared by Royal Navy and Royal Canadian Engineer teams, armoured support was to be provided by the Sherman Duplex Drive tanks of the Fort Garry Horse, the Centaur tanks of one battery of the 2nd Royal Marine Support Regiment, and the AVREs and flail tanks of one squadron of the 5th Engineer Assault Regiment, RE and detachments of the 22nd Dragoons respectively. Artillery support was to be provided by the 14th and 19th Canadian Field Regiments.

8th INFANTRY BRIGADE
(Brigadier K.G. Blackader)

The Queen's Own Rifles of Canada
Le Régiment de la Chaudière
The North Shore (New Brunswick) Regiment

9th Infantry Brigade

Commanded by Brigadier D.G. Cunningham, the 9th Infantry Brigade comprised the standard three infantry battalions, in this instance Canadian Scottish units in the form of The Highland Light Infantry of Canada, The Stormont, Dundas & Glengarry Highlanders, and The North Nova Scotia Highlanders. Like the two other brigades it partnered in the Canadian 3rd Infantry Division, the 9th Infantry Brigade was unblooded in combat but well trained in its basic role and well equipped as the reserve and follow-up brigade of the Canadian assault landing on Juno Beach.

Under command of the headquarters of the Canadian 3rd Infantry Division, the 9th Infantry Brigade was brought up to full operational capability in a nicely conceived programme of tactical training between the early summer of 1943, when the 3rd Canadian Infantry Division was retained in the UK for use in Operation Overlord, and the early summer of 1944 just before the implementation of Overlord. This training combined practical and theoretical aspects of the amphibious operation that was to be launched against the German defences in North-West France. The practical aspect involved a whole series of factors ranging from the basic elements of the typical amphibious landing (embarkation, disembarkation, obstacle climbing, minefield clearance etc.) to more advanced elements of battlefield tactics (co-operation within the division with other brigades, effective use of the divisional troops, optimum deployment of attached armoured units, close air support, etc.). This training was undertaken in four separate but linked phases.

These four phases were basically identical to those undertaken by the Canadian 3rd Infantry Division's other two organic brigades, namely the 7th and 8th Infantry Brigades. Of these phases, the first was undertaken in the south of England and comprised a combination of theoretical work and elementary training in the nature and practices of amphibious warfare. The second stage was undertaken in Scotland for the development of assault landing skills (using real landing craft and artillery fire support) initially at company level but soon increasing via battalion strength to full brigade level. The third stage saw the brigade's return south to the English Channel for more realistic training in the nature of an assault landing with proper naval support. Like the other two brigades, the 9th Infantry Brigade took part in Exercise 'Pirate', and as a result soon had its 25-pounder towed gun/howitzers replaced by 105mm 'Priest' self-propelled howitzers.

Even after the arrival of these 'Priest' equipments, however, there remained doubt about the overall efficiency of fire support from these embarked equipments. Based on the large fully tracked chassis of the M3 Lee/M4 Sherman medium tank, the US-developed M7 105mm Howitzer Motor Carriage was called 'Priest' by the forces of the British empire and common-wealth because its defensive machine gun was located in a pulpit-like barbette on the front right of the fighting compartment. The 'Priest' offered fire accuracy much superior to that of any lashed-down 25-pounder gun/howitzer, but many officers felt that a moving landing craft was too unstable a basic platform for the accuracy required in assault landing work. The question was resolved in Exercise 'Savvy' (12 February 1944), which was watched by General Sir Bernard Montgomery. The success of this realistic live-firing exercise confirmed the accuracy and thus the utility of artillery fire from moving landing craft.

The fourth and last stage of the brigade's training involved full-scale divisional assault landings, and here the most significant element was Exercise 'Fabius' early in May 1944, which was undertaken in three sub-exercises for the three divisions of the British Second Army. The sub-exercise for the Canadian 3rd Infantry Division was 'Fabius III' which was ended prematurely by bad weather though not until many important lessons had been learned.

The Canadian 3rd Infantry Division was to land its brigades in a 'two up and one down' arrangement with the 2nd Armoured Brigade divided into regimental groups to support the three infantry brigades. The 9th Infantry Brigade was the division's reserve brigade, and with the Sherbrooke Fusiliers Regiment was to follow the 8th Infantry Brigade over the 'Nan' assault area.

The only other commander appointed to the 9th Infantry Brigade's in the course of World War II was Brigadier J.M. Rockingham, who succeeded Brigadier Cunningham on 8 August 1944, nine days after the Canadian 3rd Infantry Division had been pulled out of the line (after 55 days in the face of the enemy) and replaced in the Canadian II Corps by the Canadian 4th Armoured Division. The respite for the division and its three infantry brigades was short-lived, for the formation was brought back into the line on 14 August for Operation 'Tractable', the drive by the Canadian II Corps to take Falaise and so close to the neck of the 'Falaise pocket' and thus prevent the escape of the German 7th Army and Panzergruppe Eberbach. The division remained in North-West Europe for the rest of the war, and saw further action in the crossings of the Rivers Seine and Somme, the reduction of the Boulogne and Calais pockets, the Scheldt operation, the destruction of the Breskens pocket, the advance from the River Maas to the River Rhine, the offensive over the Rhine to the north of the Ruhr, and the final operations in the northern Netherlands and north-western Germany. The division was disbanded on 23 November 1945.

The Highland Light Infantry of Canada

9th INFANTRY BRIGADE
(Brigadier D.G. Cunningham)

The Highland Light Infantry of Canada
The Stormont, Dundas & Glengarry Highlanders
The North Nova Scotia Highlanders

2nd Armoured Brigade

Commanded by Brigadier R.A. Wyman, who had led the Canadian 1st Armoured Brigade with some distinction during the Sicilian and southern Italian fighting, the 2nd Armoured Brigade comprised the standard three tank regiments, in this instance the Canadian 6th Armoured Regiment (1st Hussars), Canadian 10th Armoured Regiment (The Fort Garry Horse) and 27th Armoured Regiment (The Sherbrooke Fusiliers Regiment). The brigade was part of the Canadian 3rd Infantry Division when this latter was 'associated' with the British I Corps on 12 November 1943, and the operational plan for the division called for each of its three infantry brigades to be supported by one of the armoured brigade's three tank regiments.

Though the training of the three armoured regiments emphasized the type of infantry co-operation that would be required in the first phase of the invasion of France, it was appreciated that operations would become more mobile once the Allies had broken out of their Normandy lodgement, and for this reason the regiments of the 2nd Armoured Brigade were also schooled in the tactics required once the brigade had become part of an armoured division.

Like the infantry brigades of the Canadian 3rd Infantry Division it was to support in the Normandy fighting, the 2nd Armoured Brigade was unblooded in combat, but was well trained in its basic role and, was ultimately well equipped for its tasks. Unfortunately, however, the brigade received its Sherman medium tanks very late in the build-up for D-Day and was perhaps not as comfortable with these excellent fighting vehicles as it might have been. The brigade undertook much of its training early in 1944 with the obsolete Infantry Tank Mk III (Valentine) and more modern Cruiser Tank Ram, the latter a Canadian development based on the chassis and hull of the US M3 medim tank with a Canadian turret.

The 2nd Armoured Brigade started to receive its Sherman tanks in January 1944, but it was the end of May before all three regiments had their full establishment of the new tanks. Many of these required modification, but there was inadequate time to complete the conversion programme. The modification of the vehicles required to bear the brunt of the D-Day fighting was completed in all essential details, however, and this fact reflects great credit on the three regiments' fitters and the brigade's complement of Royal Canadian Electrical and Mechanical Engineers.

The Fort Garry Horse

The 1st Hussars and Fort Garry Horse were entrusted with the task of supporting the amphibious assaults of the 7th and 8th Infantry Brigades respectively, so two of the three squadrons in each regiment were equipped with the Sherman Duplex Drive tank. This was a standard Sherman medium tank converted for amphibious capability with a flotation screen and two propellers for waterborne propulsion. Collapsible struts were used to hold the waterproof canvas screen that provided buoyancy even though it prevented the firing of the guns; once ashore, the Sherman DD could be turned into a 'standard' tank by collapsing the struts so that the screen fell to the tank's decking and the turret-mounted 75mm gun could be used. The Sherman DD was considered to be one of the Allies' most important weapons for D-Day, and the 1st Hussars and Fort Garry Horse undertook secret training with the Sherman DD at Great Yarmouth in Norfolk under the supervision of Major General Sir Percy Hobart's British 79th Armoured Division, which was the 'parent' of this and other 'funny' armoured fighting vehicles.

A key element in the training of the 2nd Armoured Brigade was effective use of the Sherman DD. While some of these vehicles were to be landed as conventional tanks by landing craft that beached in Normandy, the majority were to be launched at sea and 'swim' toward the shore. This was a hazardous task because the Sherman DD was a sluggish beast not well suited to operation in choppy water, was vulnerable to loss of buoyancy if its screen was hit and either torn or holed, and was incapable either of defending itself or of undertaking offensive action until its flotation screen had been lowered. But the British plan called for the Sherman DD tanks to be the first part of the Allied armada to reach the beach so that their guns could tackle any German weapons that had survived the earlier aerial and naval bombardments and could now, unless silenced, decimate the infantry landing craft and their loads.

Under command of the headquarters of the Canadian 3rd Infantry Division, the 2nd Armoured Brigade was brought up to full operational capability in a nicely conceived programme of tactical training between the early summer of 1943 and the early summer of 1944, just before the implementation of Overlord. This training combined practical and theoretical aspects of the amphibious operation that was to be launched against the German defences in North-West France. The practical aspect involved a whole series of factors ranging from the basic elements of the typical amphibious landing to more advanced elements of battlefield tactics. This training was undertaken in a programme that paralleled the four phase preparation of the Canadian 3rd Infantry Division, though there had to be differences as a result of the 2nd Armoured Brigade's specific tasks. The Brigade's later commanders, from 9 August and 9 December 1944 respectively were Brigadier J.F. Bingham and Brigadier G.W. Robinson.

2nd ARMOURED BRIGADE
(Brigadier R.A. Wyman)

Canadian 6th Armoured Regiment (1st Hussars)
Canadian 10th Armoured Regiment (The Fort Garry Horse)
Canadian 27th Armoured Regiment (The Sherbrooke Fusiliers Regiment)

4th Special Service Brigade

Created in November 1943, the 4th Special Service Brigade was organized along standard lines for this type of light unit. The unit was commanded from brigade headquarters, which also controlled the brigade signal troop and Light Aid Detachment 'Type A', and comprised four Royal Marine Commandos (Nos 41, 46, 47 and 48). Each of these Commandos had a strength of 24 officers and 440 other ranks, of whom most were in the subordinate fighting units, which were each known as troops rather than companies and organized on the basis of three officers and 60 other ranks.

Whereas the 1st Special Service Brigade attached to the British 3rd Infantry Division was to land on the division's left wing on Sword Beach and undertake the twin tasks of subduing the German guns in Ouistreham and of striking inland to relieve the air-head held by the British 6th Airborne Division east of the Canal de Caen and River Orne waterways, the 4th Special Service Brigade had a more coastal task. The brigade was to land only three of its four Commandos on D-Day with the task of taking coastal defences and linking neighbouring formations.

Of the three Royal Marine Commandos involved on D-Day, No.41 was attached to the British 3rd Infantry Division and No.48 to the Canadian 3rd Infantry Division. These two Commandos had complementary tasks: they were to strike out respectively west and east from their divisions to meet at Luc-sur-Mer on the dividing line between Gold and Juno Beaches. No.47 Royal Marine Commando was to perform a half-brother task on the other flank of the side-by-side landings of the Canadian 3rd and British 50th Infantry Divisions: it was to advance west from Gold Beach to reach and take Arromanches-les-Bains and the battery to its west at Longues, and also to link up with units of the US 1st Infantry Division probing east from Omaha Beach.

4th SPECIAL SERVICE BRIGADE
(Brigadier B.W. Leicester)

No. 41 Royal Marine Commando [under command of the
 3rd Infantry Division]
No. 46 Royal Marine Commando [landed after D-Day]
No. 47 Royal Marine Commando [under command of the British
 50th Infantry Division]
No. 48 Royal Marine Commando [under command of the
 Canadian 3rd Infantry Division]
 one troop of the Royal Marine Engineer Commando
 [under command of the Canadian 3rd Infantry Division]
 three troops of the 5th Independent Armoured Support Battery
 [under command of the 3rd Infantry Division]
Brigade Signal Troop
Light Aid Detachment Type A

THE BATTLES

7th Infantry & 2nd Armoured Brigades

Two miles east of Gold Beach's eastern limit at la Rivière lay the 'Mike' and 'Nan' assault beaches of Juno Beach where the Canadian 3rd Infantry Division was to land. Here the coast itself is low-lying and basically similar to that of Gold Beach, but the inshore approach is made considerably more difficult by a rocky reef with a gap only off Courseulles-sur-Mer and the mouth of the River Seulles. The Germans had thickened their layers of beach defences in this gap, and south of it the coastal houses had been strengthened as defensive strongpoints interlaced by concrete mortar and machine gun positions behind the inevitable belts of barbed wire and mines.

The 7th Infantry Brigade was to land over Mike assault beach astride the mouth of the River Seulles, and its tasks were to take Courseulles and Graye-sur-Mer as its 'Yew' initial objectives, push inland on an axis just west of south toward Reviers, Banville, Colombiers-sur-Seulles and Creully, and then advance to reach a line south of the road and rail lines between Caen and Bayeux between Putot-en-Bessin and Carpiquet.

The landing had been planned for 0735 hours, but was postponed by 10 minutes because the rough weather made the approach difficult. Even

A Sherman DD of the Canadian 2nd Armoured Brigade advancing through Courseulles-sur-Mer on D-Day morning.

then, it was only in one place that the Sherman DD tanks reached the beach before the infantry, according to plan. As the tide was now rising, many of the landing craft were faced with the problem of reaching the beach among rather than in front of the German obstacles, which could not be cleared effectively as many were now under water. As a result, some 90 of Force J's 306 landing craft were lost or damaged as they threaded their way onto or off the beach.

Fortunately for the infantry, the Germans' coastal defences were effectively silenced by gunfire from destroyers and support craft. The Winnipeg Rifles (with C Company of the Canadian Scottish) and Regina Rifles landed west and east of the River Seulles. The Winnipeg Rifles encountered only limited resistance and moved forward Graye, but it was mid-afternoon before the Regina Rifles managed to clear Courseulles with armoured assistance from the Royal Marine Armored Support Regiment and the 6th Engineer Assault Regiment.

Landing on the extreme western flank, C Company of the Canadian Scottish found its initial objective, a small coastal battery, destroyed by naval gunfire and pushed inland toward Vaux

and Ste. Croix-sur-Mer with the rest of its battalion following after it had landed. Meanwhile the exit of the Regina Rifles from Courseulles was being hampered by a host of factors. Even though the Sherman DDs and infantry had the upper hand over the defence, the specialized armour of the available detachments from the 6th Engineer Assault Regiment and the 22nd Dragoons had a hard time of it: their vehicles had to climb dunes 15ft high and cross between 200 and 400 yards of flooded low ground, all festooned with wire and littered with mines, before they could reach the coastal road and prepare the planned beach exits.

The Canadians now pushed forward into undulating farmland that rose slowly to the south. The infantry battalions and their associated armour moved inland with the Winnipeg Rifles on the right, the Canadian Scottish in the centre and the Regina Rifles on the left. The infantry took large numbers of demoralized German prisoners, but in front of larger villages ran into occasional resistance from better led infantry clustered round a machine gun or piece of artillery, which on occasion caused damage and/or casualties. In general the advance proceeded without undue incident, however, but was slower than had been planned. Thus the brigade, whose headquarters had been established at Colombiers-sur-Seulles, reached only a line approximating to its 'Elm' intermediate objectives, about half way to the day's 'Oak' final objectives, before halting for the night on a line extending roughly between Creully and Fontaine Henry with some elements farther south in the areas south-west of Creully, and around Cainet and le Fresne Camilly.

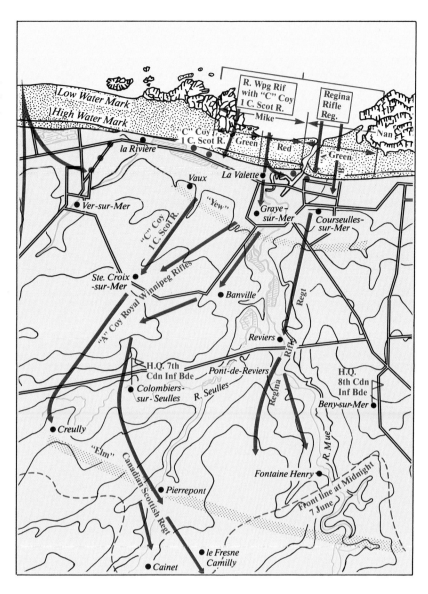

THE BATTLES

8th Infantry & 2nd Armoured Brigades

The 8th Infantry Brigade was scheduled to start landing on the 'Nan' assault beach at 0745 hours, some 10 minutes later than the 7th Infantry Brigade's arrival on the 'Mike' area of Juno Beach. As had happened with the 7th Infantry Brigade, operational conditions and the sea state now resulted in a delay of 10 minutes from the scheduled time, and even then the ordering of the assault forces was thrown into some dis-array so that none of the tanks from the brigade's armoured regiment reached the beach before the infantry.

The 8th Infantry Brigade's assault beach lay to the east of that used by the 7th Infantry Brigade, and stretched from a point just west of Bernières-sur-Mer to the middle of St. Aubin-sur-Mer. The assault was delivered by The North Shore (New Brunswick) Regiment on the left and by The Queen's Own Rifles of Canada on the right. The infantry had already started to land when the first Sherman DD amphibious tanks of The Fort Garry Horse reached the beach. Tank numbers had

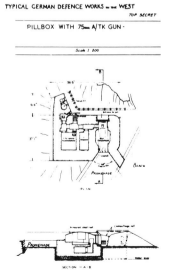

already been depleted by the loss of a landing craft and its four tanks after being hit by artillery fire, and another two tanks were knocked out by German fire as they started to climb the beach. This left 34 tanks and some specialized vehicles to support the two assault battalions.

On the right of the Canadian attack, the Queen's Own Rifles were faced by a sea wall that was 12ft high in places, and then by a row of houses which the Germans had fortified. Several of these houses had been demolished by the naval bombardment, but in the rest the Germans had two 50mm anti-tank guns, two heavy mortars, eight machine guns and infantry in prepared positions. The width of the German defences meant that the Queen's Own Rifles met enfilading fire as they moved forward, and as a result there were many casualties. The attack nonetheless reached the comparative safety of the area under the sea wall, and once this had been scaled the attacking infantry was able to flank the German position and roll up its defenders.

On the left of the Canadian attack a somewhat similar scene unfolded as The North Shore Regiment tackled the comparable defences in St. Aubin. Here the Canadian infantry had the support of some AVREs of the 6th Engineer Assault Regiment, but it took three hours of determined fighting before the back of the German defence was broken, and even then sporadic sniper fire continued to harass the Canadians until nightfall.

As The North Shore Regiment was tackling the defences of St. Aubin, its reserve company landed 20 minutes after the main assault and pushed through the western end of this small town toward Tailleville, about one mile south of the 'Yew' line. This ran approximately parallel to the shore just inland from St. Aubin and Bernières, and marked the limit of the 8th Infantry Brigade's initial objectives.

Beach congestion was now creating havoc with the Canadians' schedule for their development inland from St. Aubin and Bernières. This played into the hands of the Germans, who had time to extemporize blocking positions on the main inland routes. When they started to probe south from the two coastal towns, therefore, the Canadians were frequently checked by pockets of German resistance generally centred on a piece of artillery (often a devastating 88mm gun), or a *Nebelwerfer* multiple rocket launcher or a well-sited machine gun, each with infantry support.

As the two assault regiments were mopping up on the coast the brigade's third battalion, Le Régiment de la Chaudière, had assembled just to the south of Bernières. It was 1200 hours before the battalion started to advance, however, with the support of self-propelled artillery and one squadron of The Fort Garry Horse. The battalion moved south, crossing the area's main lateral road about half a mile west of Tailleville and capturing a battery of artillery in the process, and then skirted a battery of rocket launchers whose 80 rockets were inoperable as bombing had severed the control cables. By 1430 hours, Le Régiment de la Chaudière had taken Bény-sur-Mer, in the process taking 50 prisoners and overrunning a battery of four 105mm guns.

Leaving one company to clear St. Aubin, The North Shore Regiment advanced on Tailleville, which accommodated a battalion headquarters and one company of the German 736th Grenadier Regiment. The Germans held positions connected by tunnels, and had survived the virtual destruction of the village by bombing. This was a difficult target for the Canadians, and it was late afternoon before Tailleville had been cleared.

Le Régiment de la Chaudière was meanwhile pushing forward from Bény with one support of The Fort Garry Horse. The Canadians reached Basly shortly after 1700 hours, and shortly after this took Colomby-sur-Thaon on the 'Elm' line that marked the brigade's intermediate objectives for the day. Meanwhile The Queen's Own Rifles had mopped up in Bernières and, passing inside Le Régiment de la Chaudière's line of advance, moved past its left wing and continued farther to

the south, eventually reaching Anguerny on the 'Elm' line and pushing detachments as far forward as Anisy, where sporadic fighting continued to the middle of the night.

The brigade headquarters had moved up behind the advancing infantry, and were established at Bény. After a difficult start, it had been a fairly good day for this Canadian brigade, even though it had achieved only its intermediate objectives on the 'Elm' line rather than its ultimate objectives on the 'Oak' line, which was the rail line between Caen and Bayeux in the area of Carpiquet. The Germans still held a salient into the line of the Canadian 7th and 8th Infantry Brigades along the valley of the River Mue between Fontaine Henry and Colomby-sur-Thaon, but this presented no real threat. More worrying was the presence on the brigade's left flank of elements from Generalleutnant Edgar Feuchtinger's 21st Panzer Division, but these were pulling back.

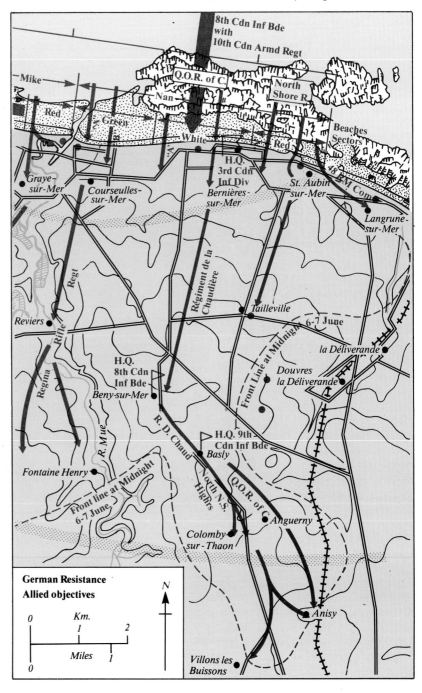

THE BATTLES
9th Infantry & 2nd Armoured Brigades

The Canadian 3rd Infantry Division's reserve element was provided by the 9th Infantry Brigade, which was supported by the Sherman medium tanks of The Sherbrooke Fusiliers Regiment. Comprising three infantry battalions and one armoured regiment, this reserve element was held back until the 7th and 8th Infantry Brigades and their two armoured support regiments had cleared the Germans' first line of coastal defences and started to move inland.

General Keller finally ordered that the reserve should start to land at about 1130 hours, but this process was slowed by the chaos on the beach. The water's edge was littered with sunken or damaged landing craft, and the beach itself was being narrowed by the rising tide. The narrowing of the beach compressed men, vehicles and equipment into an ever reducing area, and though a number of exits had been created they were frequently jammed by vehicles and equipment affected by mechanical problems or hit by German artillery fire. The beach congestion spread inland, and soon the small town of Bernières was also filled with elements of the Canadian division looking for the extra exits that were gradually being created to permit movement inland.

By 1400 hours, the whole of the Canadian 3rd Infantry Division's fighting elements were finally ashore in the form of three brigades of infantry, one brigade of armour and four regiments of self-propelled field artillery. By the time the 7th and 8th Infantry Brigades had advanced some four to five miles inland at 1430 hours, the 9th Infantry Brigade had at last gathered in some semblance of order about half a mile inland of Bernières. The task of the brigade was the capture of Carpiquet on the 'Oak' line that marked the division's final objectives for the day, but this entailed an advance of some 10 miles through Bény-sur-Mer, which was not cleared by the 8th Infantry Brigade until late in that afternoon. This delayed the advance of the 9th Infantry Brigade still further, and it was after 1900 hours before the whole of the reserve brigade had reached Bény.

If the day's objectives were to be obtained, speed was now even more of the essence than hitherto. At about 1830 hours, therefore, Brigadier Cunningham had ordered the North Nova Scotia Highlanders to embark on the tanks of the Sherbrooke Fusiliers and head south as fast as possible. This tank-riding advance offered the only real possibility of achieving a significant advance before nightfall, but was slowed by the presence on its flanks of German anti-tank and mortar positions. The column's tanks and infantry were able to deal with these isolated positions, but the process wasted further valuable time. As the fading light of the evening slowed and finally halted the advance, the column had reached the outskirts of Villons-les-Buissons, which was the

TYPICAL GERMAN DEFENCE WORKS IN THE WEST

SHELTER FOR ONE INFANTRY SECTION

most southerly point reached by the Canadian 3rd Infantry Division during D-Day, but was only about one mile beyond the 'Elm' line that marked the division's intermediate objectives and thus still some four miles short of Carpiquet with the villages of les Buissons, Buron, Authie and Franqueville still to be taken.

The North Nova Scotia Highlanders had the Queen's Own Rifles of the 8th Infantry Brigade slightly to their left and rear at Anisy, but these two Canadian battalions were somewhat exposed in a comparatively deep tactical salient jutting into German-held territory. The nearest troops of the British 3rd Infantry Division with which the Canadian 3rd Infantry Division was supposed to meet were still some three miles to the east to Lébisey, and this gap was held by armoured elements of Generalleutnant Edgar Feuchtinger's 21st Panzer Division. The North Nova Scotia Highlanders were therefore ordered to establish a so-called 'fortress' round the crossroads between Villons and Anisy. The rest of the 9th Infantry Brigade halted for the night near Bény, and the brigade headquarters set up at Basly about half way between the brigade's forward and rear elements.

THE BATTLES 4th Special Service Brigade

The tasks allotted to the 4th Special Service Brigade for D-Day involved the reduction of German coastal positions and the linking of various Allied formations. This involved three of the brigade's four Royal Marine Commandos, which were attached to the one Canadian and two British infantry divisions landed in Operation Overlord. No.41 Royal Marine Commando was allocated to the British 3rd Infantry Division, whose landing on Sword Beach falls outside the scope of this book. The other two were Nos 47 and 48 Royal Marine Commandos, which were attached to the British 50th and Canadian 3rd Infantry Divisions respectively. Brigadier Leicester and his brigade headquarters were attached to the Canadian formation, and were to land over the 'Nan' assault area of Juno Beach after Le Régiment de la Chaudière.

The task allotted to No.47 Royal Marine Commando was the westward extension of the British 50th Infantry Division's flank and the establishment of links in the region of Port-en-Bessin with the left-hand regimental combat team of the US 1st Infantry Division moving east from Omaha Beach. No.47 Royal Marine Commando arrived on the 'Jig' assault area behind the 2nd Devon. The tide, which was unexpectedly high, presented problems and three of the commandos' five landing craft hit mined obstacles and sank. Most of the commandos managed to swim ashore, but 43 men and almost all of the Commando's radio equipment were lost. Under fire from le Hamel, the surviving 300 men assembled behind the beach, acquired a radio from the headquarters of the 231st Infantry Brigade and headed inland before wheeling west toward Port-en-Bessin.

The commandos ran into a small group of determined Germans at la Rosière, and there followed a sharp fight in the early evening before the Royal Marines could resume their advance. Progress across country was not fast, and night had fallen before No.47 Royal Marine Commando reached

Headquarters troops of 4th Special Service Brigade landing at St. Aubin-sur-Mer.

Point 72, a hill about one and a half miles south of Port-en-Bessin. Here the commandos halted and dug in, their intention being to attack Port-en-Bessin on the following morning.

On the other flank of the area of the British 50th and Canadian 3rd Infantry Divisions was No.48 Royal Marine Commando, which was to move east to the area of Langrune-sur-Mer and Luc-sur-Mer, where it was to establish links with the westward progress of No.41 Royal Marine Commando attached to the British 3rd Infantry Division. The Commando approached the 'Nan' assault area of Juno Beach at about 0900 hours, but by this time most of the beach obstacles had been covered by the advancing tide. The Commando was embarked in plywood-built LCI(S) craft, and five of these (three carrying the brigade headquarters and two carrying commandos) were lost. A sixth LCI(S) was hit by German fire as it beached. In this chaotic situation the landed troops and the survivors from the water came under heavy machine gun fire from St. Aubin-sur-Mer, and only a few more than 200 men (about half of the Commando's original strength), reached the sea wall and started to move east on Langrune.

Lying just east of St. Aubin, this small town was another of the spots which the Germans had turned into a fortified location with light artillery, mortar and machine gun positions built into strengthened houses inside a perimeter of barbed-wire entanglements and mines. The commandos made several assaults, but were repeatedly driven back. Support craft operating close inshore and the armoured fighting vehicles of a detachment of the 2nd Marine Armoured Support Regiment added their not inconsiderable capabilities to the fight, but Langrune remained untaken to the end of the day and no link was established with No.41 Royal Marine Commando, which was similarly stalled some two and a half miles to the east at Lion-sur-Mer.

Allied Air Support

Air power and its effective employment were both vital to the success of Overlord. This applied first to the period leading to the start of the operation, and second to the time of the landings proper and then the inland development of the Allied lodgement. The importance of air power to the Allies' overall scheme is attested by the appointment of an airman, Air Chief Marshal Sir Arthur Tedder, as General Dwight D. Eisenhower's deputy.

At Eisenhower's disposal for the approach to D-Day were the European-based strategic air forces commanded by Lieutenant General Carl A. Spaatz. These were Air Chief Marshal Sir Arthur Harris' RAF Bomber Command and Lieutenant General James H. Doolittle's US Eighth Army Air Force in the UK, and Lieutenant General Nathan F. Twining's US Fifteenth Army Air Force in Italy. These were to supplement the tactical efforts of Eisenhower's England-based Allied Expeditionary Air Forces led by the Overlord air commander, Air Chief Marshal Sir Trafford Leigh-Mallory. The AEAF comprised Air Marshal Sir Arthur Coningham's British Second Tactical Air Force and Major General Hoyt S. Vandenburg's US Ninth Army Air Force, each operating medium bombers and fighter bombers.

From January 1944 onwards these air armadas combined for an assault on targets in occupied Europe with emphasis, in order of priority, upon aircraft production, railways, V-1 sites and airfields in January; V-1 sites, airfields and railways in February; railways, aircraft production, V-1 sites, coastal fortifications and airfields in March; railways, airfields, V-1 sites, coastal fortifications and shipping in April; and railways, rolling stock, road bridges, coastal radar installations, V-1

Allied bombers attack the Mézidon railway marshalling yards south of Caen to prevent the reinforcement of the German defenders on the Normandy beaches.

Over 50 airfields in the United Kingdom were used to support the D-Day operations.

sites and coastal fortifications in May.

The object of this campaign was to halt the movement of German reserves, cut German lines of communication, destroy the V-1 sites which the Allies thought would threaten the landings, eliminate German aircraft and air facilities in France and the Low Countries, and destroy the coastal radars and fortifications that might warn of the invasion and then cripple the assault forces at sea.

So successful was this campaign that on D-Day there were only 420 aircraft available to General-feldmarschall Hugo Sperrle's Luftflotte III in northern France with which to combat an Allied air armada of 10,521 warplanes (3,467 four-engined bombers, 1,645 twin-engined bombers and 5,409 single-engined fighters and fighter-bombers), 2,355 transport aircraft and 867 gliders.

This meant that the Allies had total air superiority over Normandy. After the beach defences and other targets had been given a last pounding by the heavy bombers, the primary air burden fell to the tactical air forces. Air cover was provided for the ships in the English Channel, the transport of airborne forces, the landing beaches and the pushes toward Caen and Bayeux. The Second Tactical Air Force flew a multitude of sorties to attack HQs, batteries, strongpoints, road junctions, troops, and vehicles in the Anglo-Canadian sector, using warplanes such as the de Havilland Mosquito, Douglas Boston and North American Mitchell bombers, North American Mustang and Supermarine Spitfire fighter-bombers, and Hawker Typhoon attack fighters. Extra air activity was represented by the sorties of the photo-reconnaissance aircraft. Yet such was the Allies' mastery of the air that over the Anglo-Canadian sector in this 24-hour period only 36 German aircraft were seen.

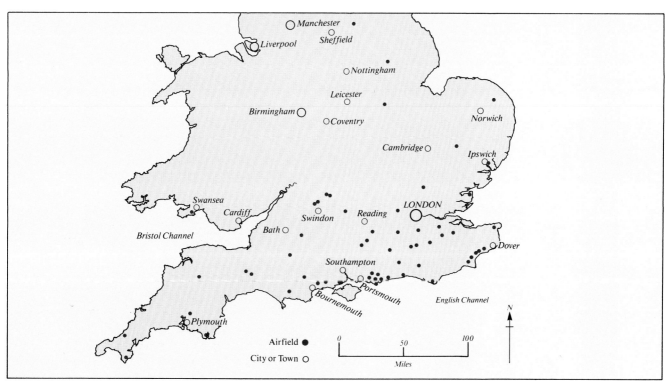

Allied Naval Support

The Allied naval operation for the Normandy landings was 'Neptune', which was planned by the staff of Admiral Sir Bertram Ramsay, the Naval Commander-in-Chief Expeditionary Force. Within the context of the Allied plan to land five infantry divisions (two American in the west and a combination of one Canadian and two British in the east), the plan established two task forces within a total naval strength of 1,213 warships and 4,126 landing ships and craft.

The Eastern Naval Task Force under Rear Admiral Sir Philip Vian, flying his flag in the cruiser *Scylla*, was allocated to the Anglo-Canadian landings. The ENTF's very substantial naval assets included four landing ships HQ, 37 landing ships infantry, three landing ships dock, 408 landing craft assault, 11 landing craft headquarters, 155 landing craft infantry (25 of them American), 130 landing ships tank (37 of them American), 487 landing craft tank, 19 landing craft flak, 16 landing craft gun, 83 landing craft support, 22 landing craft tank (rocket), 100 landing craft personnel (smoke and survey) and 952 ferry craft including 396 landing craft vehicle personnel and 240 landing craft mechanized, for a total of 2,426 landing ships and craft. These were supported by three battleships, one monitor, 13 cruisers (one of them Polish), two gunboats (one of them Dutch), 30 destroyers (two of them Norwegian), 14 escort destroyers (including two Polish, one Norwegian and one French), four sloops, 42 fleet minesweepers, 87 other minesweepers and danlayers, 19 frigates (two of them French), 17 corvettes (two of them Greek), 21 anti-submarine trawlers, two minelayers, 90 coastal craft (30 of them American), one seaplane carrier and, to mark the approach lane, two midget submarines.

In reserve Ramsay held one battleship and 40 minesweepers, while the British home commands contributed 20 destroyers (including four American and two Polish), six escort destroyers, 10 sloops, 32 frigates, 50 corvettes (including three Norwegian and one French), 30 anti-submarine trawlers, two minelayers, 292 coastal craft (including 13 Dutch, eight French and three Norwegian) and 58 anti-submarine vessels. The ENTF's arrangement included three Bombarding Forces and three Assault Forces, one of each type being allocated to each of the assault beaches.

For the support of the British 50th Infantry Division's landing on Gold Beach there were Bombarding Force K and Assault Force G commanded respectively by Captain E.W.L. Longley-Cook and Commodore C.E. Douglas-Pennant in the cruiser *Argonaut* and command ship *Bulolo* respectively. Bombarding Force K comprised four light cruisers, 13 destroyers (including one Polish) and one Dutch gunboat. Assault Force G was divided into Assault Groups G1, G2 and G3 carrying the 231st, 69th, and 56th and 151st Infantry Brigades respectively.

As the ships of Assault Force G approached the Normandy coast, the warships of Bombard-

Rear Admiral F. H. G. Dalrymple-Hamilton on the bridge of HMS *Belfast* during 6 June.

Allied warships tasked with the naval bombardment of the German targets in Gold and Juno sectors of the Normandy landings.

ing Force K moved ahead of them and followed a van force of minesweepers toward their allotted anchorage off the mouth of the River la Gronde. There the four cruisers opened fire at 0530 hours: from west to east, the *Ajax*, *Argonaut*, *Emerald* and *Orion* engaged the Longues, Vaux-sur-Aure, more westerly Arromanches-les-Bains and Mont Fleury batteries. The gunboat *Flores* was operating with Force E's two cruisers and engaged the more easterly of the two batteries located at Arromanches. Lighter vessels prepared to tackle multiple beach-head targets.

For the support of the Canadian 3rd Infantry Division's landing on Juno Beach there were Bombarding Force E and Assault Force J commanded respectively by Rear Admiral F.H.G. Dalrymple-Hamilton and Commodore G.N. Oliver in the cruiser *Belfast* and command ship *Hilary* respectively. Bombarding Force E comprised two light cruisers and 11 destroyers (including two Canadian, one French and one Norwegian). Assault Force J was divided into Assault Groups J1, J2, J3 and J4 carrying the 7th, 8th, 9th Infantry and the 1st and 4th Special Service Brigades respectively.

As the ships of Assault Force J approached the Normandy coast, the warships of Bombarding Force E moved ahead of them and followed a van force of minesweepers toward their allotted anchorage off the mouth of the River de Provence. There the two cruisers opened fire shortly after 0530 hours: at the western end of the lines was Force K's *Flores*, but then came the *Belfast* and *Diadem* which engaged the Ver-sur-Mer and Moulineaux batteries respectively. Lighter vessels engaged smaller emplacements on the beaches. Then the assault was launched.

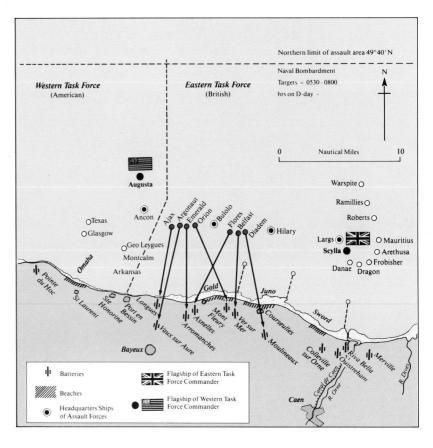